creative photoshop lighting techniques

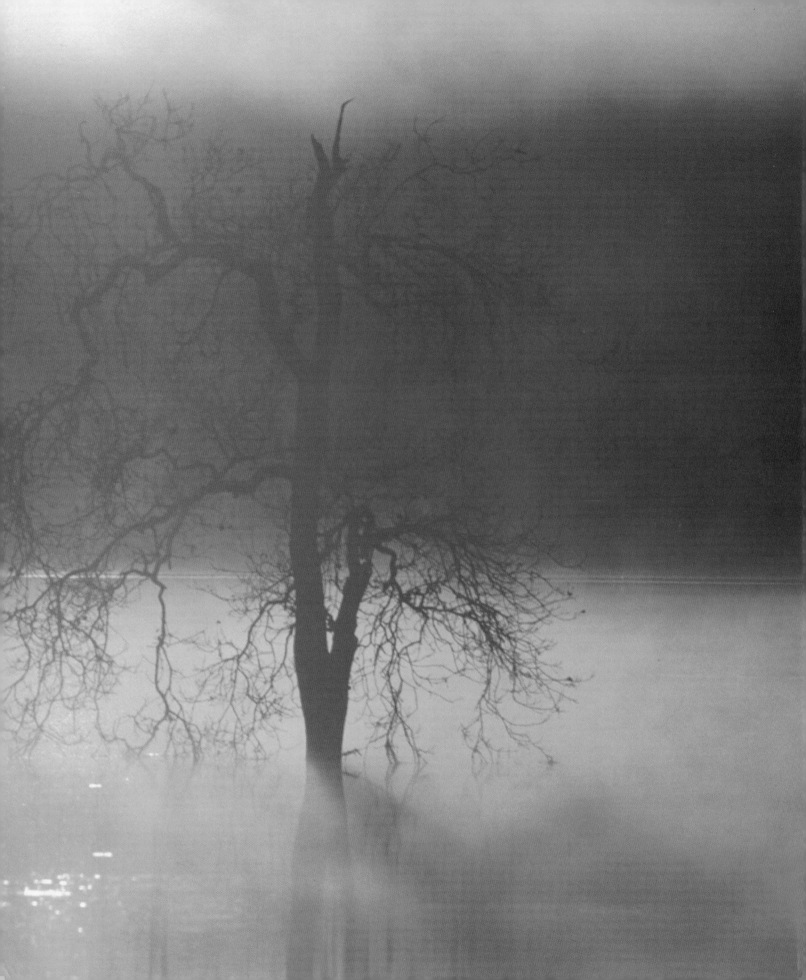

creative photoshop lighting techniques

Barry Huggins

LARK BOOKS

A Division of Sterling Publishing Co., Inc.
New York

Creative Photoshop Lighting Techniques

10 9 8 7 6 5 4 3 2 1

Library of Congress Cataloging-in-Publication Data

Huggins, Barry.
 Creative photoshop lighting techniques / Barry Huggins.-- Rev.
and updated ed.
 p. cm.
 Includes index.
 ISBN 1-57990-760-1 (pbk.)
 1. Photography--Lighting. 2. Photography--Digital techniques.
3. Adobe Photoshop. I. Title.
TR590.H83 2006
006.6'86--dc22
 2005016033

Published by Lark Books, a division of
Sterling Publishing Co., Inc.
387 Park Avenue South, New York, N.Y. 10016

© The Ilex Press Limited 2006

This book was conceived, designed, and produced by:
ILEX, Cambridge, England

Distributed in Canada by Sterling Publishing,
c/o Canadian Manda Group, 165 Dufferin Street,
Toronto, Ontario, Canada M6K 3H6

If you have questions or comments about this book, please contact:
Lark Books, 67 Broadway, Asheville, NC 28801, (828) 253-0467

Printed in China

ISBN: 1-57990-760-1

For more information on Photoshop lighting techniques, see:
www.web-linked.com/lifxus

For information about custom editions, special sales, premium and
corporate purchases, please contact Sterling Special Sales
Department at 800-805-5489 or specialsales@sterlingpub.com.

CONTENTS

INTRODUCTION

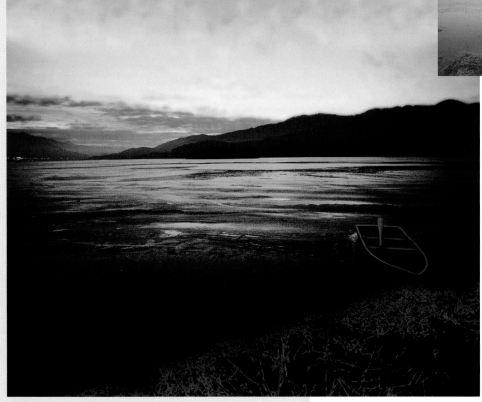

CREATING LOW-KEY IMAGES
Page 32

CREATING CANDLELIGHT
Page 44

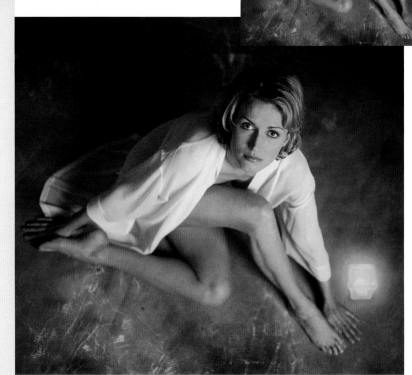

Even the world's greatest photographers sometimes need a helping hand to capture the image that they see in their mind's eye. Nature has a habit of being at its most unaccommodating just at the moment you squeeze the shutter button. The speed at which the elements and lighting conditions change can leave all photographers, both professional and amateur, with a constant love-hate relationship with Mother Nature as she provides you with the image of a lifetime, only to snatch it away before you've had the chance to take the lens cap off.

The fact remains, that even with decades of experience, access to top of the range photographic equipment, location, timing, and a large slice of luck—the final image may be a poor reproduction of the original scene. This is where Photoshop can step in and put that "wow" factor back into your images.

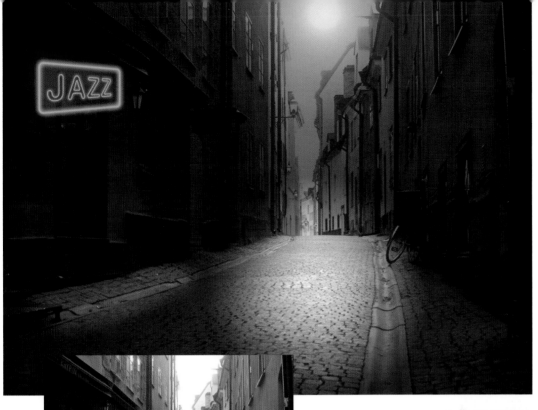

CREATING NEON LIGHT
Page 48

CASTING LIGHT AND SHADOW THROUGH VENETIAN BLINDS
Page 86

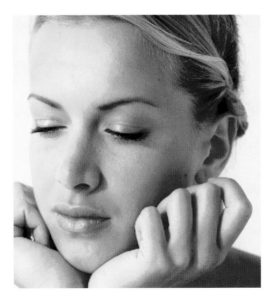

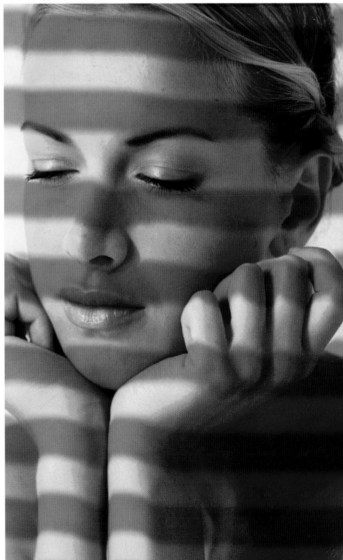

With the know-how documented throughout this book, you will be capable not only of recapturing a lost moment, such as missing a sunset by a few seconds, or erasing bystanders reflected in your shots, but also of generating a believable scene that never actually existed.

The art of illusion is a skill in itself and the ability to create lightning, water, fog, moonlight, fire and a host of other natural and manmade atmospheric effects will be easily within your grasp as you work through the tutorials. The images displayed in this introduction are just a small selection of the effects that you will create as you work through the book.

CAST LIGHT THROUGH WINDOWS
Page 90

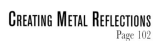

CREATING METAL REFLECTIONS
Page 102

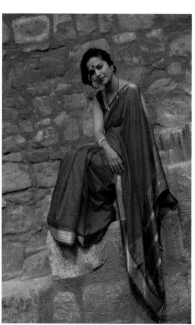

CREATING REFLECTIONS IN WATER
Page 98

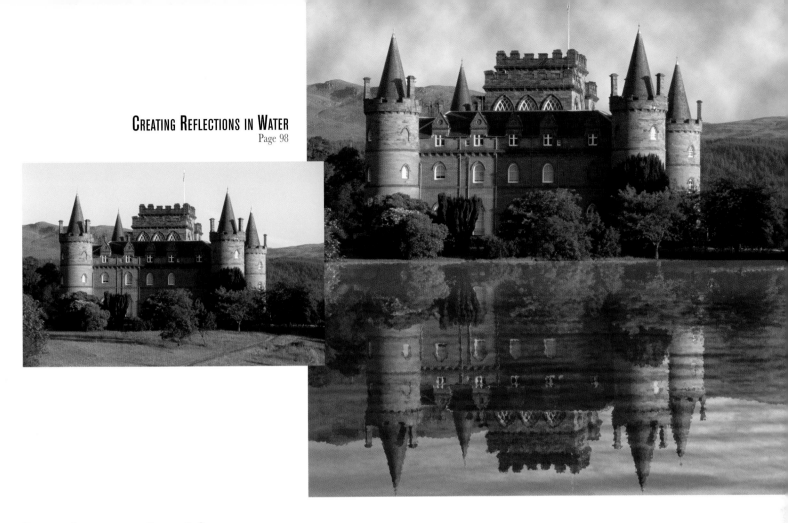

CREATING LIGHT THROUGH SMOKE & STEAM
Page 126

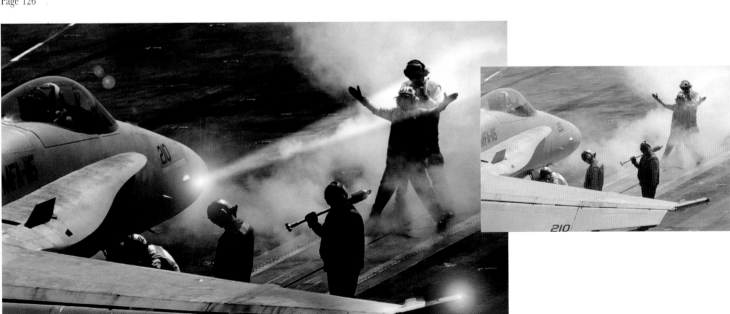

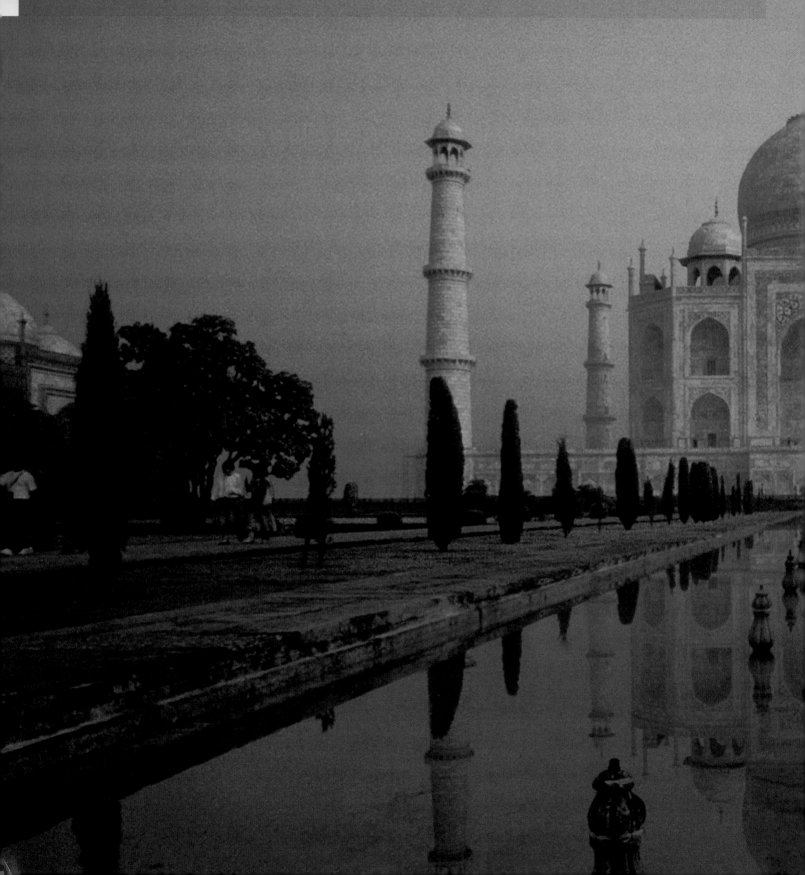

UNDERSTANDING LIGHT

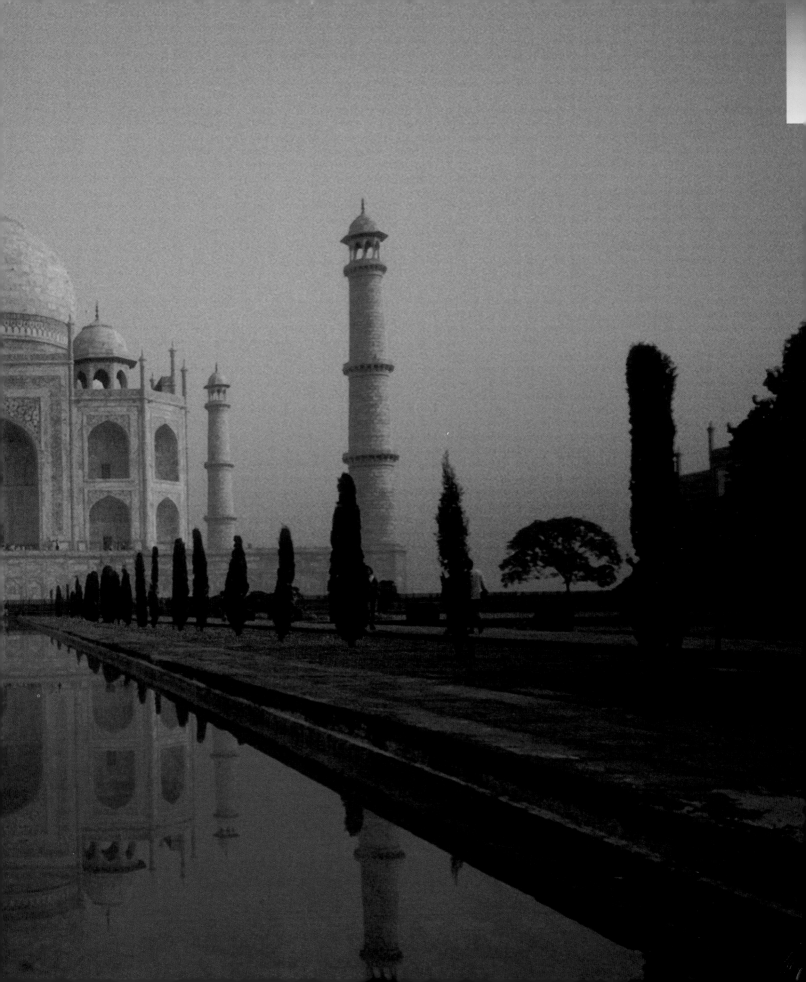

WHAT IS LIGHT?

This is perhaps a question that few people consider in a lifetime. It's just another of those things we take for granted, like the air we breathe or water from a tap. Glibly we could say it is the thing that comes from the sun or a torch, but as someone involved in the field of digital imagery, you will find that a deeper knowledge will help your understanding not only of light and its quirks, but also of color, an essential requirement if you are to harness the full power of both in your images.

THIS PAGE

Above-right The color wheel displays all of the colors of the visible light spectrum in order of wavelength.

Below The full **electromagnetic spectrum** runs from short—as small as 0.003nm—gamma-rays at one end to long—sometimes several kilometers—radio waves at the other. The **visible light spectrum** occupies a short area of the electromagnetic spectrum, with wavelengths ranging from about 400 to 700nm.

FACING PAGE

Above-right The blue vase illustrates how we only see single colors, even though the light shining on an object contains a mix of colors.

Below-left CDs act as prisms, and can be used to show that the sun's light is made up of all of the colors of the visible spectrum.

Below-right These feathers reflect back only their own color wavelength, and absorb all others.

THE ELECTROMAGNETIC SPECTRUM

Light as we know it is just one small part of a greater entity known as the Electromagnetic Spectrum. The Electromagnetic Spectrum describes a range of energy in wave form, which we more commonly know as radiation. The range encompasses gamma-rays at one end of the spectrum where the wavelengths are short, to radio waves at the other end where wavelengths are long. The wavelength itself is defined as short, long, or somewhere in between by measuring from the crest of one wave to the crest of the adjacent wave.

Other wavelengths beyond gamma-rays and radio waves exist within the electromagnetic spectrum, and these are displayed in sequence in the diagram below.

The part that we are interested in is the section toward the center, called the visible light spectrum. Nestled between the Ultraviolet and Infrared wavelengths, which are not visible to the human eye, is the Visible Light Spectrum. The wavelengths here encompass all the colors visible to the human eye, ranging in wavelength from 400 nanometers (nm), which we perceive as the color violet to 700nm, which we perceive as red. One nanometer is equal to one thousand-millionth of a meter. All wavelengths outside this range are invisible to the naked eye.

So when we talk about color, we are actually discussing electromagnetic radiation wavelengths. Each color in the visible light spectrum conforms to a wavelength which can be seen in the diagram. Of course, no one sits in a romantic restaurant on a moonlit night and whispers to their date "Your eyes sparkle with a wavelength of 500 nanometers." They would say "Your eyes are so blue" and the evening might develop; the common words we use are better for widespread descriptive purposes.

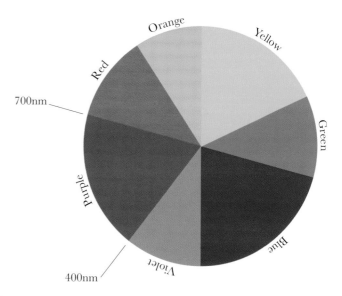

COLOR WHEEL

THE COLOR WHEEL

It was Sir Isaac Newton who created the first color wheel, which follows exactly the same configuration of color as the horizontally represented visible light spectrum. The color wheel remains a powerful aid to designers, photographers, and creative artists of all kinds. The wheel displays how analogous (adjacent) colors work well in combination, as do complimentary colors (those at opposite sides of the wheel). In the color wheel above, the color purple appears outside the visible wavelengths. This is because purple does not conform to a specific wavelength, but is instead created by mixing wavelengths of red and violet.

THE COLOR OF LIGHT

When all the colors of the visible spectrum are combined, the result is white light. If this sounds odd, you'll see the proof next time a rainbow appears in the sky. Water droplets in the air act as prisms and refract the white light generated by the sun, revealing the individual wavelengths, which we know as rainbows. The same effect can be witnessed by shining white light onto any object able to act as a prism, such as a CD.

You will notice that black is omitted from the visible light spectrum, as black is not a color wavelength in itself, but merely the absence of light.

Radio Wave - Long Wavelength

Distance = Wavelength

Gamma-Ray - Short Wavelength

Distance = Wavelength

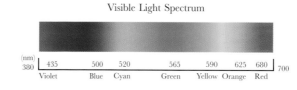

Electromagnetic Spectrum

Gamma-Rays X-Rays Visible Light Microwaves Radio Waves

Ultraviolet Infrared

Visible Light Spectrum

(nm) 380 435 500 520 565 590 625 680 700

Violet Blue Cyan Green Yellow Orange Red

How Our Eyes See Wavelengths as Color

There may appear to be a missing link at this stage. We've discussed electromagnetic radiation wavelengths and how colors are assigned to specific wavelengths, but you may be wondering how our eyes and brains perceive red, yellow, green, or any color just by seeing a wavelength.

The answer lies in the eye itself. Photosensitive cells exist in the retina at the back of the eye that absorb light. These cells are categorized as either rods or cones. The rods are responsible for sensing light intensity and the cones for distinguishing color. Three sets of cones exist and are receptive to the different wavelengths of red, blue, and green. Although wavelengths of many frequencies are entering the eye, only the maximum wavelengths of red, green, and blue are responded to and therefore perceived as the color. In the case of yellow, you will notice from the electromagnetic spectrum that the yellow wavelength sits between the red and green wavelengths, so the red and green receptors in the retina receive equal stimulation with little impact being made on the blue receptor, resulting in the eye perceiving yellow.

The Color of Objects

It is logical to say that we need light in order to see an object, but does it still sound logical if we say that in order to see the color of an object, the light falling on it must contain all of the necessary wavelengths? After all, isn't a red object always red? Well, not necessarily. If you cut your finger pruning roses in the garden in the afternoon, you will see red blood, whether it's sunny or cloudy. Cut your finger while scuba diving a few meters underwater, however, and your same blood will appear anything from green to near black, depending on how deep you are. While seeing green blood can be very disconcerting, physics can prevent you from going into panic. Upon encountering water, light wavelengths will be reflected right back, penetrate straight through it, or become absorbed. Which action takes place depends on the wavelength and the depth of the water. At relatively shallow depths, the longer red wavelengths are absorbed by the water. Objects too will also reflect, absorb, or enable light wavelengths to pass through them. So in order for the red blood to be perceived as red, it must reflect back the red wavelength and absorb all others, and therefore without the red wavelength underwater, the color we perceive is green-black.

It is important to recognize that the color of an object is not solely an intrinsic quality, but a combination of its color characteristics and the wavelength of the light that falls on it. When a white light falls on an object, the object will absorb all color wavelengths except for the color wavelength of its own appearance, which it will reflect back. If an object's surface reflects back all colors, it appears white; and if it absorbs all colors, it appears black.

The blue vase pictured is illuminated by the white light of the sun which, as we now know, is a combination of all the color wavelengths of the visible spectrum. Red, green, and blue in combination can create all of the other spectrum colors. The red and green wavelengths are absorbed by the blue vase, but the blue is reflected back, enabling the eye to perceive the object as blue. Similarly, the multicolored feathers are each reflecting back their own color wavelength only and absorbing all others.

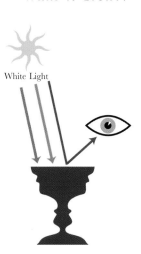

White Light

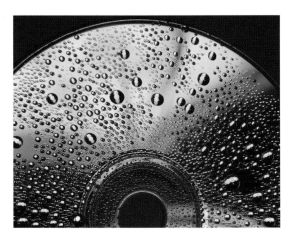

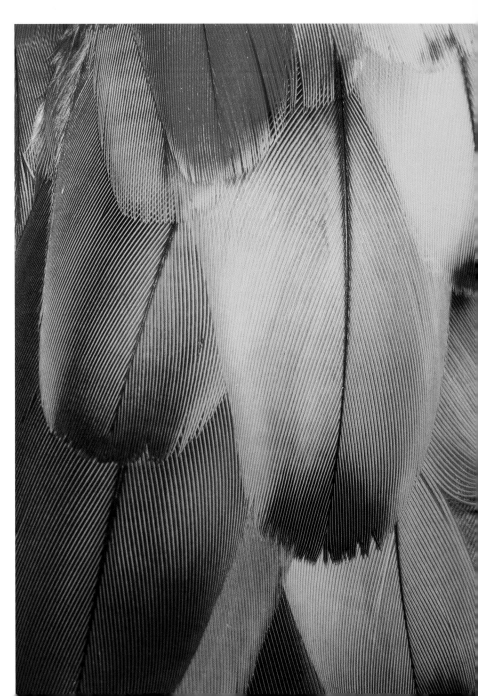

Kelvin Color Temperature Scale

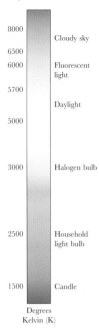

8000	Cloudy sky
6500	
6000	Fluorescent light
5700	
	Daylight
5000	
3000	Halogen bulb
2500	Household light bulb
1500	Candle

Degrees
Kelvin (K)

Above The Kelvin color temperature scale provides an accurate way of describing the color of light. The mean noon sunlight temperature of 5,400K is an arbitrary figure taken as the average direct midday temperature in Washington DC. Of course, daylight color temperatures can vary wildly, but 5,400K is a good base to work from.

Right These two images illustrate how much difference color temperature can make to our perceptions of a scene. The warm, welcoming yellows and oranges of the top picture evoke feelings of happiness and contentment, reflecting, from a purely temperature-based point of view, the warmth found in the reds and yellows of fire. The blues and violets of the lower image evoke a much cooler tone. They immediately conjure up visions of the cold light of daybreak and the freezing blues of ice. In both of these images it is easy to attribute the color of light to our perceptions of temperature and its associated feelings.

COLOR TEMPERATURE

The color of daylight can change throughout the day, having a major impact on an image. It would be useful to define these colors by a fixed unit of measurement, so accurate descriptions can be used when adjusting a light source to simulate a given lighting condition.

Such a measurement exists, and is called the Kelvin scale. The Kelvin scale uses a measurement of degrees Kelvin (K) to describe the apparent color of a light source relative to heating a black body source such as a piece of metal. Imagine applying a heat source to an ordinary metal key. As the key heats up, it first starts to glow red. As the heat source is maintained, the temperature increases and the key changes color accordingly to orange, then yellow, white, and finally a blue color. So the heat at any given point can be directly correlated to the color of the light emitted and denoted a numeric value.

The diagram displays typical Kelvin values for a range of common lighting conditions. Lower values are considered warm colors, higher values are cold colors. It should be noted that the color temperature is not influenced by the intensity of the light, but only the color.

With the Kelvin unit of measure as a base reference, it is now very easy to adjust different types of light sources so they match and produce a uniform light color. For instance if halogen bulbs are being used to supplement natural daylight, a color correction gel could be used to change the halogen bulb's 3000K temperature to something closer to the common daylight temperature of about 5000K.

COLOR TEMPERATURE, PERCEPTION, AND EMOTIONAL RESPONSE

If we remove the physics from the subject of light and color for a moment and look at the psychology, we will find that the descriptions of warm or cold colors have a great impact on our emotional response to an image. As a warm-blooded species, most humans are more comfortable in an environment that is warmer rather than colder. For many, the archetypal vision of relaxed, home comforts might be an image of a roaring log fire in a room diffused with a deep orange glow. It is natural, therefore, that images with warmer colors (lower temperatures as defined by the Kelvin scale) should have deep associations in the human psyche with comfort and an air of welcoming and desire.

Contrast this with images with an overall cold range of colors, and the human reaction is quite different. It's like pulling the welcome mat from under your feet. Take a look at the two pictures of the Taj Mahal. Although similar images in terms of content, the messages they convey are quite different. This has nothing to do with artistic merit or right and wrong. Both images are successful for their designated purpose. However the orange-colored version might inspire the viewer to kick off their shoes and walk lazily through the water, sipping cool drinks and dreaming of hot balmy nights. The tones of the blue version depict the first light of dawn, its colors reminiscent of the chill associated with the early morning. Though the ambient air temperature may, in fact, be similar to the ambient air temperature in the orange version of the image, our perception and therefore our emotional response will be quite different.

In these examples, we have looked at color temperature in the context of how it relates to ambient air temperature and this may seem a logical conclusion to form based on the knowledge

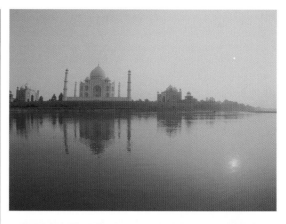

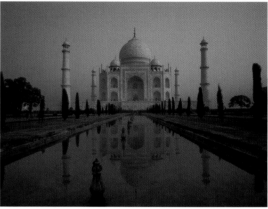

that fire is yellow-orange (warm colors) and generates heat, and ice is associated with a blue aura (cold color) and generates cold. If we now ignore the link with air temperature, psychology offers us further insights into how our emotions are affected by exposure to warm or cold colors.

Warm colors are considered to invoke such emotions as happiness, elation, and enthusiasm in the yellow to orange range and aggression and hostility in the red range. From within the cold color range, blue and green are associated with serenity and refuge, and black, brown, and gray with distress and despondency. Of course, these statements are an oversimplification and broad generalization because the perception of color temperature psychologically is, in fact, very subjective.

And yet we see examples of this psychology in practice everyday, principally in the field of advertising, where posters and television advertisements use orange and yellows to inject enthusiasm, joy, and vitality, blues and greens to inspire confidence and security, and, not unsurprisingly, there is a distinct lack of brown and gray. It would be imprudent, however, to implement these findings into an advertising campaign without first paying heed to such vital factors as fashion and cultural differences, which in extreme cases can turn much of the theory upside down.

Take the test yourself. Does the picture of the lake instill a sense of serenity in you inspired by the cold blue light?

Do you feel enthused and a sense of happiness when looking at the warm color of the yellow walls and orange doors?

Whatever your immediate feelings, the effect may be purely subliminal and if over the next hour you feel overwhelmingly elated or deeply peaceful, one or other of the images may have just kicked in.

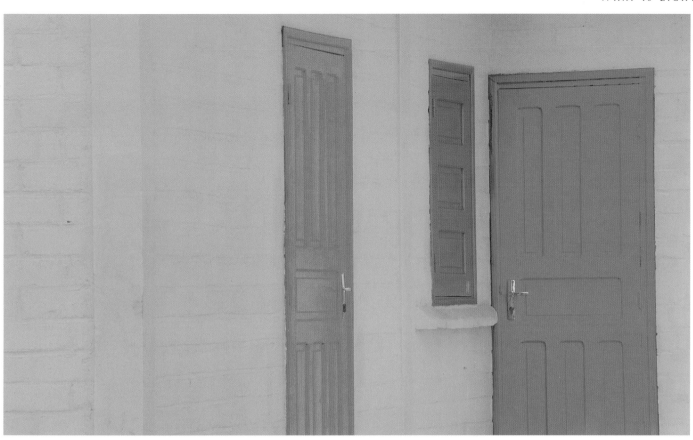

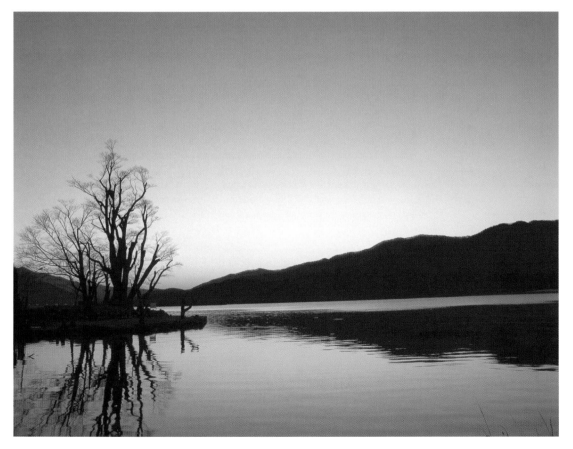

Above and left The psychology of color is based upon many diverse factors and extensive testing, but different people still respond to color in entirely different ways. There are, though, some standard psychological responses to color that can be assumed to affect most people. For example, leaving aside the temperature response that people have to yellows and blues, look at the two images on this page and see if they stir any of the following emotions.

The yellows and oranges of the doors and walls evoke feelings of playfulness, creativity, and an easygoing attitude if bright, but duller yellows hint at caution and sickness. Yellow is also a difficult color on the eye, and its attention-grabbing properties can be overbearing at times.

The blues of the sky and water in the lower image are relaxing and harmonious. They indicate loyalty and trust, but also sadness and solitude. Perhaps the inherent tranquillity of this image is enhanced by the combination of the lonely blues and the contented oranges of the sunset?

DIFFERENT LIGHT TYPES

It would be easy to think of light as one generic entity that simply makes visibility possible, yet the different types of light are almost as diverse as night and day itself. Choosing the right kind of light for any given image is as critical and fundamental to the image as focusing the camera. Whether you are harnessing natural daylight or creating an artificial lighting setup, some thought needs to be given as to the final desired effect and the type of light that would be most appropriate to the project. In this section we will look at examples of the most commonly used types of light.

AMBIENT

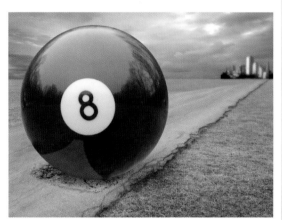

Ambient is the most common form of light that we encounter in our daily lives. It is the overall light emanating from the sun or the artificial lights that illuminate a room. Often the direction of ambient light is vague, shadows are faint or limited, and the coverage of light is fairly widely distributed. Ambient light also consists of the light reflected from other objects in the environment. As a source for general photographic lighting, it merely provides illumination, but for more specific lighting scenarios props or additional lighting is required.

In the image of the pool ball, ambient light can be seen in the form of light from the sky as well as reflections from the concrete and the grass.

DIRECT LIGHT

Direct light can be from a natural source as in the sun, or from an artificial light source that projects light as a concentrated, directable beam, such as a spotlight or a torch. What both natural and artificial direct lights have in common is the fact that they are considered a small source light. Direct light results in what is termed as hard light falling on the subject, revealing hard-edged shadows and extremes of contrast. This makes it ideal for dramatic images and emphasis on specific areas of the photograph.

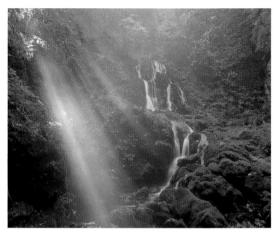

In the example, direct light is manifesting as rays of light because the direct sunlight is filtered though the foliage.

DIFFUSED LIGHT

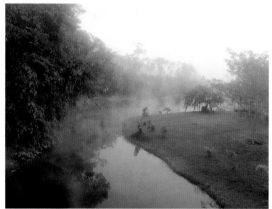

As with direct light, diffused light can be from the sun or artificial lights. The common factor in this case is the fact that they are both categorized as large source lights. In the case of the sun, it hasn't physically changed size, but on an overcast day the cloud cover will disperse the light, converting the entire sky into the new source. Such conditions provide a flat, even light with little or soft-edged shadow. For artificial lights, even a spotlight can be converted to a diffused light by placing a semitransparent gel, tissue paper, or similar material over the light. This serves the same purpose as clouds where the sun is concerned. On days when there is no cloud cover and diffused light is desired, the same effect can be achieved by using a large white umbrella or similar prop to soften the light.

Mist rising from the water is adding to the overall diffusion in this river scene. The image also demonstrates the richness of the color of the grass. Greater saturation is a common feature of diffused lighting.

OMNI LIGHT

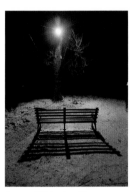

An omni light describes a light that radiates a circular, uniform spread of light, such as a household light bulb. This kind of light is fine for general lighting purposes but its nondirectional qualities mean that it can be difficult to control and produce creative effects.

HARD LIGHT

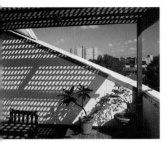

Hard light, as we have already seen, is generated from a small light source such as direct sun or a spotlight. The effect of hard light on the subject is to create hard-edged, well-defined shadows. Hard light can be considered severe and in some cases unflattering for portraits unless the desired effect is one of drama. This is where hard light excels, producing high-contrast,

strong images with an interesting juxtaposition of light. Hard light is also successful at rendering texture when suitable light angles are employed and well suited to enhancing definition.

The picture of the roof terrace demonstrates the hard-edged, well-defined shadows of hard lighting.

The vividly colored buildings have caught the direct sun at such an angle that the corrugated surfaces are well defined revealing their true texture.

SOFT LIGHT

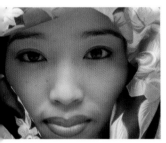

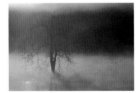

In the portrait of the girl, the silk scarf adds to the already diffused light where only her nose and lips show any discernable highlight. The softness of the shadow is highly complimentary to the girl's skin tone, suggesting an unblemished, porcelain-like surface.

As explained earlier soft light is generated from a large light source, such as an overcast sky. Soft light renders soft, subtle shadows that are flattering in portrait photography. Detail is minimized, with emphasis being on the overall form rather than the texture.

In the picture of the tree, the heavily diffused sun caused by a combination of cloud and mist has created an almost abstract image where most of the image information has been subdued except for the softened monotone branches, lending an eerie, timeless quality to the image.

HIGH KEY

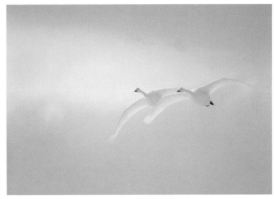

High-key images are created by flooding the scene with a profusion of light. No one type of light source is solely responsible for the effect, although a diffused light will offer more pleasing results. A number of light sources can ideally be used for optimum effect with additional reflective surfaces making their own contribution to the image. Despite this abundance of light, shadow areas are an integral part of high-key images to prevent the image from being

nothing more than an overexposed photograph.

All the ethereal qualities associated with high-key images are embodied in the photograph of the swans. The grace and poise of the airborne birds, although not essential to a high-key image, add to the heavenly dreaminess of the composition. The predominantly light tones are relieved only by the slightly deeper shade of sky at the top of the picture and the almost pure black beak, eyes and feet.

BACK LIGHT, RIM LIGHT & SILHOUETTES

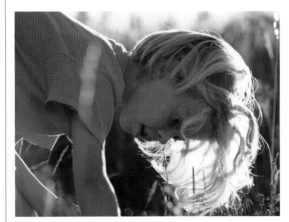

This multiple category is, in fact, one type of light, namely, backlight. As the name suggests, the light source is positioned behind the subject and, depending on circumstances such as the intensity of the light

and whether additional light sources or reflections are trained on the subject, the result could be a silhouette or a rim light resembling a halo effect.

In the picture of the girl, she is backlit, but the sun

LOW KEY

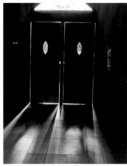

If high key is predominantly light, then low key is predominantly dark, but the same rules apply. A dark image risks being merely underexposed and uninteresting. As with the high-key image, it is the opposites that create the contrast and relief. In the case of a low-key image, strategically placed highlights create the mood and bring the image to life.

In the image of the door, the atmosphere is almost tangible. The small areas of light seem to be trying to burst forward, creating a tension and inviting anticipation in the viewer as to what may lie behind the door. The overriding sinister and mysterious aura is typical of successful low-key images.

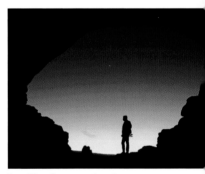

is positioned at an angle to her. This enables its light to define her outline and also pass through the finer areas of her hair, forming a rim light effect.

The second photograph, taken from within a cave, is illuminated solely by light coming in from the background sky. This forces the framework of the cave and the lonely figure of the man into total silhouette.

LIGHT SOURCES

Of all the factors that determine the final quality of an image, the source of light is undoubtedly key. No other single part of a photographer's toolkit can so radically change the mood and context of a photograph.

The range of light sources itself is enormous, each source having its own characteristics and contributing its unique qualities to the finished work. The sun, the ultimate natural light source, has many characteristics. Its light is influenced by its position in the sky, cloud, and other atmospheric conditions. Choosing the right time of day and weather conditions for the type of desired image is a simple way of utilizing natural light to its best effect. Overcast days offer a flat diffused light with little shadow. On clear days, early morning and evenings provide a warm flattering light with long shadows and rich colors, while midday suffers from harsh direct light with little shadow to shape and mould subjects.

Although props can be used for a degree of control over natural daylight—such as white umbrellas or aluminium foil for diffusion and reflection, lens filters to correct or enhance color, and fill-in flash to minimize unwanted shadow—the true level of control is limited. This makes natural daylight sometimes unsuitable for certain situations, such as portraiture, still life and product advertising shots.

In these situations, the photographic studio provides a controlled environment where the full range of tones can be rendered with pinpoint precision through the use of blackouts, reflectors, photo lamps, and spotlights. Different factors now come into play, primarily the number of lights, their size, and their positions relative to the subject. A broad array of lighting configurations are possible but, perhaps surprisingly, a relatively small number are required to recreate most common lighting conditions.

This is demonstrated in the examples that follow, in which a statue is being used as the subject. The statue is a combination of both smooth and textured surfaces, with angular projections as well as soft contours, raised edges as well as deep recesses, and matt and shiny surfaces side by side. These extremes are not unlike many common subjects, such as a human face or a bowl of fruit, and the mood we create for that subject is all down to some basic decisions on how many lights to use, what size, and where to put them.

SINGLE SOURCE LIGHTING

For many photographers, the vast majority of their images will be taken under single source lighting conditions. Outdoor photography, for instance, is largely reliant upon the sun as the main, if not the only, source of light. Single source lighting needn't be considered inferior in itself. Some of the greatest images ever shot have used nothing more than natural daylight. It's not so much the number of lights used, but rather the quality of the light and what kind of atmosphere is intended.

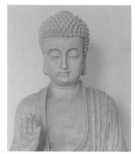

Diffused Light
An example of a natural single diffused light source is a cloudy day, when the entire sky becomes the light source. The sun being shrouded by cloud is converted to a large source with the resultant light being even and generating either little shadow or shadows with soft edges.

In a studio, placing a semi-transparent material such as tissue paper or a translucent gel over a single spotlight or photo lamp will have the same effect. In the example, the minimal shadows and lack of definition combine to make the image uniform and simplified.

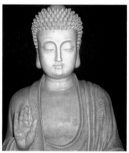

Direct Small Source Light
Direct sun is actually considered a small light source. Although it engulfs the earth with its size, the fact that it is over 93 million miles away reduces it to small source of light. This is mimicked in the studio with a single unobstructed light with a small concentrated focal point. Harsh shadows and removal of texture in the concentrated area are typical of this kind of light. The example shows a single light shining directly at the statue from the front, focusing on the face. The face area is almost completely washed out, with harsh shadows revealing detail in the peripheral areas around the lights concentration.

Top or Down lighting
Although this lighting condition is a very common one, particularly if you live in a country prone to overcast skies, it is generally unflattering from a portrait photography point of view. Small-source top lighting in particular will render harsh shadows down the face, darkening the area beneath the eyes, nose, and mouth and highlighting the brow and nose making a stark impression.

From a dramatic point of view, though, top lighting can convey a celestial air and a general aura of cascading light.

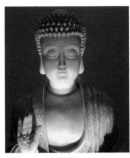

Bottom or Up lighting

As with top lighting, drama is the byword here. The unflattering nature of this form of lighting in respect of portraiture makes it less than ideal as a method for illuminating the human face, unless of course a sinister or stylized impression is desired.

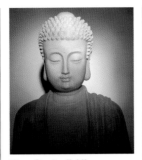

Three Quarter lighting

This type of lighting achieves a good compromise between the depth of detail and shadow and highlight areas. The angle of the light is such that it illuminates the majority of the subject and still provides for a degree of shadow to mold and define the contours. This is equally true of peoples' faces or any subject with depth to its form.

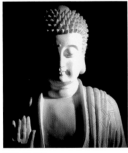

Side Lighting

Single light source side lighting produces high-contrast images with strong detail where the shadow and light mix. Although detail is revealed, it should be noted that very little information is preserved in the extreme areas of highlight and shadow, making the image more of a curiosity piece rather than a detailed study of the subject.

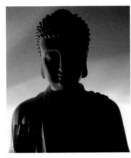

Backlight

Backlighting would not generally be considered a prime source of lighting for classic composition, but for silhouettes, dramatic effect, and any situation where detail is less important than mood, it has great merit. Despite much of the subject being in shadow in the example, its contours are picking up light, providing highlighted areas of interest. These areas add to the mystique as small visual clues offer hints as to the image's form.

MULTIPLE LIGHT SOURCES

An extra light source adds another dimension to the subject. Rather than the decision being constrained to which side to have the shadow and which side to have the highlight, an additional light can be used to add additional highlights or, indeed, to cancel out shadows cast from the primary light.

This combination can realize a far better illuminated image with a generally more pleasing and flattering distribution of light and shadow. Compromise is no longer necessary as the full field of vision can be sculpted with the range of tones as desired.

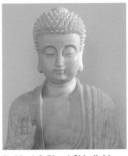

Ambient & Direct Side light

This combination works well when good general lighting is required plus additional detail for information or dynamic interest. In the example, the ambient light is natural diffused daylight entering through the large studio windows. The second light is a small source direct light illuminating from the side. This immediately generates highlights, revealing a shiny surface and shadows that define the texture and contours of the statue.

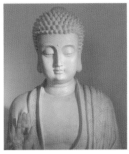

Diffused Front & Three Quarter Light

A perfect choice for flattering light, which offers good uniform illumination with strong detail. Whereas the single-source three-quarter light we saw earlier provided good detail for the subject, the degree of illumination was limited and fairly focussed. The addition of a large source diffused light located at the front of the subject, as in the example, expands the influence of light, making for an altogether more welcoming upbeat image.

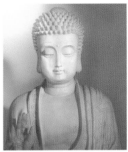

Adding a Third Light Source

A third light source gives you the ability to create a perfectly balanced composition. Careful management of each light allows you to mold the subject through the interaction of highlight and shadow. Undesirable elements can be cloaked in shadow, while areas of interest can be bathed in light. For portraits, different lights can be used to place equal emphasis on the eyes, nose, and mouth. Another light can be used to define the jaw line with shadow. In the example, three large source diffused lights are used, two using three-quarter lighting on the left and right and the third shining down from the 11 o'clock position. This has produced highlights on both cheekbones, with a high quality of light illuminating the central facial area. The third light then serves to remove most of the heavy shadow area on the face generated from the other two lights.

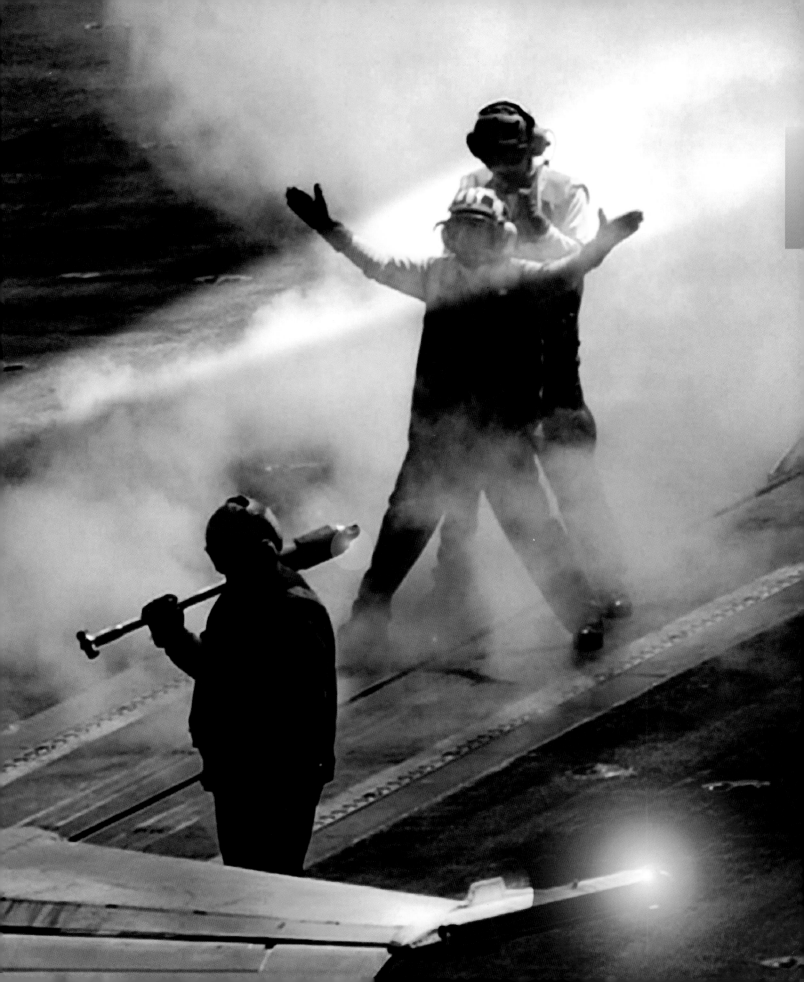

USING THE LIGHTING EFFECTS FILTER

Although far from being the only way to introduce light into images in Photoshop, the *Lighting Effects* filter does offer a fast and photorealistic way of creating an artificial light source. On first accessing the *Lighting Effects* filter, the array of settings and options can seem overwhelming, so in this section we are going to break down into bite-size chunks what each option does and how it affects the image.

To get you up and running quickly, the *Lighting Effects* filter comes with a number of preset lighting options that can be used in their original form or as a starting point for creating your own customized light. By way of demonstrating these presets, I am using a neutrally colored image with fairly flat, even light. The existing light conditions are such that each *Lighting Effects* preset will be able to demonstrate its effect without the complication of any extraneous light.

In all the examples that follow, the preset has been applied without any adjustment. It will be clear from some of the examples that further adjustments are necessary in order to make the light appear realistic.

The *Lighting Effects* filter can be accessed from the menus by going to *Filter > Render > **Lighting Effects***. It should be noted that the *Lighting Effects* filter works on image pixels only and will have no effect on transparent areas of a layer.

The presets are in the *Style* drop-down box at the top of the *Lighting Effects* dialog box. To apply a preset, select the one you want to use and click *OK*.

HERE'S HOW EACH OF THE PRESETS AFFECTS THE IMAGE OF THE ROOM.

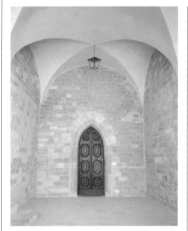

Original without lighting

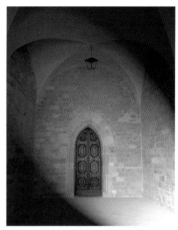

Default

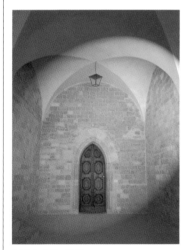

2 O'clock Spotlight

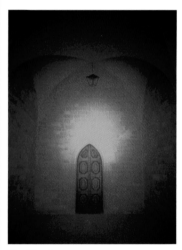

Blue Omni

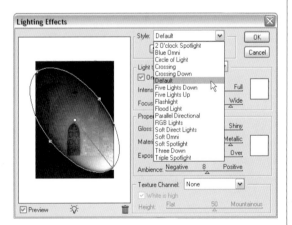

Circle of Light

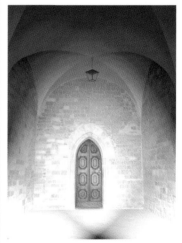

Crossing

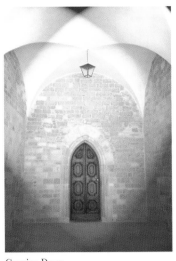

Crossing Down

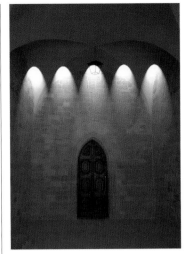

Five Lights Down

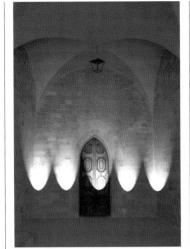

Five Lights Up

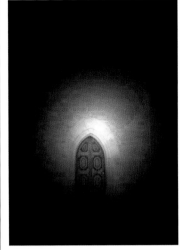

Flashlight

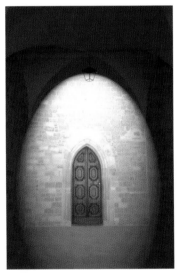

Flood Light

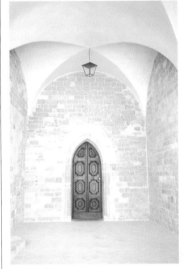

Parallel Directional

RGB Lights

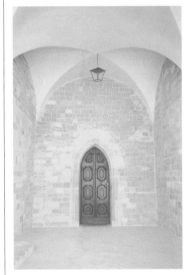

Soft Direct Lights

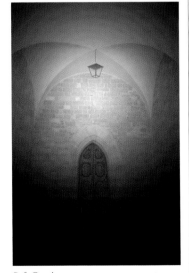

Soft Omni

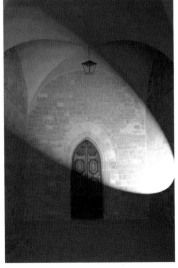

Soft Spotlight

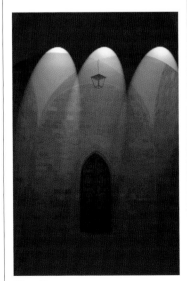

Three Down

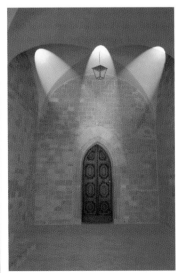

Triple Spotlight

CUSTOMIZING LIGHTS

The ability to control the lights offers you an endless variety of lighting situations that would not be possible by using the presets alone.

LIGHT TYPE

There are three types of lights to choose from. These can be accessed from the *Light type* drop-down box.

Directional Shines a light from a great distance, such as the way we receive light from the sun, so that the angle of the light doesn't change.

Omni Illuminates evenly from a central point in the same way as a light bulb would.

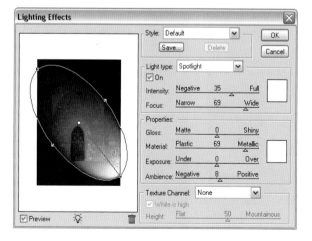

Spotlight Creates an elliptical beam of light that becomes weaker as it travels farther away from the source.

CHANGING THE LIGHT TYPE SETTINGS

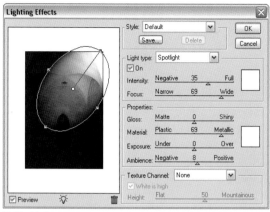

Field of Influence

Once a *Light type* has been chosen, it needs to be positioned and have its field of influence defined. This is the area that will be affected by the light. The example shows a spotlight with its field of influence defined by an elliptical shape. The white circle at the center of the ellipse defines the center point of the light and is used to reposition the light within the preview window. The light's source is defined by the point that connects to the center of the ellipse by the gray line. All four handles around the circumference of the ellipse can be used to change the ellipse's size and shape. In the example, the spotlight has been positioned so that its source is just out of the preview window, so the source will not appear in the image, only the light which it casts.

Intensity Regulates how much light emanates from the source. Drag the slider to the right to increase light, and to the left to decrease light.

Focus Defines how much of the ellipse is filled with light. Drag the slider to the right to fill the ellipse, and to the left to restrict the spread of light.

Light Color Creates the effect of a colored filter being placed over a light. Click the white square in the *Light type* section to access the *Color Picker* where the desired color can be selected.

Properties

Gloss Defines how reflective the image should be in terms of the finish of a printed photograph. Drag toward *Matte* for low reflective and toward *Shiny* for high reflective properties.

Material Refers to the light's color reflection qualities. Drag toward *Plastic* if the light's color should be reflected, and toward *Metallic* if the object's color should be reflected.

Exposure Has the effect of increasing or decreasing the overall light in the scene. Drag toward *Over* to increase light, and toward *Under* to decrease.

Texture Channel Can be used to create pseudo-3D effects through the use of grayscale alpha channels, which are used to map highlight, midtone, and shadow areas to different degrees of elevation. We will be using this technique to create some chrome 3D text later in the book.

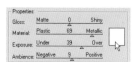

Ambient Light Color In the same way as lights can be colored, so can the ambient light in the scene. To change the color, click the white square in the *Properties* section.

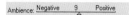

Ambience Takes into account other light sources in the scene, such as daylight or artificial lights, and diffuses the created light with those light sources. Drag toward *Positive* to increase light, and toward *Negative* to decrease light.

Creating Additional Lights New lights can be created by clicking and dragging from the light bulb icon onto the preview area. A maximum of 16 lights can be created.

Deleting Lights To remove a light, drag it from its center point into the bin. There must be a minimum of one light left in the scene.

Duplicating Lights Press the Alt key and click and drag from an existing light to duplicate it with exactly the same settings.

Saving New Light Styles Having created a lighting setup, you may want to save it for future use with other images. Click the *Save* button and type a name in the *Save as* box that opens. The style can now be selected from the *Style* drop-down box in the same way as the presets.

Deleting Light Styles Select a style and press the *Delete* button to remove it from Photoshop's folder.

Switching Lights On and Off For testing purposes, you may wish to switch one or more lights off to preview the effect. Select the desired light and uncheck the *On* box to switch it off. Click again to switch on.

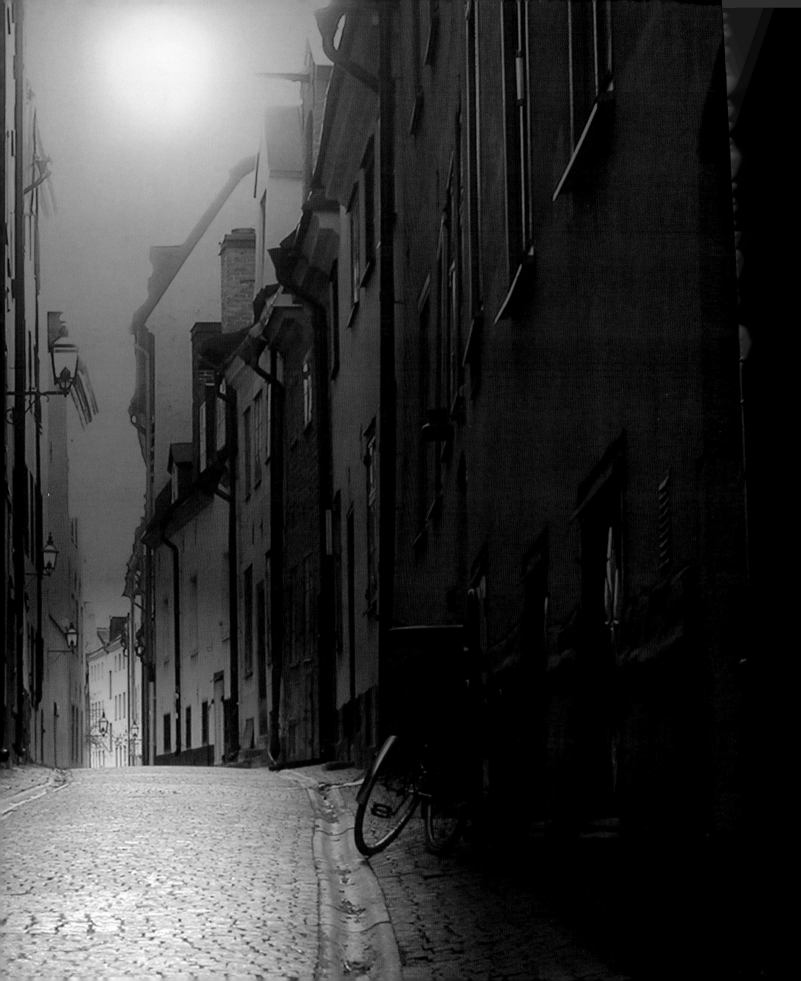

CREATING WARM LIGHT

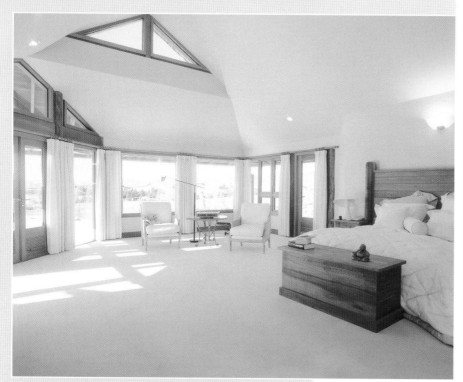

1 Add a *Curves* adjustment layer to the *Background* layer.

The link between the quality of light and human emotions cannot be understated. The world of sales and marketing observed and began to exploit this link many years ago. Whether selling a house, a hotel room, or the seat on a plane, warm light instantly conveys an impression of calmness, security, and all the creature comforts of home.

We'll now put this concept into practice by warming up the light in this interior setting.

2 Rather than applying the curve to the RGB composite, we are going to edit only the *Red* and *Blue* curves to warm up the overall light in the image. Apply the settings as shown to the relevant channels.

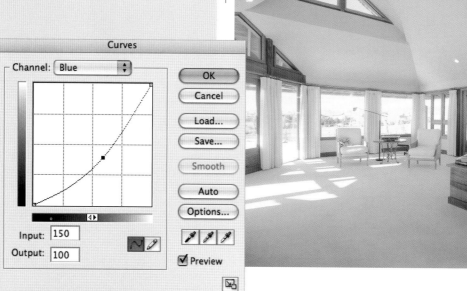

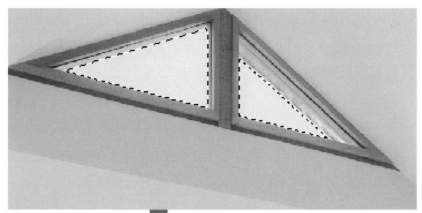

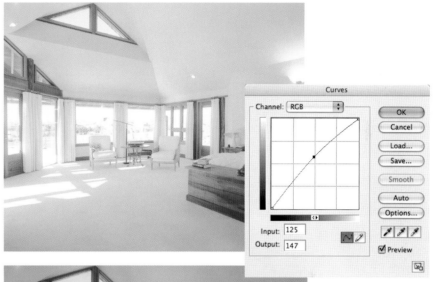

5 The final image displays a much more inviting feel purely as a result of warmer colors being introduced. You now have complete control over how warm the colors are by editing the *Curves* adjustment layer. Adjusting the curve to the whole RGB composite enables you to darken or lighten the image as desired.

3 The triangular shaped windows at the top of the room also need their color warming up to balance with the rest of the room. Use the *Magic Wand* tool to select both windows.

4 Go to *Image > Adjust >* **Color Balance**. Apply the displayed settings to the *Highlights* only.

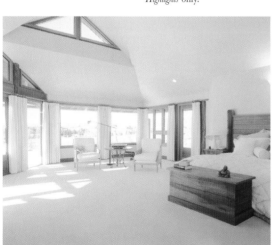

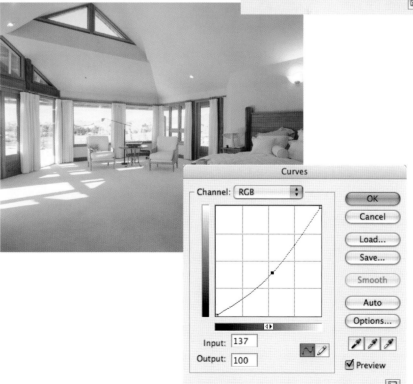

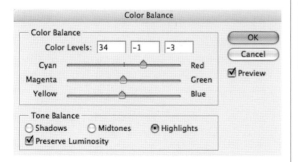

CREATING COLD LIGHT

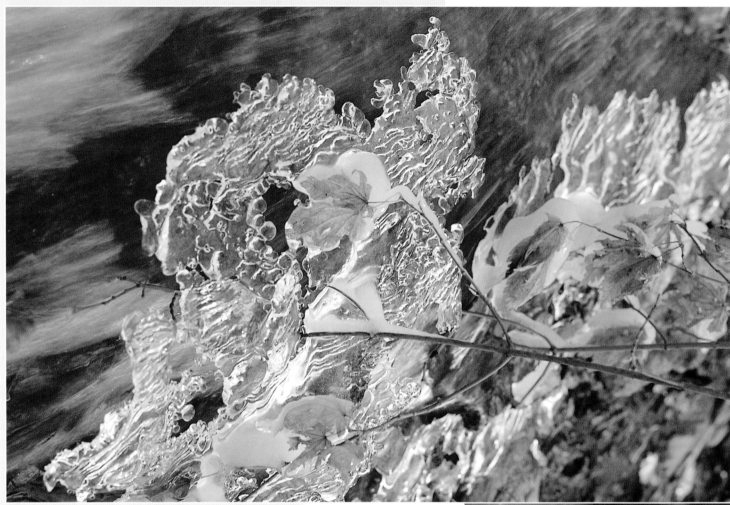

The first brief moment of dawn just before the sun emerges above the horizon is a prime time to photograph cold light. Although many conditions exist where cold light can be photographed successfully, few situations can match the primeval rawness of this time of day. However, if a warm bed is too inviting to leave at this hour, Photoshop has everything you need to reproduce it.

The fact that this image depicts ice suggests the scene is cold, yet the ambient light contradicts that fact: the colors are leaning toward the warm end of the spectrum. This in itself is not necessarily a bad thing, but if you are trying to instill in the viewer a sense of icy cold in the depths of winter, it doesn't really convey the message.

1 Create a *Curves* adjustment layer.

2 We'll make 3 adjustments to the curve. First, edit the curve for the RGB composite to lighten the overall scene.

3 Now the *Red* curve can be edited to reduce the amount of red and suggest the introduction of blue light.

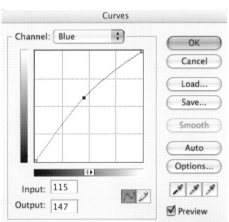

4 Finally, the *Blue* curve is raised slightly to strengthen the blue and add a little more light.

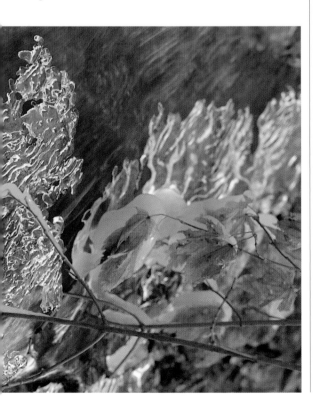

CREATING LOW-KEY IMAGES

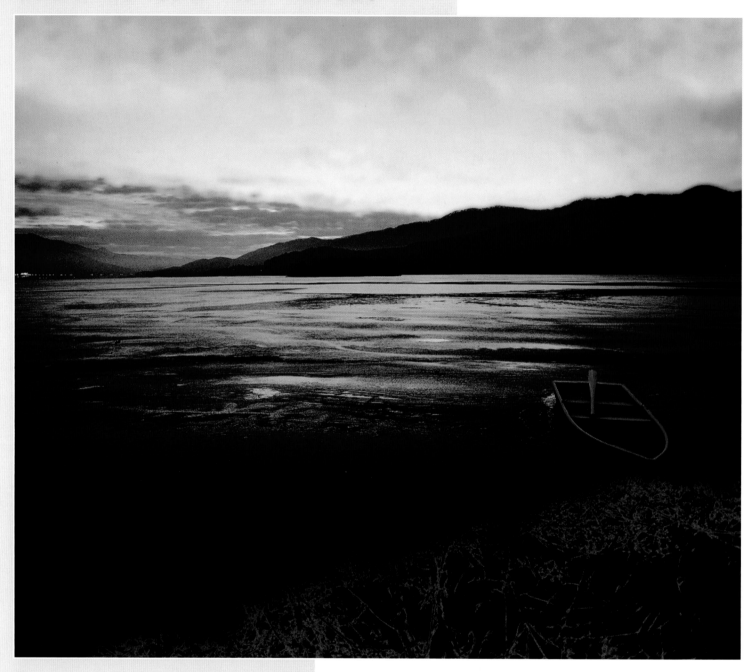

The nature of a low-key image is one that consists primarily of dark tones with highlight areas to add dramatic contrast. The images are often moody and thought-provoking, and a world apart from the popular misconception that a low-key image is merely one that is underexposed. A truly classic low-key image, therefore, is one where the highlights shoulder as much importance as the shadows in determining the success of the finished image.

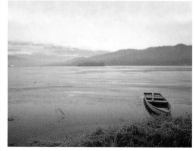

The original image.

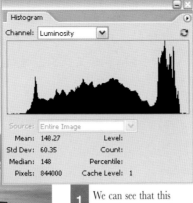

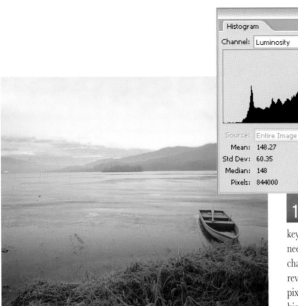

1 We can see that this image is clearly not low key. If confirmation were needed, checking the *Luminosity* channel in the *Histogram* palette reveals a broad distribution of pixels across the full range of highlights through to shadows.

5 With the *Background* layer active, go to *Select > Color Range* and use the eyedroppers to select some of the pale colored strands of foliage and click *OK* to confirm.

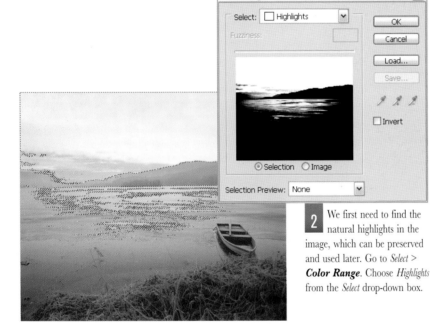

2 We first need to find the natural highlights in the image, which can be preserved and used later. Go to *Select > Color Range*. Choose *Highlights* from the *Select* drop-down box.

6 Press Ctrl (Cmd on a Mac) + J and rename the new layer *Foliage*.

3 Press Ctrl (Cmd on a Mac) + J to copy and paste the selection to a new layer. Once that's done, name the layer *Highlights*.

4 Make a rough, feathered selection of the foliage in the foreground. These too will be used to reveal some highlight areas shortly.

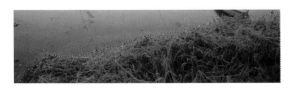

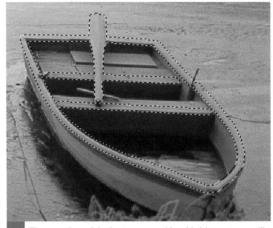

7 The top edges of the boat and oar will also provide a stark contrast against a darkened background and provide added interest, so we'll isolate those onto their own layer too. Make a selection of the boat's top edge and oar.

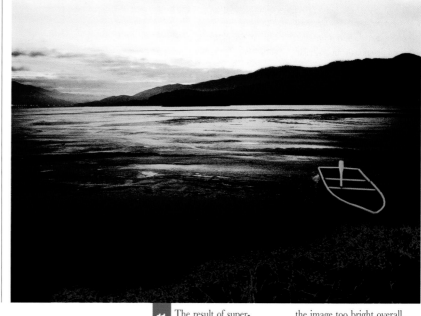

8 Press Ctrl (Cmd on a Mac) + J and rename the new layer *Boat highlights*.

9 All the highlight and midtone areas have now been isolated. Now the shadow areas need to be defined. Create a *Curves* adjustment layer above the *Background* layer.

10 Create a curve similar to the one shown to darken the *Background* layer.

11 The result of super-imposing the highlight and midtone areas on top of the dark background has made the image too bright overall. We need to add some subtlety for a true low-key image.

12 Add a layer mask to the *Highlights* layer.

Curves

Channel: RGB

Input: 170
Output: 0

☑ Preview

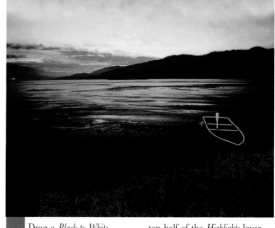

13 Drag a *Black to White* linear gradient on the mask from top to about halfway down the image. This hides the top half of the *Highlights* layer, revealing the dark sky of the *Background* layer.

14 The foliage also is not subtle enough. In a similar way to the last step, add a layer mask to the *Foliage* layer and paint along the top edge with black to soften it.

15 Change the *Foliage* layer's blend mode to *Linear Dodge*.

16 Finally, the boat highlight looks a little false. Change the layer blend mode to *Pin Light* to unify it with the rest of the scene, and we're left with a classic low-key image.

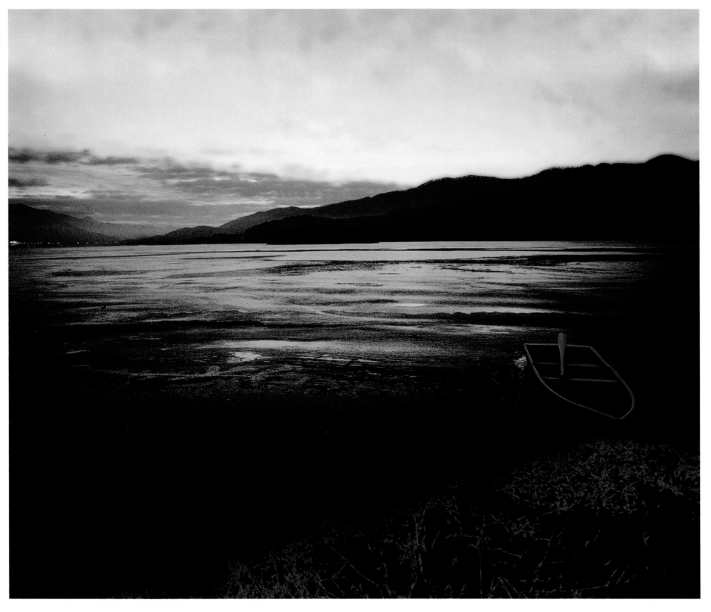

CREATING HIGH-KEY IMAGES

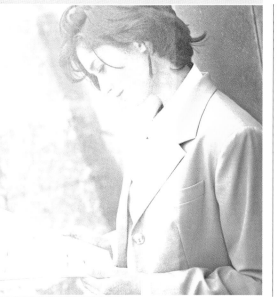

1 Add a *Levels* adjustment layer to the *Background* layer.

Celestial light and dreaminess: two of the qualities that are the hallmarks of a high-key image. The soft flood of abundant light that permeates the shadows all but suffocates the image with its radiance, but as with low-key images, opposites are crucial to mastering the effect. The absence of any shadow detail would merely result in an overexposed image. So in this walkthrough we'll be concentrating on the creation of light, but also ensuring that some darker tones are preserved.

2 Drag the white and gray markers to the left to increase light in the highlight and midtone areas.

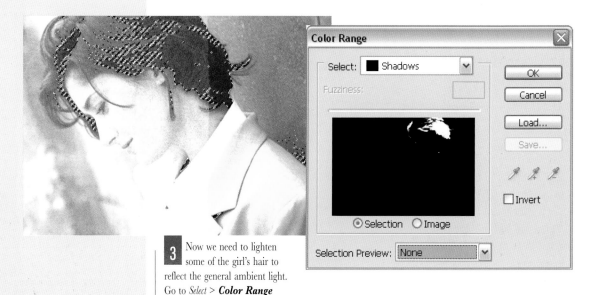

3 Now we need to lighten some of the girl's hair to reflect the general ambient light. Go to *Select* > **Color Range** and choose *Shadows* from the *Select* drop-down box.

4 To avoid any harsh lines, feather the selection by about 15 pixels for a high resolution file.

5 Create a *Curves* adjustment layer. The selection automatically becomes a mask for the *Curves* layer.

6 Drag the white point of the curve in a straight line to the left to lighten this area only.

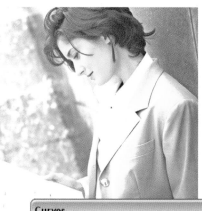

7 We already have a very effective high-key image, but to invoke that ethereal quality typical of so many high-key photographs, we need a soft wash of white light. Create a new black-filled layer called *White Light*.

8 Go to *Filter > Render > Lens Flare*. Apply the settings shown to the top-left corner of the preview window.

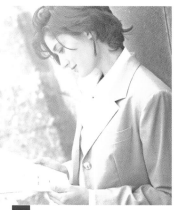

9 Change the *White Light* layer blend mode to *Screen*. The amount of light flooding the scene can be controlled by using the layer opacity.

MIXING DIFFERENT TYPES OF LIGHT

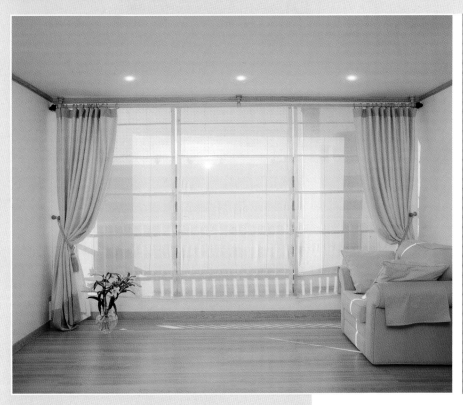

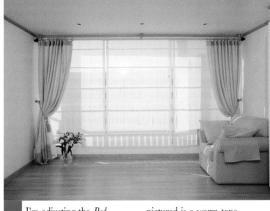

1 First we need to warm up the interior. Create a *Curves* adjustment layer.

The difference between the blue color of natural daylight and the yellow color of incandescent light bulbs is virtually cancelled out by our eyes, as we adapt to lighting conditions very well. A white shirt will be perceived as white, although the shirt may well be tinged with blue or yellow depending on the light source. Cameras are not so adept at adjusting to these different conditions, although it must be said the latest crop come fitted with white balance adjustment to alleviate this problem. Nevertheless, for creative reasons you may wish to see both of these extremes of lighting conditions in one image. In the example we are going to work through, we'll convert an image to simulate the blue cast of daylight through the windows and the warm yellow of incandescent light within the interior of a room.

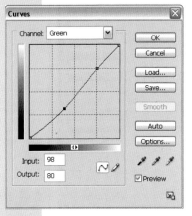

2 I'm adjusting the *Red*, *Green*, and *Blue* channels independently, in each case leaving the highlight areas untouched and just changing the midtone to shadow areas. The result of the settings pictured is a warm tone, but with a natural looking distribution of the full range of tones from light to dark within the room. The windows, however, remain a fairly cold blue, which is what we want.

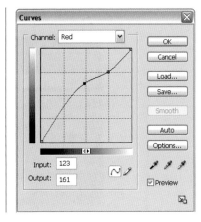

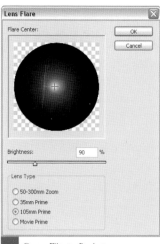

3 Although the *Curves* settings we applied have maintained a cool blue in the window area, the effect needs strengthening to make it more interesting. We don't want to change the interior, though, so we need to select the window area. Go to *Select > **Color Range***. Use the eyedroppers to select most of the window area. It's fine to leave some of the wooden frames of the window unselected, as this will help avoid a strong uniform color change that can look unrealistic.

4 With the selection visible, add a *Hue/Saturation* adjustment layer. This automatically adds the selection to a layer mask that is linked to the adjustment layer. This means the color changes we make won't affect anything but the window area.

5 Apply the settings shown.

6 The finished result has a good contrast between the warm and cold colors, and because we have used adjustment layers they can be edited until you get the color balance just right. The layer mask on the *Hue/Saturation* adjustment layer also enables you to edit the degree of blue on the window panels and walls behind the drapes.

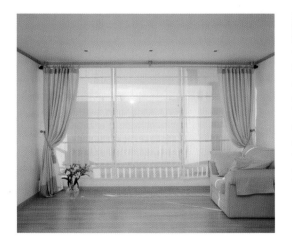

7 The main source of light in the room is supposed to be from artificial lighting with a few traces of sunlight, as seen on the floor and sofa. To emphasize this fact, we need to switch on the ceiling lights. In a new layer, create a circular selection filled with black.

8 Go to *Filter > Render > **Lens Flare***, and use the settings shown.

9 Press Ctrl (Cmd) + T to bring up the *Transform* bounding box and scale the circle nonproportionately to simulate looking at the light from an angle.

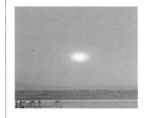

10 Change the layer blend mode to *Lighten* and position the flare over one of the ceiling lights.

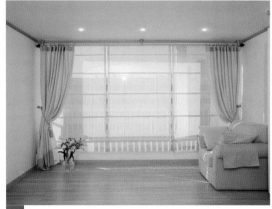

11 Duplicate the layer twice to make the other two ceiling lights and drag into place.

CREATING MOONLIGHT

The ethereal qualities of moonlight make it a subject for photography in itself, as well as being an inspiring source of light. As with all forms of light, moonlight comes in a variety of tones, from soft, silvery light that molds long gentle shadows to strong directional rays that bathe the atmosphere in a calm blue haze. It is this powerful mental association with moonlight and strong silvery blues that renders so many attempts to capture moonlight on camera disappointing. Even the most sophisticated of cameras can struggle when it comes to immortalizing the essence of our perception of moonlight. This is not so much a criticism of camera technology, but rather a testament to the genius of the workings of the human eye. Photoshop can provide that link between what the camera captures and what we perceive as a glorious moonlit scene. In this section, we will look at two different ways of putting the romance back into moonlit images.

USING LIGHTING EFFECTS

1 Duplicate the *Background* layer, naming the duplicated layer *Moonlight*.

2 The expanse of white sky is ideally positioned to place the moon. The narrowness of the alley means that we'd expect to see quite a well-defined shaft of moonlight reflected on the cobblestones, with suitably shadowy areas on the buildings. The cobblestones are also quite moist, and this can be used to our advantage to emphasize reflected moonlight. Go to *Filter > Render > Lighting Effects*. Select the *Blue Omni* light from the *Style* drop-down. Set *Intensity* to 93 and the light color to R68 G98 B249. The real trick behind simulating moonlight with this filter is to perfectly balance the *Exposure* and *Ambience* properties. We need to reduce the exposure sufficiently to depict the soft, relatively small halo of light around the moon while maintaining the optimum ambient light to suggest low levels of generated moonlight without producing an overly dark image that lacks depth. Set the *Exposure* to −40 and *Ambience* to 14. All the settings are in the example pictured. Don't click *OK* yet, as we need a second light.

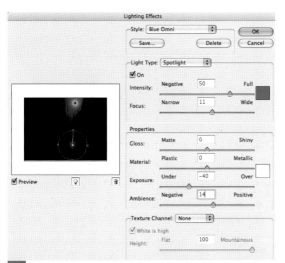

3 We now need to create a bold reflection from the moon on the cobblestones. Create a new light, choosing *Spotlight* from the *Light Type* menu. Apply the positioning and settings as in the example and click *OK*.

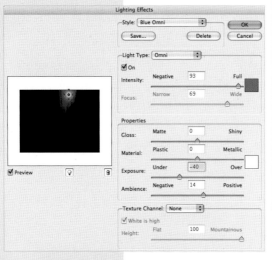

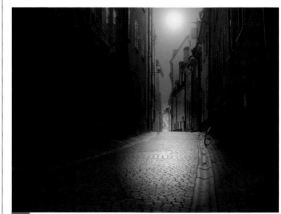

4 Here is the finished effect. If you're not completely satisfied with your result, simply undo the effect and return to the *Lighting Effects* filter, where you'll find the same settings that you just applied. It's very easy to adjust the depth of shadow if desired by increasing or decreasing the *Ambience* setting. I've left the shadow-filled area in the left of the image intentionally dark, as it will provide a perfect backdrop for some neon lights that we will produce in a later exercise.

USING GRADIENTS

Using the *Lighting Effects* filter is just one highly photorealistic way of simulating moonlight. A similar effect can also be achieved through the use of gradients. Ultimately it comes down to personal preference and the final desired effect. In the next example, we'll convert a bright daylight scene into a moonlit one with the help of gradients and some additional techniques to help the illusion.

It is important to remember when simulating lighting conditions that there should be no visible elements that conflict with the effect you are trying to achieve. A typical example would be a shadow that lies in the wrong direction for the light you have created. In this image, there is already a strong shadow being cast from the palm tree and umbrella, but if we place the false moonlight above and to the right of the tree and umbrella, the existing shadows will actually help the deception.

3 Create a new layer called *Gradient*.

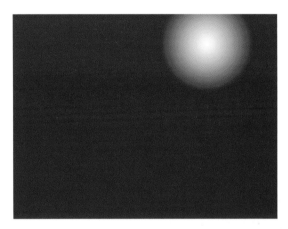

4 Set up the *Gradient* tool with a radial gradient set to *Foreground to Background*. Use white for the foreground and a deep blue for the background. Drag the gradient from the top-right corner to create a gradient similar to the one shown.

1 Duplicate the *Background* layer in case any mistakes are made so it can be used again.

2 Make a selection of the palm tree and press Ctrl (Cmd) + J to copy and paste it onto a new layer named *Tree*. This layer will be used later to help with highlights.

5 Set the *Gradient* layer blending mode to *Multiply*.

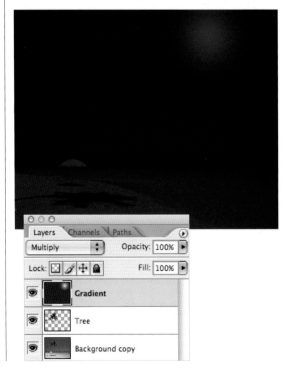

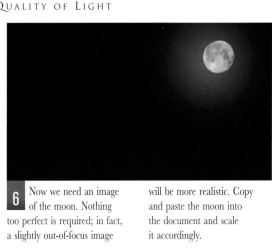

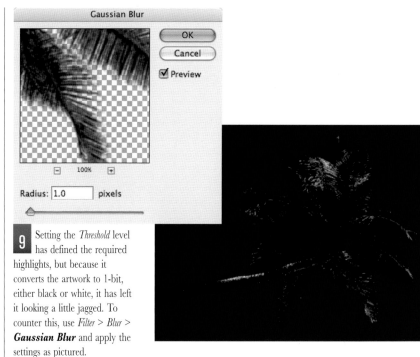

6 Now we need an image of the moon. Nothing too perfect is required; in fact, a slightly out-of-focus image will be more realistic. Copy and paste the moon into the document and scale it accordingly.

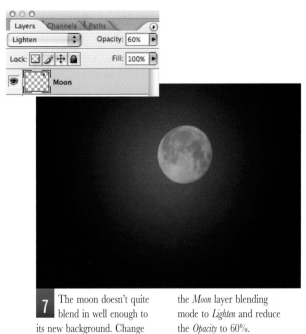

7 The moon doesn't quite blend in well enough to its new background. Change the *Moon* layer blending mode to *Lighten* and reduce the *Opacity* to 60%.

8 To add further realism, we need to create some reflections from the moonlight. Drag the *Tree* layer to the top of the *Layers* palette, then go to *Image > Adjustments > Threshold*, applying the setting in the illustration.

9 Setting the *Threshold* level has defined the required highlights, but because it converts the artwork to 1-bit, either black or white, it has left it looking a little jagged. To counter this, use *Filter > Blur > Gaussian Blur* and apply the settings as pictured.

10 To bring the whole effect together, change the *Tree* layer blending mode to *Color Dodge* and reduce the layer's *Opacity* to 50%. It has left us with a subtle illusion of light being picked up from the moonlight.

11 To complete the scene, we need to add some surface reflection to the water. Use the *Pen* tool or *Lasso* tool to draw the outline of a likely surface reflection.

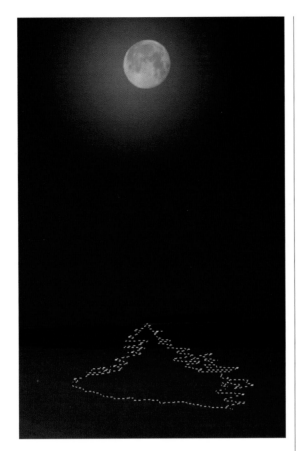

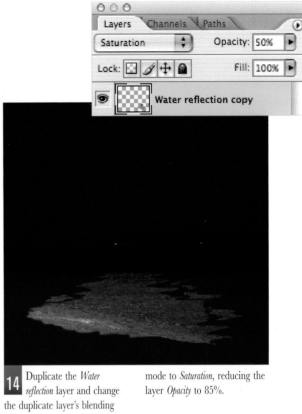

14 Duplicate the *Water reflection* layer and change the duplicate layer's blending mode to *Saturation*, reducing the layer *Opacity* to 85%.

12 Activate the *Background copy* layer and press Ctrl (Cmd) + J to copy and paste the selection onto a new layer named *Water reflection*.

13 Drag the *Water reflection* layer to the top of the *Layers* palette and change the blending mode to *Vivid Light*. This makes the effect a little too vivid, so we need to tone it back a little.

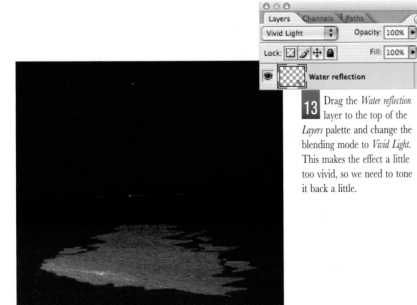

15 Now that all the elements are in place, you can decide how much light is being generated. Add a *Levels* adjustment layer to the *Background copy* layer and adjust the level of brightness to taste.

CREATING CANDLELIGHT

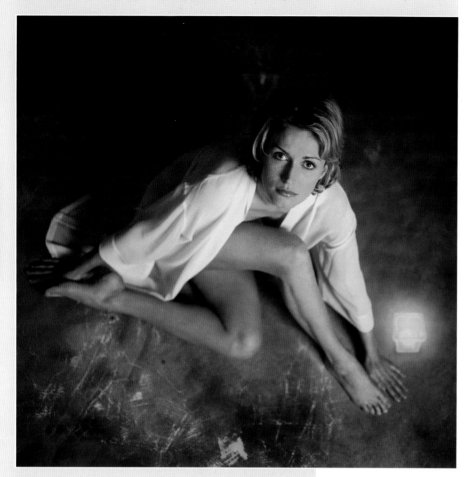

1 Duplicate the *Background* layer.

2 Add a *Color Balance* adjustment layer to the original *Background* layer.

Candlelight as a primary or supplementary source of light can offer a richness and depth of light matched only by a few other sources. It is not designed for capturing rapid movement, but still life scenes, or images where small amounts of blur are acceptable, are brought to life with the intensity of warmth generated by the glow of a candle.

Because of the limited range of candlelight, an image can be particularly striking when the candle is an additional light source in a room where other light sources are of a contrasting nature, such as cold evening light or moonlight. This is the effect we are going to produce where the secondary source of light in the form of cold blue light contrasts with the warm, inviting glow of the candlelight.

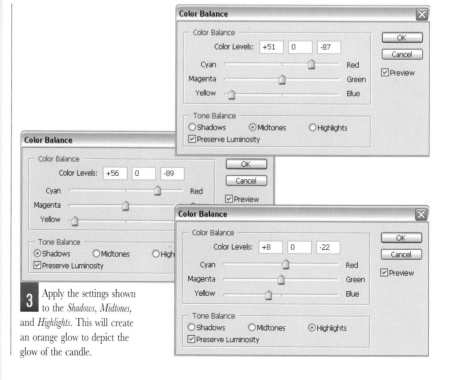

3 Apply the settings shown to the *Shadows*, *Midtones*, and *Highlights*. This will create an orange glow to depict the glow of the candle.

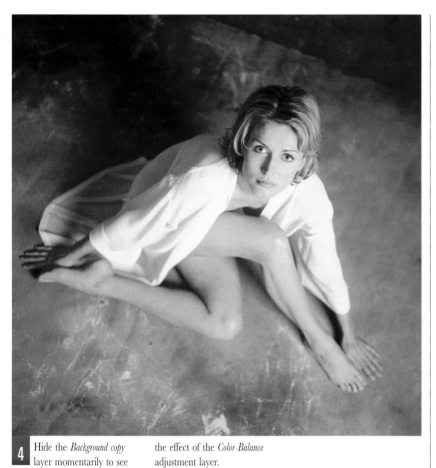

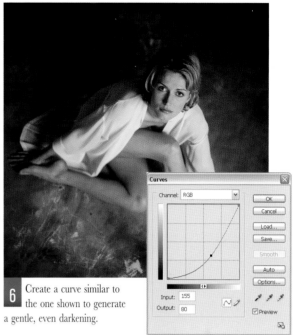

6 Create a curve similar to the one shown to generate a gentle, even darkening.

4 Hide the *Background copy* layer momentarily to see the effect of the *Color Balance* adjustment layer.

5 As the candlelight is supposed to be the main source of light, we need to darken the overall image. Add a *Curves* adjustment layer above the *Background copy* layer.

7 Make a selection of the candle image and drag it onto the image of the girl.

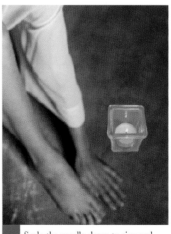

8 Scale the candle down to size and position it to the right of the girl.

9 The photo of the girl was taken with a very limited depth of field, which explains why her face is in focus and her hands and feet are blurred. This causes problems for the candle, which sits on the same plane as the hands and feet and should therefore conform to the same degree of blur. We can easily fix this by adding some blur to the candle. Go to *Filter > Blur > **Gaussian Blur*** and apply the settings shown if you are using a high resolution file. For lower resolution files, reduce the setting accordingly.

10 Name the candle layer *Candle* and create a new layer above it called *Glow*.

11 Although the candle will ultimately generate a relatively broad area of light, the immediate vicinity of the candle should display a soft, intense glow. Create a selection around the candle with a high feather setting. About 40 will work well for a high resolution file.

12 Fill the selection with orange. I'm using R245 G178 B52.

13 Change the layer blend mode to *Linear Light* to reveal the candle.

14 Now that we have the source of light in place, we can create the wider glow to illuminate the girl. Add a layer mask to the *Background copy* layer.

17 This has made a perfect selection of the high points of the girl and her clothing as well as of the candle itself. Activate the existing *Curves* adjustment layer and create another *Curves* adjustment layer, using the previous layer to create a clipping mask. This has the effect of making a mask from the selection that is automatically linked to the new *Curves* adjustment layer. This means that the adjustments we now make will affect only the areas that we highlighted.

15 Drag a *Black to White* radial gradient on the mask from point A to B. This lets the orange background layer show through.

18 Adjust the curve for the *Red* and *Blue* channels only to intensify the yellow light.

Color Range

Select: ☐ Highlights ▾

Fuzziness: []

○ Selection ● Image

Selection Preview: None ▾

OK
Cancel
Load...
Save...

☐ Invert

Curves

Channel: Red ▾

OK
Cancel
Load...
Save...
Smooth
Auto
Options...

Input: 160
Output: 170

☑ Preview

Curves

Channel: Blue ▾

OK
Cancel
Load...
Save...
Smooth
Auto
Options...

Input: 150
Output: 90

☑ Preview

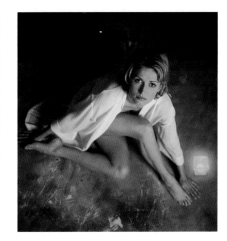

16 That's created a nice soft wash of candlelight over the girl and the floor, but I really want to emphasize the concentrated glow of the candle and the stark cold of the room farther away from it. One way of doing this is to increase the intensity of the candlelight on the high points of the girl only, primarily her face and some of the clothing most exposed to the light. This would be a natural effect for anyone sitting so close to the candle. Go to *Select* > **Color Range**. Choose *Highlights* from the *Select* drop-down box.

CREATING NEON LIGHT

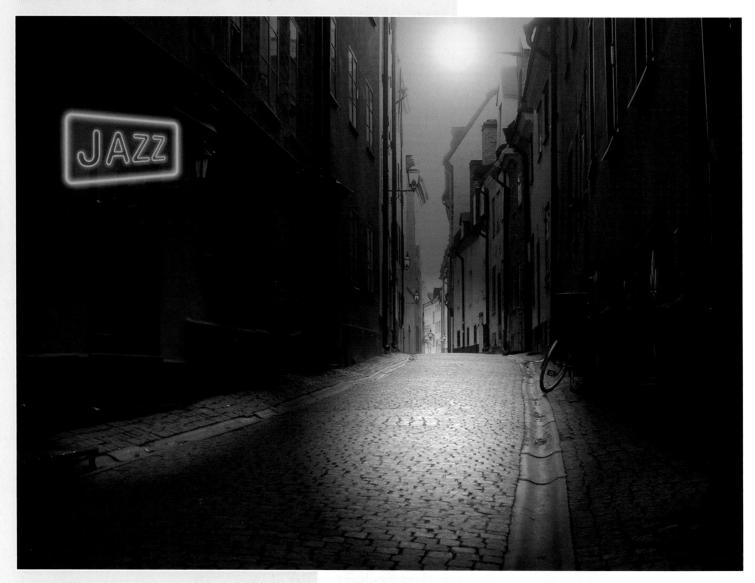

In this exercise, we are going to create a neon text sign for a jazz club. Neon signs are synonymous with nightclubs, and their unique quality of light has a subtle and atmospheric effect on the surrounding night scene. Although not considered as a source of light to aid visibility, the light they emit will still illuminate the immediate environment, but with an almost ghostly air. It is this secondary light in addition to the fluorescent tubes themselves that will make our work convincing.

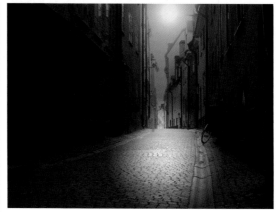

I'm using the finished image from one of the moonlight creation tutorials earlier in the book. The dark area in the bottom left of the image was left intentionally dark as a backdrop for the neon light.

1 Type the word *JAZZ* in black at 72 point with *Tracking* set to 75. Rounder fonts work best to depict the tubes of neon text. I'm using Arial Rounded MT Bold.

2 We need to change the perspective of the text to match the street, but first it is necessary to rasterize the text. To do this, go to *Layer > Rasterize > **Type***.

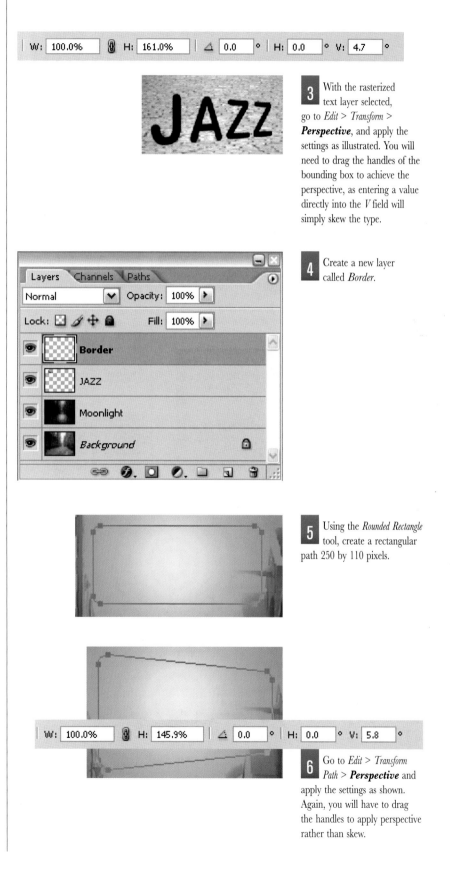

3 With the rasterized text layer selected, go to *Edit > Transform > **Perspective***, and apply the settings as illustrated. You will need to drag the handles of the bounding box to achieve the perspective, as entering a value directly into the *V* field will simply skew the type.

4 Create a new layer called *Border*.

5 Using the *Rounded Rectangle* tool, create a rectangular path 250 by 110 pixels.

6 Go to *Edit > Transform Path > **Perspective*** and apply the settings as shown. Again, you will have to drag the handles to apply perspective rather than skew.

7 Set up the brush tool with a soft-edged, 6 pixel, round brush and the foreground color set to R228 G230 B250.

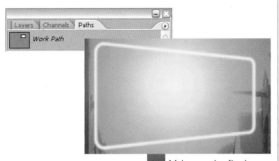

8 Make sure the *Border* layer is still active, then stroke the path, using the icon at the bottom of the *Paths* palette.

9 Now that the text and border of the sign are complete, we can start to apply the neon effect. Activate the *JAZZ* text layer and choose the *Outer Glow* option from the *Layer Style* icon at the bottom of the *Layers* palette.

10 Apply the settings as shown in the *Layer Style* dialog box. I've used a bright color, as intense colors look most convincing. Don't click *OK* yet; we are going to add a couple more styles.

11 Click the *Inner Glow* option immediately below the *Outer Glow* and apply the illustrated settings.

12 Finally click on the *Stroke* setting, which is the last style in the *Styles* list. The settings are pictured once again. The stroke color is a deep pink this time. Click *OK*.

13 Change the *Jazz* layer blend mode to *Screen*.

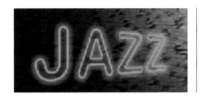

14 Repeat the process for the *Border* layer. The settings for each of the styles is displayed for you to copy. A midblue was used this time to contrast with the red text.

15 Position the text and border in the left of the image as if the sign is mounted on the wall.

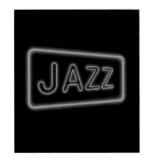

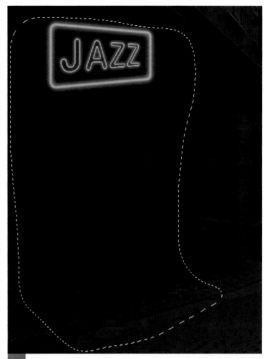

16 There would be a fair amount of ambient light generated from this kind of sign. The quality of the light would be quite subdued, though, as a consequence of the heavy coloring of the light. We will therefore use the original lighting of the image as the basis for the range of highlights and shadows. This should result in a very realistic projection of light. Make a 25 pixel, feathered selection with the *Lasso* tool as shown.

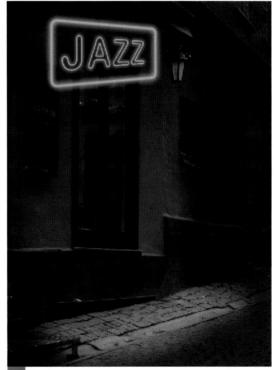

17 Activate the *Background* layer and then press Ctrl (Cmd) + J to copy and paste the selection to a new layer.

18 Name the layer *Ambient* and drag it above the *Moonlight* layer.

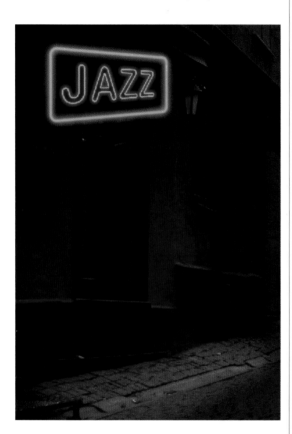

19 We now have the apparent light falloff in place, but we need to rectify the color. To do this, go to *Image > Adjustments > **Hue/Saturation***, and apply the settings as pictured.

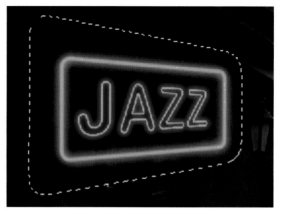

20 To add the final touches, we need to create a soft blue glow to echo the blue border, and a slightly more intense red glow that radiates in the immediate vicinity of the text. Make a 30 pixel, feathered selection as shown.

21 As before, activate the *Background* layer and press Ctrl (Cmd) + J to copy and paste the selection to a new layer. Name the layer *Blue glow* and position it above the *Ambient* layer.

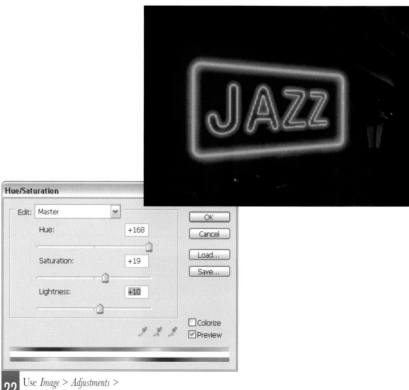

22 Use *Image > Adjustments > **Hue/Saturation***, and apply the settings as shown in the example.

23 Press Ctrl (Cmd) + click the *Blue glow* layer to load its selection and then contract it by 60 pixels by going to *Select > Modify > **Contract***.

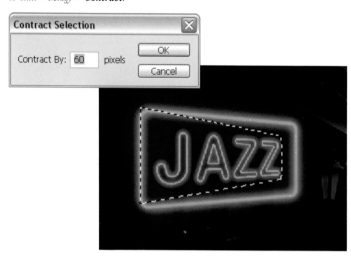

24 We now need to repeat the earlier process to copy the selection from the *Background* layer. Activate the *Background* layer and press Ctrl (Cmd) + J. Name the new layer *Red glow* and position it above the *Blue glow* layer.

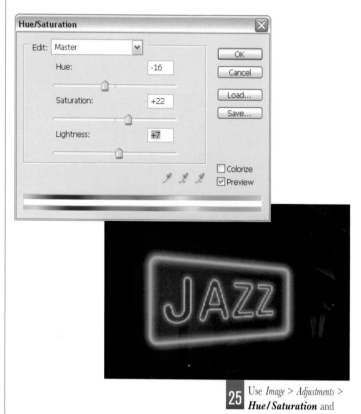

25 Use *Image > Adjustments > **Hue/Saturation*** and apply the settings as shown.

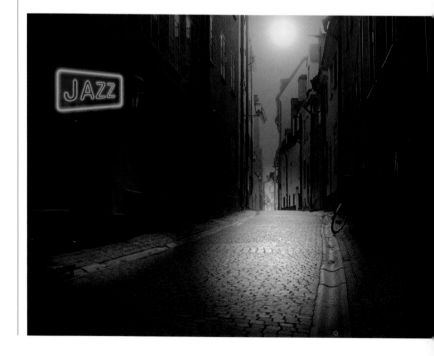

LIGHTING AND WEATHER

CREATING SUNSETS FROM DAYLIGHT SCENES

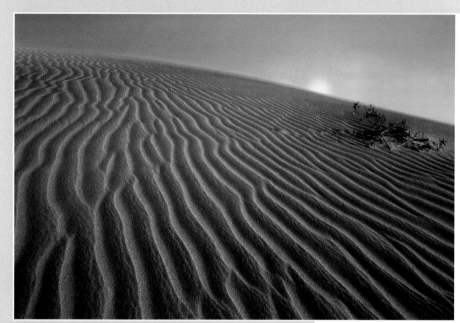

1 Duplicate the *Background* layer.

2 Add a layer mask to the *Background copy* layer.

It has been said that no two sunsets are the same. Whether or not you agree with that statement, one fact that is certainly beyond doubt is the sheer variety of sunsets that grace our skies. Sunsets appear as a result of the different colored light wavelengths traveling over a longer distance to reach your eyes as the sun sets lower in the sky. This increased distance means the light waves must travel through more atmosphere, whereupon the shorter blue wavelengths are scattered as they collide with particles of gas molecules and dust. This leaves only the longer wavelength colors such as yellow and red to reach your eyes. The most dramatic sunsets appear when there are increased particles in the air, such as during the aftermath of a storm. In this situation yellow light, which has a shorter wavelength than red, is also dispersed in the atmosphere, leaving only the longer red wavelengths as visible red light and thus producing rich red skies.

3 Drag a *Black to White* linear gradient on the mask from the top of the screen to about one fifth of the way down. This enables a small strip of the original blue from the background layer to be revealed at the top of the screen, and will prove very effective as the sunset is built up.

4 Make a selection of the blue sky and save it as an alpha channel called *Sky*. This is required to cut the sunset in half, giving the illusion that the sun has dipped below the horizon. Deselect the selection when saved.

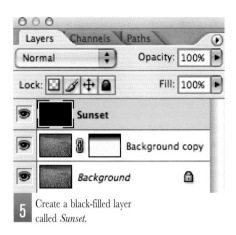

5 Create a black-filled layer called *Sunset*.

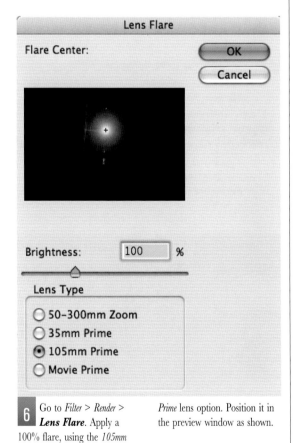

6 Go to *Filter > Render > **Lens Flare***. Apply a 100% flare, using the *105mm* *Prime* lens option. Position it in the preview window as shown.

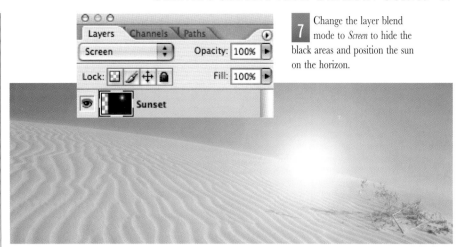

7 Change the layer blend mode to *Screen* to hide the black areas and position the sun on the horizon.

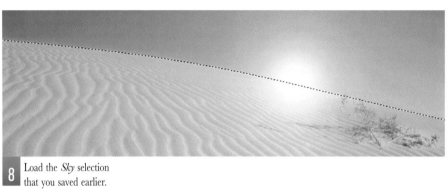

8 Load the *Sky* selection that you saved earlier.

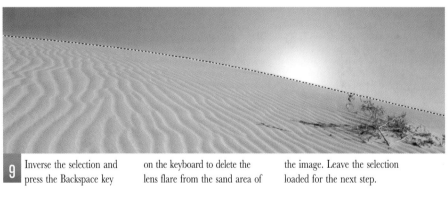

9 Inverse the selection and press the Backspace key on the keyboard to delete the lens flare from the sand area of the image. Leave the selection loaded for the next step.

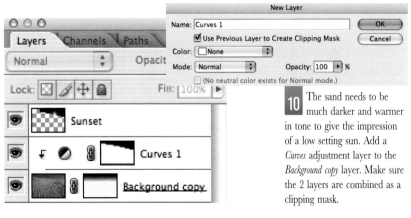

10 The sand needs to be much darker and warmer in tone to give the impression of a low setting sun. Add a *Curves* adjustment layer to the *Background copy* layer. Make sure the 2 layers are combined as a clipping mask.

11 Create a curve shaped as in the example to get the desired effect.

12 The sun also needs warmer colors. Create a *Hue/Saturation* adjustment layer that is clipped to the *Sunset* layer.

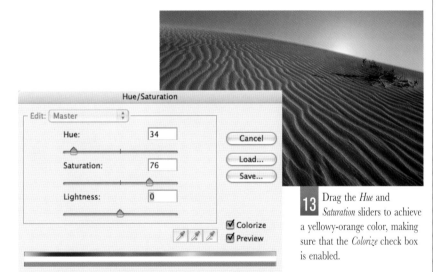

13 Drag the *Hue* and *Saturation* sliders to achieve a yellowy-orange color, making sure that the *Colorize* check box is enabled.

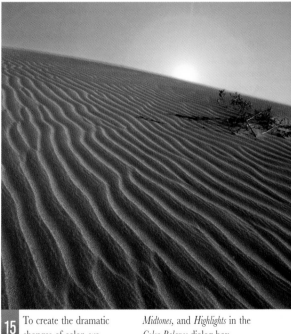

14 In order to add some real drama to our sunset, we are going to introduce a pink glow around the sun. Add a *Color Balance* adjustment layer that is clipped to the *Hue/Saturation* adjustment layer.

15 To create the dramatic changes of color, we need to change the *Shadows*, *Midtones*, and *Highlights* in the *Color Balance* dialog box.

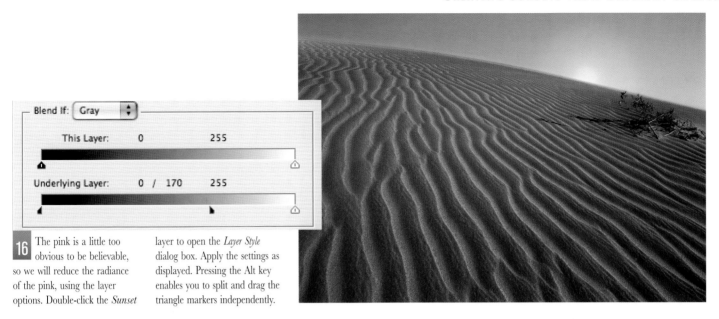

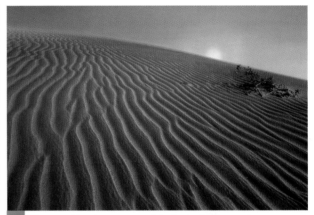

16 The pink is a little too obvious to be believable, so we will reduce the radiance of the pink, using the layer options. Double-click the *Sunset* layer to open the *Layer Style* dialog box. Apply the settings as displayed. Pressing the Alt key enables you to split and drag the triangle markers independently.

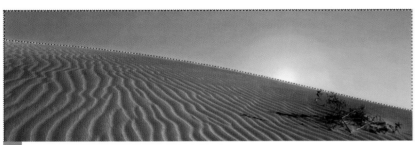

17 If we create a stronger degree of orange color to mingle with the pink, it will make for a much more complex and interesting wash of color, but also serve the purpose of generating a closer color match for the sand. These unifying techniques add considerably to the overall photographic realism. Load the selection that you saved previously.

18 Add a *Hue/Saturation* adjustment layer that is clipped to the *Curves* adjustment layer which we earlier attached to *Background copy*.

20 The great thing about the techniques used in this exercise is that you have complete control over the colors and brightness levels. By simply editing the adjustment layers, a huge array of sunset styles can be generated with just a few clicks. In the final image, the strong dark shadows from the bush have been removed with the *Patch* tool so as not to contradict the light direction, and the overall brightness of the sky has been toned down a little bit.

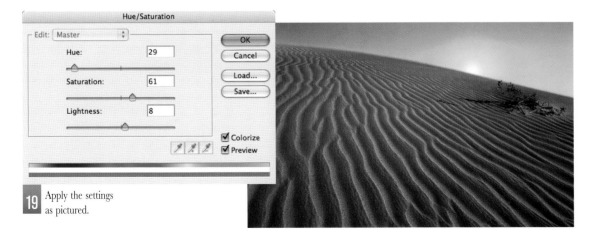

19 Apply the settings as pictured.

CONVERTING OVERCAST DAYS TO SUNNY DAYS

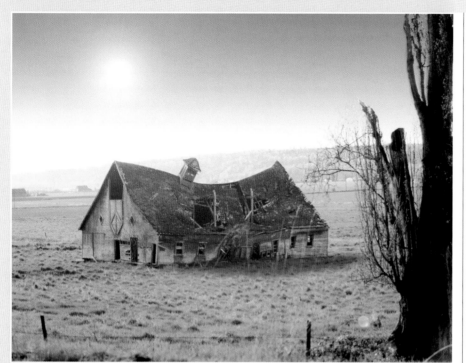

1 We'll start by generating some light and removing the strong blue cast that is overpowering the scene. Add a *Curves* adjustment layer.

How many photographs are now collecting dust in drawers and old boxes but would have been noteworthy images if only the sun had been shining when they were taken? Of the many things that can let a photographer down at the critical moment, the weather must be near the top of the list. Its sheer unpredictability makes it a force to be reckoned with. It's hardly surprising that over the millennia humanity has worshiped images of sun gods and rain gods in an attempt to appease the elements.

In the real world, the weather is its own master, in the digital world we can exercise a great deal of control, even to the extent of turning a drab, overcast day into one with bright sun and blue skies. This is exactly what we are going to do now.

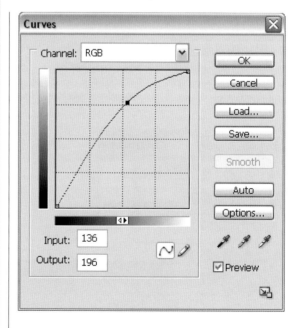

2 First adjust the *RGB* composite to lighten the image evenly.

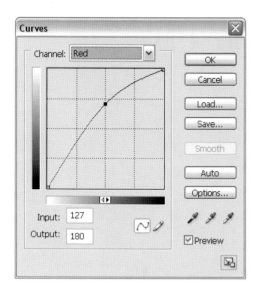

4 Create a second *Curves* adjustment layer above the first one. This will be used to add some yellow to simulate a soft wash of sunlight.

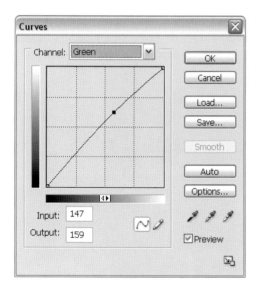

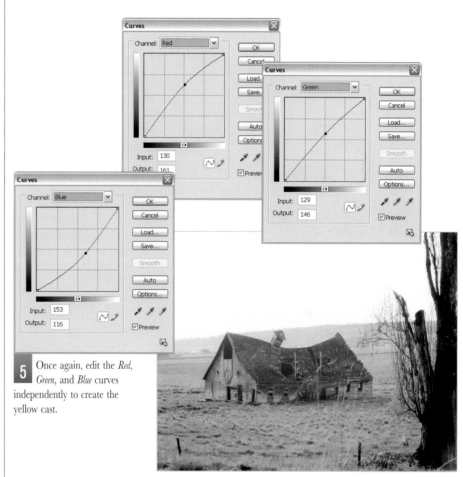

5 Once again, edit the *Red*, *Green*, and *Blue* curves independently to create the yellow cast.

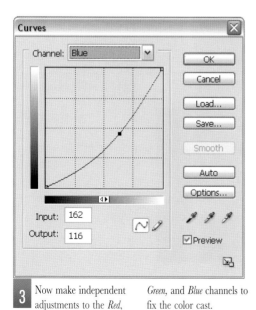

3 Now make independent adjustments to the *Red*, *Green*, and *Blue* channels to fix the color cast.

6 There's a slight haziness over the yellow cast, which is adversely affecting the illusion of bright sunlight. We'll fix this with levels. Add a *Levels* adjustment layer above *Curves 2*.

7 Drag the black and white input sliders toward each other to increase the contrast.

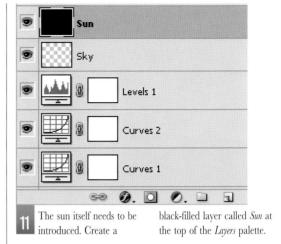

11 The sun itself needs to be introduced. Create a black-filled layer called *Sun* at the top of the *Layers* palette.

8 We now have a nice impression of strong sunlight and we've got rid of that dull, gray cloudy sky, which we can replace with a clear blue one. First make a selection of the white sky.

9 Create a new layer called *Sky*.

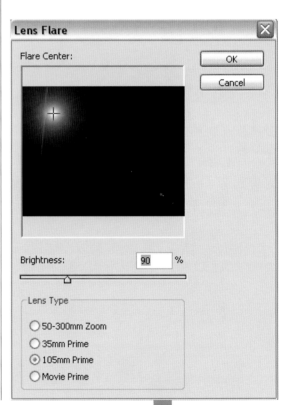

12 Go to *Filter > Render > **Lens Flare***. Apply the settings shown, clicking toward the top-left corner of the preview window.

10 Drag a *Blue to Transparent* linear gradient through the selection, then deselect.

13 Change the layer blend mode to *Screen*.

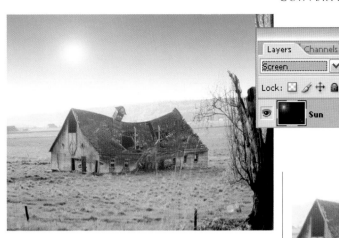

16 With the sun at this angle, the house would be casting a shadow. Create a feathered selection in front of the house.

14 To make the sun a bit more radiant, add a *Hue/Saturation* adjustment layer that is clipped to the *Sun* layer.

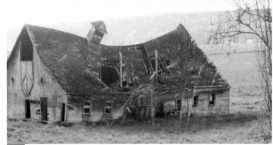

17 On a new layer, fill the selection with a color sampled from a dark area of the grass. Setting the layer blend mode to *Multiply* at 75% will add to the realism.

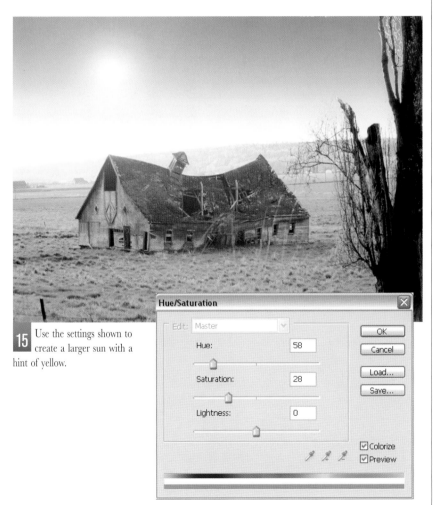

15 Use the settings shown to create a larger sun with a hint of yellow.

18 Lastly, some of the edges of the branches in the top-right corner of the image stand out too much. Use the *Burn* tool set to *Highlights* to darken them.

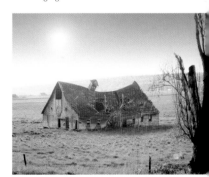

CREATING DRAMATIC SKIES

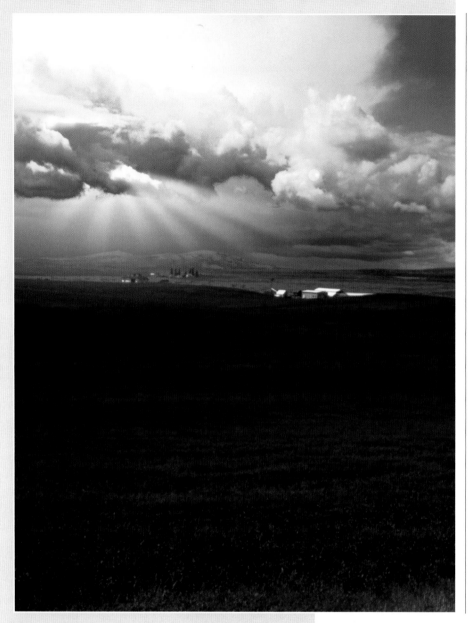

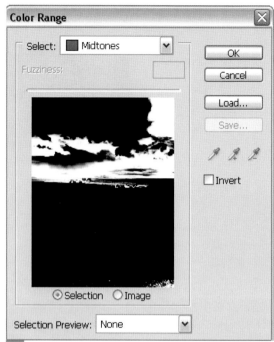

1 A section of cloud needs to be isolated so that we can create a layered file. Because of the wispy, undefined edges of these clouds, it is best to avoid the *Pen* or *Lasso* tools to make the selection. Instead, go to *Select > **Color Range***, and choose *Midtones* from the *Select* drop-down box.

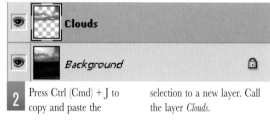

2 Press Ctrl (Cmd) + J to copy and paste the selection to a new layer. Call the layer *Clouds*.

Clouds and skyscapes have the distinction of being well suited to acting as the main subject in an image, or as a background to a more prominent focus of attention. As a subject in itself, the sky offers a rich, perpetually changing canvas of colors, shapes, and textures. Of all the possible variations, the most dramatic of skies must surely be the sunburst from behind darkened clouds. When this relatively rare phenomenon manifests itself, speed is of the essence if you intend to capture it, as it can all fade away just as suddenly as it appeared. But if time isn't on your side and you need a ready-made dramatic sky, we'll show you how to create one now.

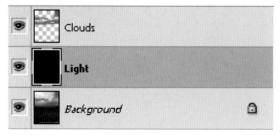

3 A burst of light partially hidden behind the clouds will inject dramatic contrast into the scene. Create a black-filled layer beneath the *Clouds* layer, calling it *Light*.

4 Go to *Filter > Render >* **Lens Flare**, and use the settings as shown.

Lens Flare

Flare Center:

Brightness: 130 %

Lens Type
- ○ 50-300mm Zoom
- ○ 35mm Prime
- ◉ 105mm Prime
- ○ Movie Prime

OK
Cancel

Layers | Channels | Paths

Screen — Opacity: 100%

Lock: □ ✎ ✛ 🔒 Fill: 100%

👁 Clouds

👁 Light

👁 Background 🔒

5 Change the layer blend mode to *Screen* to hide the black area, then reposition the central point of the flare, if necessary, so that it is tucked in behind the cloud.

👁 Light

👁 Background 🔒

6 Too much of the flare extends toward the bottom of the image. We could use the *Layer Options* sliders to reduce its radiance, but it's better to try and keep a smooth transition for this effect. Add a layer mask to the *Light* layer.

👁 Light

7 Drag a *Black to White* linear gradient on the mask from the bottom to about halfway up the image so that the bottom half of the lens flare is hidden.

👁 Clouds

8 The flare has revealed some heavy outlining along the edges of the clouds, making it look false. Add a layer mask to the *Clouds* layer.

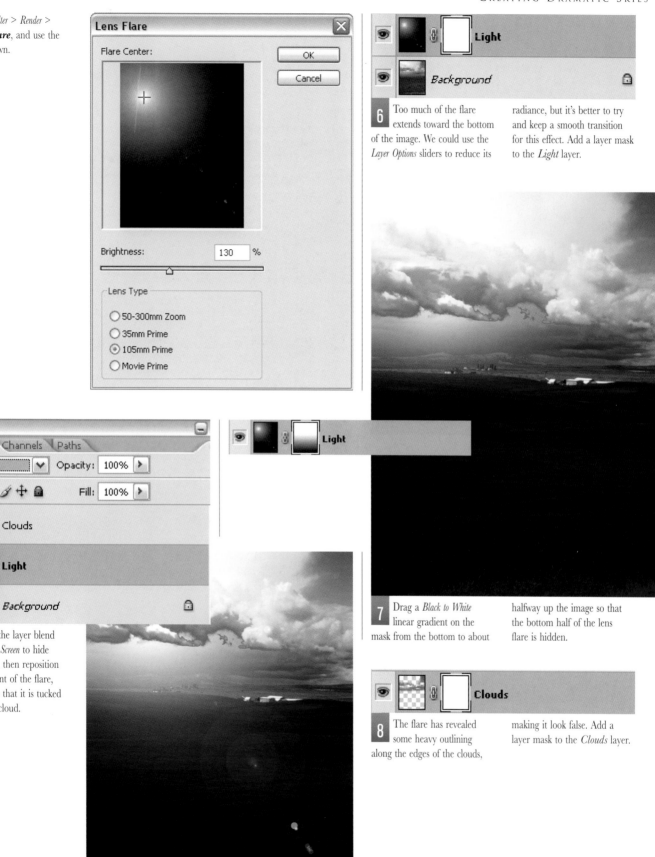

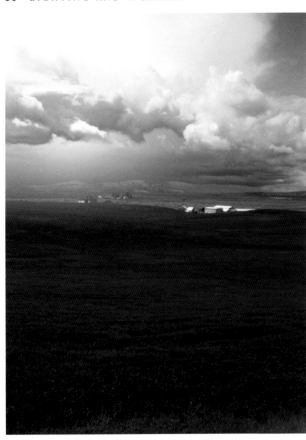

9 Using a soft-edged brush, paint with black on the mask along the edges of the clouds, hiding any obtrusive, heavy outlines.

10 Now that we have a radiant background behind the clouds, we can darken the clouds to increase overall contrast and drama. Add a *Curves* adjustment layer that is clipped to the *Clouds* layer.

11 Make a small adjustment to the *RGB* curve to darken the clouds.

12 For impact we are going to create some rays of sharp sunlight emanating from behind the cloud. Create a new layer called *Sunray* above the *Curves* adjustment Layer.

16 Finally, the foreground of the image is too dark and featureless. Add a *Curves* adjustment layer above the *Background* layer.

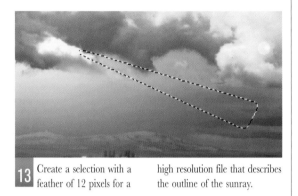

17 Edit the curve to lighten the image.

13 Create a selection with a feather of 12 pixels for a high resolution file that describes the outline of the sunray.

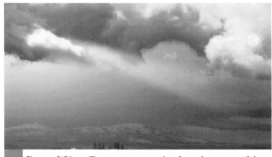

14 Drag a *White to Transparent* linear gradient about halfway through the selection, starting from the source of the light, then deselect the selection.

18 We want to lighten only the foreground, so drag a *Black to White* linear gradient on the *Curves* layer mask from the top of the image to about ¹/₅ of the way down.

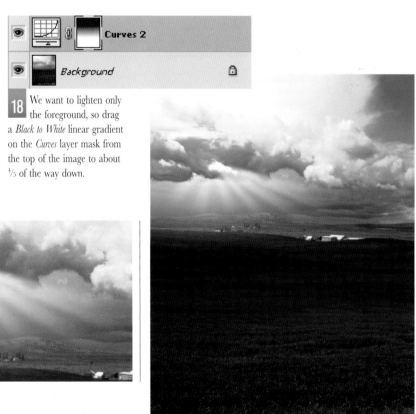

15 Repeat the same process for as many sunrays as you wish to create. If necessary, you can adjust the layer *Opacity* to make each sunray more subtle or less uniform.

CREATING LIGHTNING

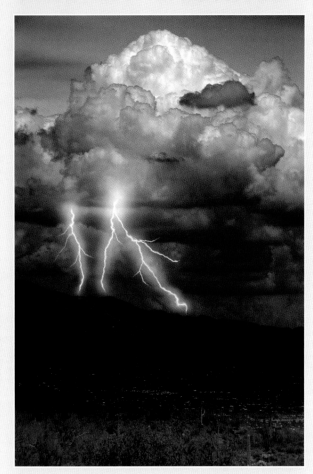

Lightning must surely be one of the most dramatic phenomena of nature. From a photographic point of view, the sheer spectacle of a lightning storm makes it a highly desirable subject. Although capturing a lightning bolt on a modern camera is not a very difficult task, the finished image may not always match the drama of the original scene. Lightning is not the most cooperative of subjects. The average lightning bolt remains visible for less than a second and gives no warning of its appearance or position in the sky. Timed exposures are the usual method, but are easily prone to becoming overexposed if the ambient light is not favorable. From the point of view of image quality, the argument for creating your own lightning in Photoshop is a compelling one. It is also considerably safer.

Although we can simulate these conditions in Photoshop, a photograph with the right buildup of cloud will go a long way toward helping the illusion in the finished result. Choose an image that would be a likely setting for lightning. It doesn't have to be a stormy, dark image of course.

1 First we need to set up the initial layers. Duplicate the *Background* layer, naming the duplicate *Dark*, and create a new layer called *Lightning*.

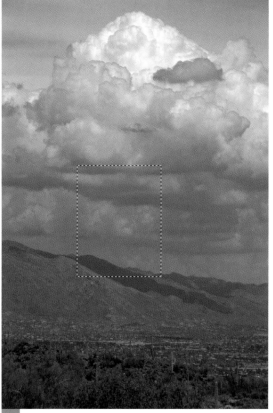

2 With the *Lightning* layer active, make a rectangular selection defining the region the lightning bolt should cover.

3 Fill the selection with a *Black to White* linear gradient at about a 45° angle. Gradients with more contrast, such as the one illustrated, result in lightning streaks that follow a straighter path.

4 Go to *Filter > Render > **Difference Clouds***.

5 The lightning needs to be pale in color, so we actually need a negative version of the current image. Go to *Image > Adjustments > **Invert*** (Ctrl (Cmd) + I) and deselect the selection.

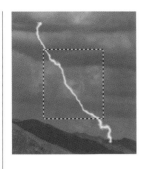

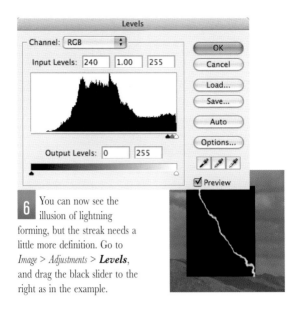

6 You can now see the illusion of lightning forming, but the streak needs a little more definition. Go to *Image > Adjustments > **Levels***, and drag the black slider to the right as in the example.

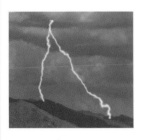

9 Lightning is often seen branching off into more than one streak. Now that the main streak has been created, it becomes very quick to create other sub-branches. Make a rectangular selection of part of the lightning.

10 Go to *Layer > New > **Layer via Copy*** (Ctrl (Cmd) + J) to copy and paste the selection onto a new layer, and name the layer *Branch*.

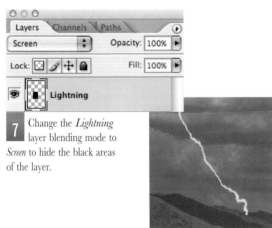

7 Change the *Lightning* layer blending mode to *Screen* to hide the black areas of the layer.

11 Press Ctrl (Cmd) + T to bring up the Transform bounding box and rotate and position the copied branch of lightning as shown.

12 To create another independent lightning streak, duplicate the *Branch* layer and name the duplicate layer *Streak 2*.

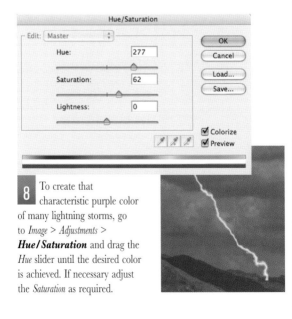

8 To create that characteristic purple color of many lightning storms, go to *Image > Adjustments > **Hue/Saturation*** and drag the *Hue* slider until the desired color is achieved. If necessary adjust the *Saturation* as required.

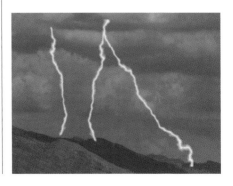

13 Go to *Edit > Transform > **Flip Horizontal***. This helps to avoid the appearance of any uniformity between the different streaks. Position the flipped streak somewhere between the base of a cloud and the horizon.

14 As long as you are happy with the final position of all the lightning streaks, you can merge the 3 lightning layers into one. Select the *Streak 2* layer and press Ctrl (Cmd) + E twice. This reduces the file size and gives us less layers to navigate around. You should now have just one *Lightning* layer.

15 Lightning usually appears to taper away, so we need some manual adjustment. Add a layer mask to the *Lightning* layer.

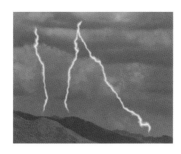

16 Using a small, hard-edged brush with low opacity, paint on the layer mask with black to simulate tapered edges at the ends of the lightning. You could, of course, simply use the *Eraser* tool to do this, but the benefit of the layer mask is that if you remove too much of the lightning by mistake, you can just use white paint to replace it, as the pixels have not been deleted.

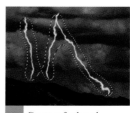

17 A little more overall contrast is required to make the lightning stand out and also to suggest dark, foreboding clouds. Add a *Levels* adjustment layer clipped to the layer called *Dark*, and apply the settings in the illustration.

18 The sheer energy generated within a bolt of lightning creates a powerful glow around the core of the lightning streak. To simulate this, make a new layer called *Glow* and position it between the *Lightning* and the *Levels* adjustment layer.

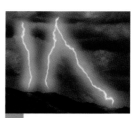

19 Create a feathered selection with the *Lasso* tool around the perimeter of the lightning. The amount of feather depends on the resolution of your document. I am working on a 300ppi image and have used a 30 pixel feather. For lower resolution files, use a lower pixel feather.

20 Fill the selection with a pale purple color. I'm using R161 G134 B190. Deselect the selection.

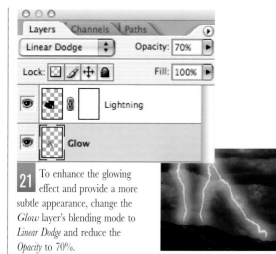

21 To enhance the glowing effect and provide a more subtle appearance, change the *Glow* layer's blending mode to *Linear Dodge* and reduce the *Opacity* to 70%.

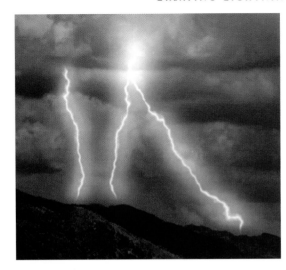

25 Position the lens flare at the top of the main lightning bolt.

22 The point at which the lightning bolt meets with the base of the cloud sometimes appears as an explosive focal point. This can add greater impact to the final image. Create a black-filled layer at the top of the *Layers* palette called *Light burst*.

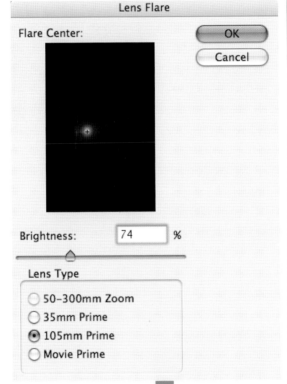

23 Go to *Filter > Render > **Lens Flare***, and apply the settings as in the example.

26 The darkened sky performs well as a backdrop to the lightning, but the overall darkness has made the foreground a little flat and featureless. This won't be a problem to fix, though, as we duplicated the *Background* layer right at the beginning. Add a layer mask to the *Dark* layer.

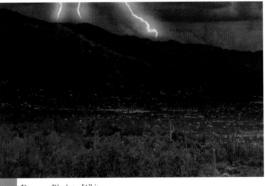

27 Drag a *Black to White* linear gradient on the layer mask from the bottom of the image to about one quarter of the way up. This reveals the lower quarter of the original background image.

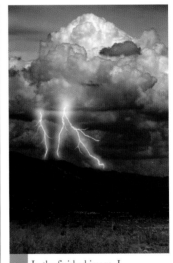

28 In the finished image, I have repeated the steps entailed in duplicating, scaling, rotating, and flipping the lightning bolts to achieve an apparently random flash of forked lightning without the need for any new artwork.

24 Change the *Light burst* layer blending mode to *Linear Dodge* and set the *Fill* opacity to 65%.

CREATING RAINBOWS

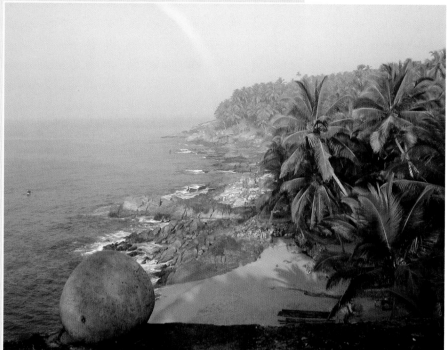

Adding rainbows to your images is one of the easier Photoshop tasks thanks to the versatility of gradients. To make it easier still, Photoshop comes with a preset rainbow gradient ready for you to use straight out of the box. However, to make the rainbow really convincing and to avoid that "clip art" computer filter look, we need to use a little trickery to achieve photographic realism.

Most real rainbows are quite subtle in their appearance. Although the full visible spectrum is contained within the rainbow, the outlying colors are often much less visible than the colors at the center. Additionally, those perfect full semicircle rainbows are best left to fantasy movies.

The image we are going to use is a good candidate for a rainbow: a watery sky with lots of moisture in the air, and the sun is shining.

1 Create a new layer above the *Background* layer and name it *Rainbow*. We're going to create the rainbow on its own independent layer so we have more control over the final look.

2 Select the *Gradient* tool in the toolbox, then click the *Gradient picker* drop-down box from the *Options* bar. Unless you have added or removed gradients previously, you will see the default Photoshop gradient set. We need to load another set.

3 Click the pop-up arrow in the top-right corner of the *Gradient picker* and select the *Special Effects* set.

4 Within this set, select the rainbow gradient named *Russell's Rainbow*, and choose the *Radial* option.

5 Make sure the *Rainbow* layer is selected. When the *Gradient* tool is used to apply the rainbow radial gradient, the point at which you first click becomes the center point of the gradient. Click and drag in approximately the same position as shown.

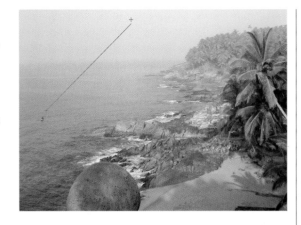

6 Depending on where you clicked and dragged, you should have a rainbow similar to the one shown. If you are not happy with the size or position, just click and drag again until you get the desired placement.

7 This rainbow has "computer generated" stamped all over it. To create some photographic realism, we are going to use a blending mode, which is one of the reasons we created the gradient on its own layer. From the *Layers* palette, make sure the *Rainbow* layer is active, then select *Screen* mode from the blend modes drop-down box.

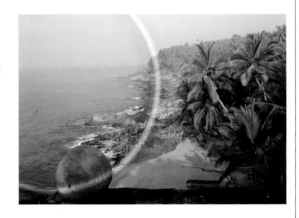

8 Now the effect is much more subtle and the outlying colors less visible, just like real rainbows. To complete the effect, we need to hide the part of the rainbow below the horizon, and at the same time achieve a realistic fading effect because few rainbows maintain full visibility all the way down to ground level. Add a layer mask to the *Rainbow* layer. The quickest way to do this is to click the icon at the bottom of the *Layers* palette.

9 First we need to set up the gradient. Select the *Foreground to Background* gradient. You may have to reload the default gradient set if you replaced it with the special effects set. Make sure black is the foreground color and white the background color and use the *Linear* gradient option.

10 We are now going to create the gradient on the layer mask, so check that you have the mask thumbnail active in the *Layers* palette, and not the image thumbnail.

11 Position the cursor on the tree line and drag a short distance as shown.

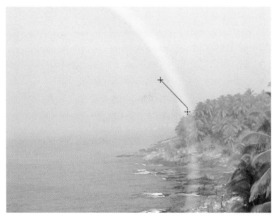

12 If you are not happy with the degree of fading at the bottom of the rainbow, simply drag with the *Gradient* tool again. Each drag overrides the previous one, so you have complete control.

CREATING A HEAT HAZE

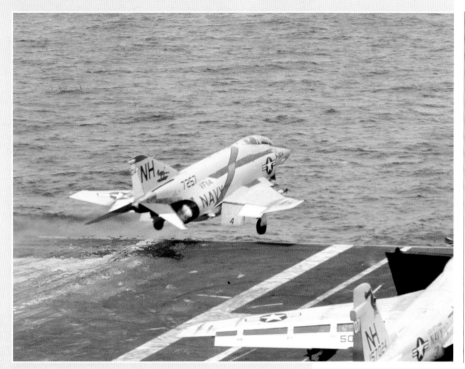

1 The source of heat for a heat haze is often fairly obvious, but there's no harm in emphasizing it to help the image along. The jet exhaust is clearly the source in this case, but we are going to boost it by a small amount.

Desert mirages, and watery, blurred images that dance in the wake of jet aircraft, or at the spout of a boiling kettle—all fall under the general term of "heat haze." This phenomenon is caused by light passing through air of different densities and therefore different refractivity. The heat of the sand in the desert or the exhaust of a jet engine heats up the air in the immediate vicinity, causing it to become less dense than the cooler air around it. Because this heated air is less dense, its refractive index is lowered, causing light to refract or bend as it passes from one density to another. The result is the classic wavy distortion, which we will now re-create near the exhaust outlet of a jet aircraft.

2 Make a feathered selection of the flames. Use a 3 pixel feather for a high resolution file.

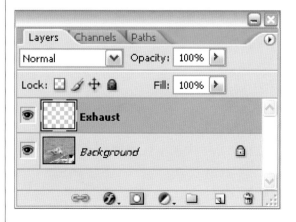

3 Press Ctrl (Cmd) + J to copy and paste the selection to a new layer. Name the layer *Exhaust*.

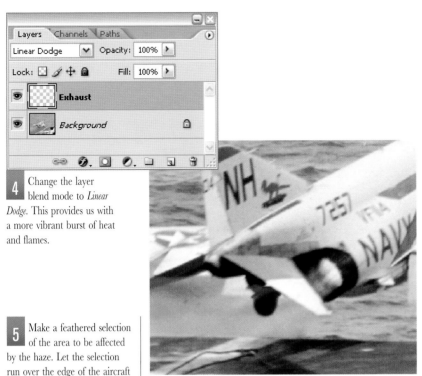

4 Change the layer blend mode to *Linear Dodge*. This provides us with a more vibrant burst of heat and flames.

5 Make a feathered selection of the area to be affected by the haze. Let the selection run over the edge of the aircraft carrier deck, and into the sea. This will enable bits of the deck to appear to distort and dance above the deck itself, just as a real heat haze would do.

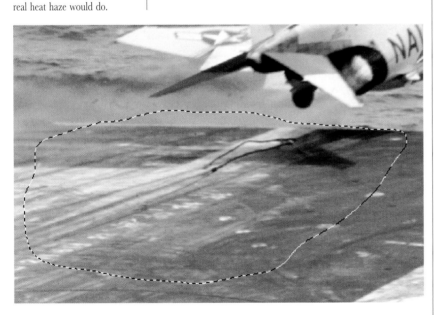

6 Activate the *Background* layer and press Ctrl (Cmd) + J. Once again, the selection is copied to another layer. Name this layer *Heat Haze*.

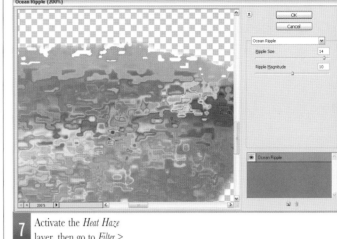

7 Activate the *Heat Haze* layer, then go to *Filter > Distort > **Ocean Ripple***. Apply the settings as pictured.

8 And that's all there is to it. Simple but effective and applicable to any situation where heat is involved.

CREATING FOG

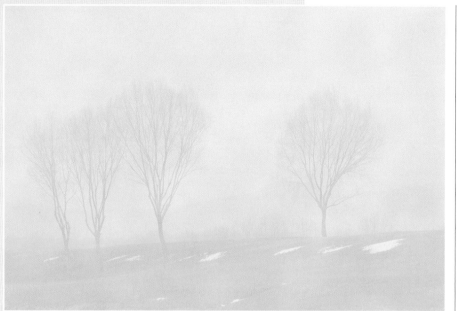

1 Fog has the effect of drinking the color out of a scene, subduing even the most vibrant of colors. To simulate this effect, create a *Hue/Saturation* adjustment layer.

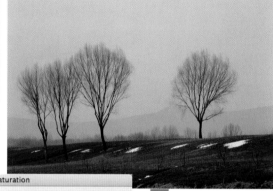

Weather and atmospheric conditions can change what would be a mundane image into a dramatic work of art. The more obvious examples, including lightning, tornadoes, and storms, speak for themselves, but less apocalyptic conditions, such as fog, have a lot of merit of their own. Logically, fog is associated with reduced visibility, and as such may be deemed a photographer's nightmare, but if you are trying to create an atmosphere to inspire a range of feelings from solitude to serenity, then fog is the perfect stage.

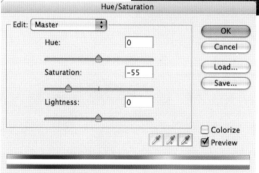

2 Drag the *Saturation* slider to the left to reduce the color intensity.

3 Fog is often associated with cooler weather conditions, and a little blue light will help to enforce this idea. Add a *Color Balance* adjustment layer to the *Background*.

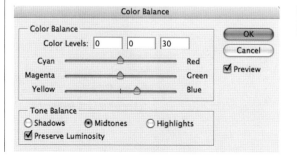

4 Add some blue to the *Midtones* only.

5 Definition also suffers from the effects of fog. This is one of those not so common situations when

Photoshop can actually be used to decrease contrast rather than increase it. Add a *Levels* adjustment layer.

9 Finally, go to *Filter > Render > **Clouds***.

10 Too many streaks would look false, so we need to apply a little blur. Go to *Filter > Blur > **Gaussian Blur***, and apply the settings shown.

6 Leave the input sliders as they are, but bring the output sliders closer together to reduce contrast.

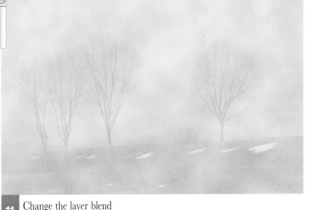

11 Change the layer blend mode to *Screen* and reduce the layer *Opacity* to 74%.

12 The *Clouds* filter is a little too patchy to be realistic, so we need to smooth it out without the scene becoming too uniform and flat. With the *Fog* layer active, go to *Filter > Artistic > **Neon Glow***. Apply the settings displayed, choosing a pale blue as the color.

7 We currently have a scene reminiscent of early morning mist, so it's time to add some patchy fog to strengthen the image. Create a layer at the top of the *Layers* palette, and call it *Fog*.

8 Set the foreground and background colors as white and a midblue gray, but not too dark.

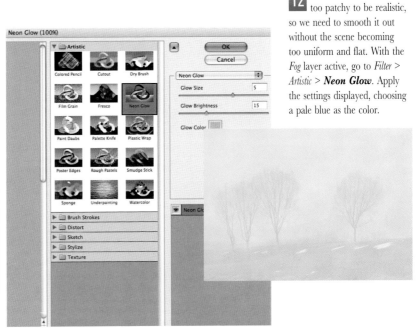

SHADOWS AND PROJECTIONS

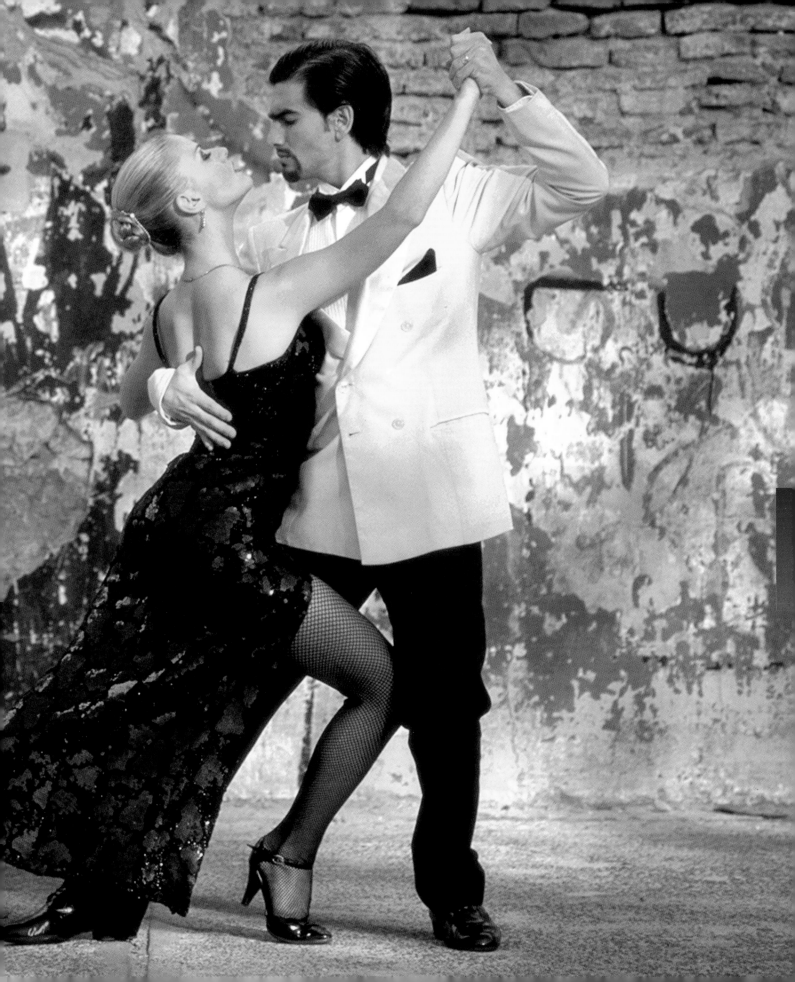

CREATING DROP SHADOWS

The ubiquitous drop shadow has been around longer than many would imagine. Today it is associated with the computer graphics revolution and its seemingly obligatory use on titles in magazines and on webpages. However, watch the credits roll on old black-and-white movies from the 1930's and you'll often see the use of drop shadows on white text. This is what it was originally meant for, of course, to provide some contrast and aid legibility. Today it plays the same role, although its overuse has led it in some cases to be regarded as kitsch. Nevertheless, used correctly it provides a valuable asset to the photographer, artist, or designer as a means of emphasizing the subject.

1 The object that will cast the shadow needs to be isolated on its own layer. Make a selection of the key.

2 Press Ctrl (Cmd) + J to copy and paste the selection to a new layer.

3 Click the *Layer Styles* icon at the bottom of the *Layers* palette and select *Drop Shadow*.

4 The settings in the dialog box that opens, enable you to edit the style of the shadow to your taste.
Blend Mode and *Opacity* have the same effect as their counterparts in the *Layers* palette itself.
Angle defines the direction of the light source.
Tick the *Use Global Light* box to configure all styles to use the same direction for the light source. This will be applied to any styles applied where the check box is enabled.
Distance is the offset for the shadow. This raises the apparent height of the object casting the shadow.
Spread enlarges the mask that creates the shadow before it is blurred. This results in a larger, heavier shadow area.
Size determines the final size of the shadow, which also softens the shadow as higher values are applied.

5 While the dialog box is open, it is possible to use the *Distance* setting to move the shadow away form the object, and also to click and drag the shadow in the image window itself.

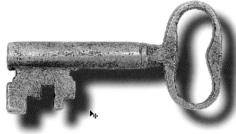

KNOCKING OUT DROP SHADOWS

The need to "knock out," or delete, a drop shadow is an important requirement where the object casting the shadow is transparent, such as in the case of colored glass, ice, and water drops. The Photoshop *Layer Style* dialog box provides a simple option to achieve this.

In this example, the colored glass is taken from another image and is on the top layer. It is not transparent and therefore doesn't reveal the girl on the bottom layer.

3 By double-clicking the *Drop Shadow* sublayer in the *Layers* palette, I can gain access to all the settings I previously applied.

4 At the bottom of the dialog box, tick the box labeled *Layer Knocks Out Drop Shadow*. This removes the shadow from any area of the layer containing pixels.

1 To make the glass transparent, I'm going to change the *Blue glass* layer's blending mode to *Hard Light* and reduce the *Fill* opacity to 75%. It's important to change the *Fill* opacity level and not the *Layer* opacity level because I want to reduce the opacity of the blue glass only, not the shadow.

2 I'll now add a drop shadow, using layer styles in the same way as with the key previously. The result gives a good impression of depth between the glass and the girl, but the shadow is now partially obscuring the girl and we've lost a lot of the transparency effect.

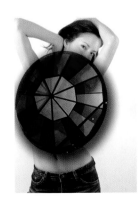

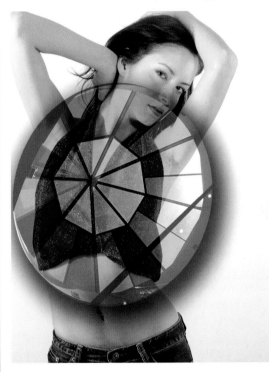

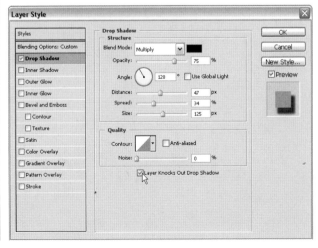

CREATING CAST SHADOWS

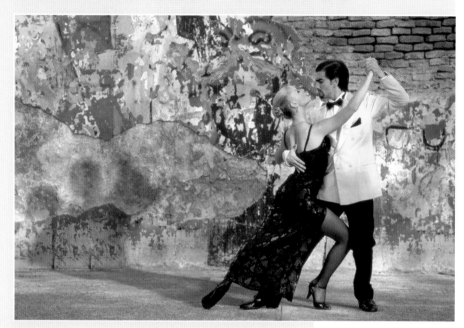

Although Photoshop makes the creation of drop shadows very easy, the automated process does have its limitations. In the example we are going to work through, a drop shadow in the traditional sense would be of little use. The dancers are some distance from the wall, so the shadow would appear on the ground first with just the tops of the dancers being cast onto the wall. Because of the distance involved, some distortion of the shadow would be apparent and the shadow would also bend where it meets the base of the wall and changes direction.

So we'll dispense with the automated method and work through a manual technique that will produce a perfectly photographic cast shadow.

1 To emphasize the shadow, we are going to increase the level of sunlight, which will provide a better backdrop and more convincing final result. Add a *Levels* adjustment layer to the *Background* layer and apply the setting shown. It is better to use an adjustment layer in this instance, as we can change the degree of light later if necessary within the context of the finished shadow.

2 Make a selection of the dancers, and feather the selection by 10 pixels if you are using a high resolution file. Lower resolutions will need a lower feather setting. Save the selection when finished.

3 Create a new layer, and call it *Shadow bottom*.

4 Fill the selection with a midgray. I am using R110 G109 B106.

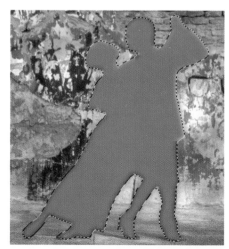

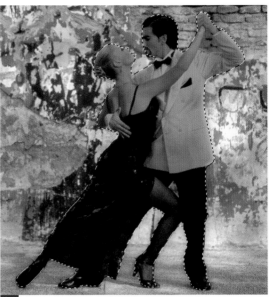

5 Change the layer blending mode to *Multiply* and reduce the *Opacity* to 75%.

6 Deselect the current selection and go to *Edit > Transform > **Distort***. Drag the corner handles of the bounding box to achieve the shape pictured. The corner handles have been highlighted with red dots to aid in their visibility. Press Enter (Return) to confirm.

7 The distortion at this point looks wrong where it meets the wall. Make a rectangular selection of the part of the shadow lying on the wall.

8 Press Backspace to remove this part of the shadow.

9 Create a new layer called *Shadow top*.

10 Load the saved, feathered selection and fill it with the same gray as used previously.

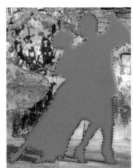

11 Deselect and make a rectangular selection of the bottom half of the shadow.

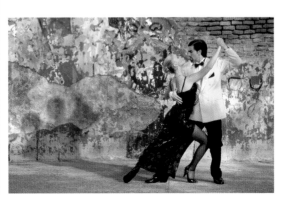

12 Press Backspace to remove this half of the shadow.

13 Deselect, then drag the remaining shadow over to the wall so it sits on top of the distorted bottom half.

14 Change the layer blend mode to *Multiply* and reduce the *Opacity* to 75%.

CREATING SHADOWS FROM OBJECTS

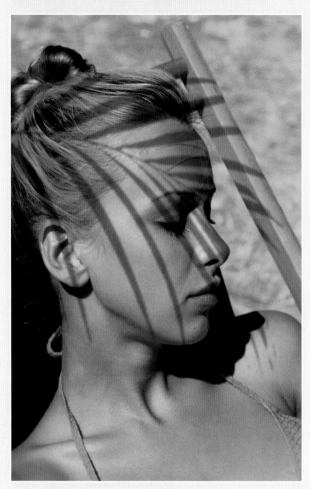

1 The intensity of a shadow is defined by the light source trained upon the object that casts it. This light source will also be evident in the area surrounding the shadow. It is therefore important that images being used for the creation of false shadows should possess a degree of light that accurately matches the shadow. At times, it may be necessary to manufacture some additional light, but in the case of the image we are going to use, the light is more than adequate. The object that will cast the shadow is the image of a palm. Make a selection of the palm.

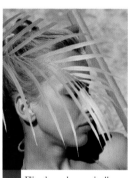

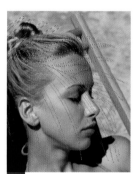

2 Drag the selection onto the image of the girl.

3 Flip the palm vertically and rotate it so that it lies across the girl's face from left to right.

4 Press Ctrl (Cmd) and click the *Palm* layer to load its selection, then hide the visibility of the layer.

Shadows can perform a role as the main subject or a supporting prop with equal success. In fact, some of the more moody, atmospheric images rely heavily on the interaction of shadows with the main theme. Shadows tend to be thought of as a background element, providing contrast and enabling the main subject to leap off the page or screen. In fact, considering a shadow as a foreground element can do much to raise the status of what might be an ordinary image. All you need is an image to cast the shadow and the simple techniques covered in the next few steps.

5 Create a new layer called *Shadow*.

6 Feather the selection by 4 pixels for a high resolution image.

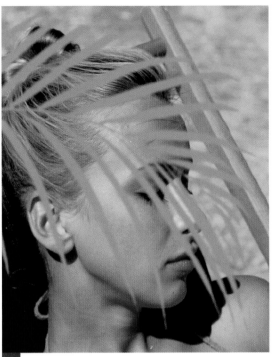

7 Fill the selection with 50% gray and deselect.

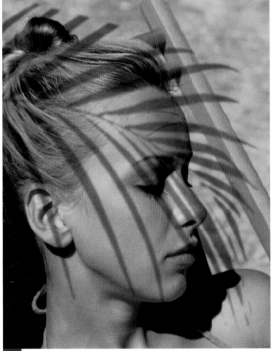

8 Change the layer blend mode to *Multiply* to see through the shadow.

Shadow

9 The intensity of the shadow works well against the ambient light, but what gives the game away is the fact that we can still see the shadow on the blue water which is some distance away. A real shadow wouldn't be cast in this way onto the background, so we need to get rid of this element. Hide the *Shadow* layer.

10 Make a selection of the blue water. The *Magic Wand* tool with *Contiguous* switched off works well.

11 Activate the *Shadow* layer.

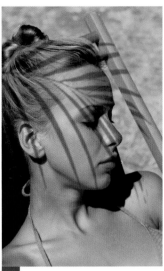

12 Press Backspace to remove the elements of the shadow lying on the water.

CASTING LIGHT AND SHADOW THROUGH VENETIAN BLINDS

1 First we need to make a grayscale file to be used as a displacement map. We are using a method that helps preserve the brightness of the image and so provides a better basis for the grayscale map. Duplicate the file and convert the duplicate to *Lab Color* mode.

2 Select the *Lightness* channel.

The play of light and shadow on a subject can set the scene for some highly atmospheric imagery. From the point of view of realism, cast light and shadows bend and flow around the object they fall upon. As we are working in a 2-D environment in Photoshop, it may seem as if 3-D realism is beyond us, and yet we have a powerful tool at our disposal in the form of displacement maps. These highly versatile methods enable us to create photographic realism, even to the extent of wrapping light and shadows around the contours of an object.

A perfect subject to demonstrate this will be the light and shadow cast from window blinds onto a girl's face.

Duplicate Channel

Duplicate: Lightness

As: Alpha 1

OK

Cancel

— Destination —

Document: *New*

Name: Displace

☐ Invert

3 Duplicate the *Lightness* channel as a new grayscale document called *Displace*.

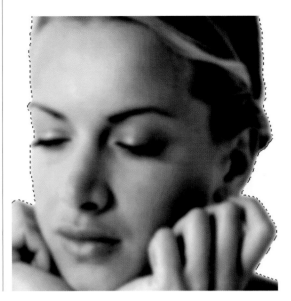

4 We now have 3 documents: the original RGB image, the duplicate Lab image, and a grayscale image. Close the Lab image, as we no longer need it. Its only purpose was to provide the *Lightness* channel as the basis for the

grayscale document. Working in the grayscale document, go to *Image > Adjustments > **Levels*** to create a little more contrast. This will assist in bending the blinds around the contours of the girl's face and hands.

6 Because the girl is some distance from the wall behind her, any single shadows being cast, would appear to break up abruptly as the shadow falls away from her face onto the wall. This effect can be achieved by making the wall pure white in color, which contrasts strongly with the grays and blacks on the girl, thus resulting in more erratic distortion. This, incidentally, is just the effect we have taken great care to avoid on the soft contours of the girl's face. Make a selection of the wall and fill it with white.

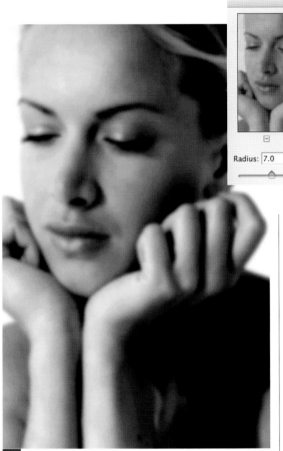

7 Save the *displace* document to update the changes and then close it. We now have just the original RGB document open. The RGB document's colors need warming up, and a little more contrast to suggest a flood of sunlight being cast onto the girl's face. Add a *Levels* adjustment layer to increase contrast.

5 Although a higher degree of light and dark areas is desirable, it is important that there are no sharp, distinctive lines between black and white. This can result in an unrealistic

and fragmented warping of the image rather than the soft bending of light and shadow that we are trying to achieve. Go to *Filter > Blur > **Gaussian Blur***, and apply a *Radius* of 7.0.

8 Now add a *Color Balance* adjustment layer and increase the amount of yellow in the *Shadows*, *Midtones*, and *Highlights*. Do the same with the amount of red, but to a much lesser degree.

9 Now to create the shadow of the blinds: create a layer called *Blinds* at the top of the *Layers* palette.

10 Create a rectangular feathered selection outlining what will be one strip of the blind. For a high resolution file, use about 9 pixels for the feather.

11 Fill the selection with 50% gray and deselect.

12 Duplicate the gray strip so that multiple strips fill the image window. All the gray strips should be on one layer.

13 Now for the displacement map that will bend the shadow around the girl: with the *Blinds* layer selected go to *Filter > Distort > Displace*. Enter the settings as shown. We want to displace the image in the vertical plane only, hence the 0% setting for the *Horizontal Scale* option. Higher settings result in greater distortion.

14 After clicking *OK*, you will be presented with a dialog box prompting you to choose a displacement map. Choose the grayscale displacement map you saved earlier.

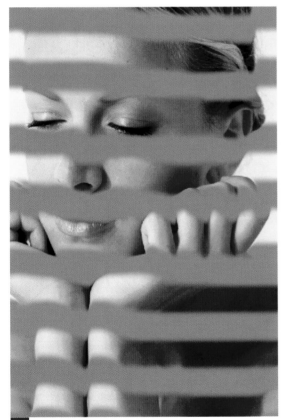

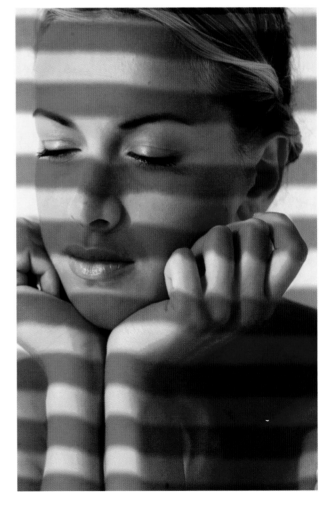

16 Finally, change the *Blinds* layer blend mode to *Multiply*, and reduce the *Opacity* to 90% to see the finished result. Notice how the shadow falling on the wall behind the girl is sufficiently offset to give a good impression of distance.

15 The displacement is clearly visible. Due to the blur we applied to soften the transition between white and black, the gray strips have gently molded themselves around the contours of the girl's face, hands, and arms. Although a certain amount of experimentation may be necessary according to the image, the basic principles remain the same and provide you with a great degree of control over the finished effect.

CAST LIGHT FROM WINDOWS

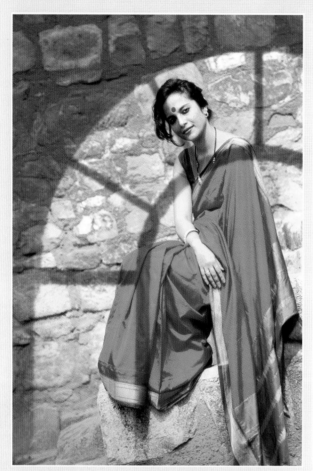

1 You can create your own design to act as a cast light object, but if you already have an image, then that too can be used with equal success. I am going to use the strong image of an arch window for a very bold effect. Make a rectangular selection of the area to be used. The method we are going to use for this effect will result in the arch window being tiled, so it does not matter if the window is much smaller than the image we are going to apply it to as we will have the ability to scale it later.

A light source can often have a more dramatic effect on a scene if it is constrained by some kind of aperture. In this way, it becomes similar to a stencil, providing a predefined shape which can then be projected onto the scene. Indeed, the shape of the projected light can itself be the focus of the image, becoming both the light source and the subject. But by combining such a light source with some existing subject matter, you can easily transform even the most mundane photograph into a work of artistic merit.

2 Light being projected onto another surface rarely has a sharp defined edge, so we need to soften the edges of the window to keep the effect realistic. Go to *Filter > Blur > **Gaussian Blur*** and apply a *Radius* of 2.0.

3 With the selection still active, go to *Edit > **Define Pattern***. Name the pattern *Arch* and click *OK*. This pattern will now be available for us to use with other images.

4 The image I am using on which to cast the light is a little darker than a well-balanced photograph would normally be. It also has quite well saturated colors. Both of these factors will compliment the finished result.

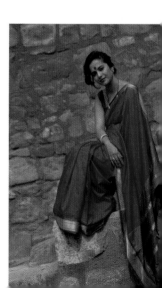

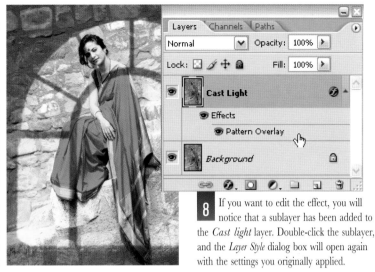

5 Duplicate the *Background* layer and rename it *Cast* *light*. The original layer will be needed later.

6 With the *Cast light* layer selected, click the *Layer Style* icon at the bottom of the *Layers* palette and choose *Pattern Overlay* from the list.

8 If you want to edit the effect, you will notice that a sublayer has been added to the *Cast light* layer. Double-click the sublayer, and the *Layer Style* dialog box will open again with the settings you originally applied.

9 If you are happy with the result, there is nothing more to do, but if you are looking for a slightly less perfect window projection, then one more finishing touch will give it the right feel. Add a layer mask to the *Cast light* layer.

7 In the *Layer Style* dialog box, select the *Arch* pattern that you just created from the *Pattern* drop-down box. This will be the last one in the list. For the settings, I used the *Colour Dodge* blend mode, 64% *Opacity*, and 216% *Scale*. All of these settings are pictured in the example. The image is updated on screen, so you can make fine adjustments of your own as you apply the settings. Click *OK* to confirm.

10 Set up the *Gradient* tool with the *Black to White* linear gradient, and drag a short distance in the bottom-left corner of the image similar to the arrow in the example. Make sure you have the mask thumbnail selected before you drag the gradient. The final effect is a gradual fading away of the cast light, resulting in a less uniform, more realistic finish. This is achieved by way of the layer mask, which enables us to hide the corner of the *Cast light* layer, revealing the original *Background* layer underneath.

CREATING LIGHT CAST THROUGH STAINED GLASS WINDOWS

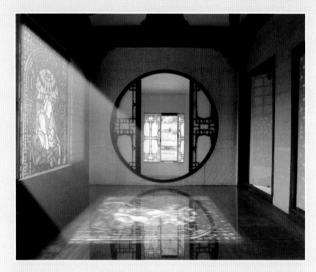

The beauty of a stained glass window is truly realized when it is flooded with strong directional light. Equally beautiful and yet not so obvious is the light that is cast from the window and the resulting projected image onto a nearby surface. In the right conditions, you have something akin to the world's largest slide projector. The right conditions, however, are not so easy to come by in terms of photographing such a scene. Such majestic windows are rarely positioned in locations with a perfect floor or wall space to act as a projecting screen. Equally rare is the chance of catching that fleeting moment when the sun's position is just right to create the beam of light without a group of tourists getting in the viewfinder.

So, we'll dispense with trying to capture the real thing on location and use Photoshop to make our own.

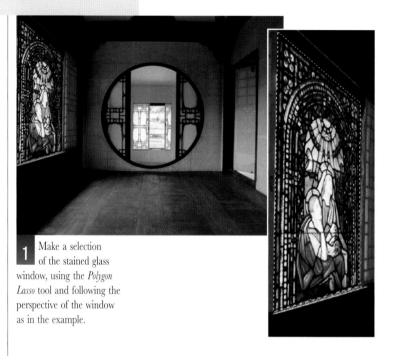

1 Make a selection of the stained glass window, using the *Polygon Lasso* tool and following the perspective of the window as in the example.

2 Press Ctrl (Cmd) + J to copy and paste the selection onto a new layer, and name the layer *Window*.

3 Go to *Edit > Transform > Flip Vertical*. This turns our duplicated window upside down.

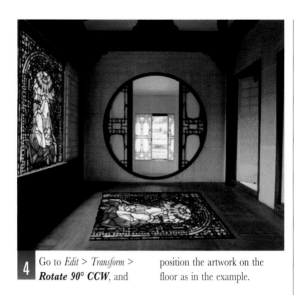

4 Go to *Edit > Transform > Rotate 90° CCW*, and position the artwork on the floor as in the example.

5 Flipping the selection has created a perspective problem, but this is easily solved. Go to *Edit > Transform > Distort*. Drag the bottom-left handle horizontally to the left. Hold the Shift key down to help you do this as you drag. Keep dragging until you reach the line between the floor tiles. This gives you a perfect guide to mimic the actual perspective. Press the Enter (Return) key to confirm the distortion.

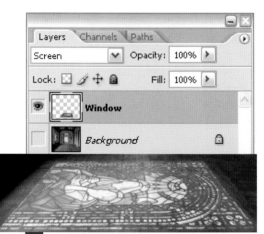

6 It currently looks a bit more like a rug than projected light, so to give it more of an airy feel, change the layer blending mode to *Screen*.

7 The window itself is not a perfect optical device as a projector lens would be, so we would expect to see a vague image rather than a crisp rendition of the window. Additionally because of the relationship between the angles of the light source, the window, and the floor onto which the light is projected, there should also be a stretched, distorted effect. To create this, click on *Filter > Blur > Motion Blur*, and set the *Angle* to 0 and the *Distance* to 19. I'm working on a high resolution document, but if you are working on lower resolution files, then you will need to reduce the *Distance* setting accordingly to achieve a similar look.

8 To create a really dynamic, ethereal feel, we are going to produce the beam of light being cast through the window onto the floor. First create a new layer called *Beam* and set the layer *Opacity* to 60%.

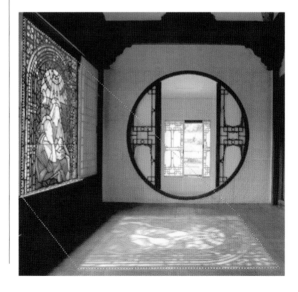

9 Using the *Polygon Lasso* tool, create the perimeter of the light beam from the window to the floor as in the example. Use a feather of 10, but lower if you are working with low resolution files.

10 Set up the *Gradient* tool to use the *Foreground to Transparent* linear option, making sure that white is the foreground color.

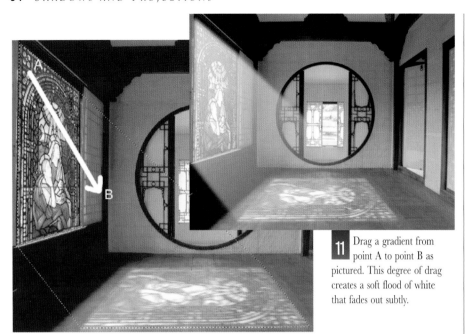

11 Drag a gradient from point A to point B as pictured. This degree of drag creates a soft flood of white that fades out subtly.

14 Select the *Gradient* tool and choose the *Transparent Rainbow* linear gradient option. This gradient is part of the default gradient set.

12 It should be remembered that the window has colored glass, and so light being transmitted through it would be expected to carry a hint of the colors. Create a new layer called *Color Beam* and set the *Opacity* to 25%, positioning the layer at the top of the *Layers* palette.

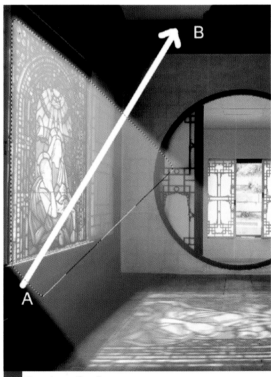

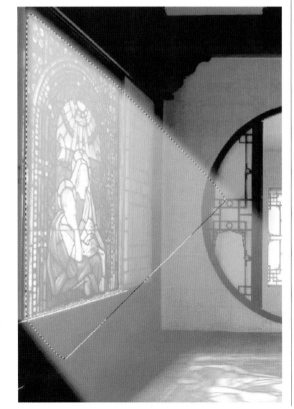

13 Hold down the Ctrl (Cmd) key and click the *Beam* layer in the *Layers* palette. This loads the layer as a selection, which we will use reuse rather than creating a new one.

15 Drag the gradient from point A to point B as shown. The idea is to create the suggestion of colored light only.

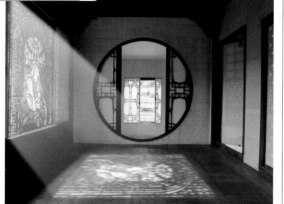

16 To add a few subtle streaks to the colored light, typical of cast light of this kind, change the layer's blend mode to *Pin Light*.

19 Go to *Edit > Transform > Flip Vertical* and drag the flipped artwork so its top edge meets with the bottom of the original wall, depicting a reflection in the floor.

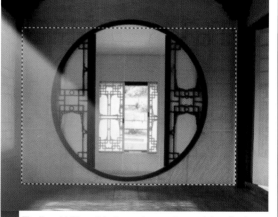

17 Finally, a highly polished floor would really strengthen the illusion of the window being projected onto the floor. We will achieve this by creating a subtle reflection of the back wall. Make a rectangular selection of part of the rear wall on the background layer, as shown.

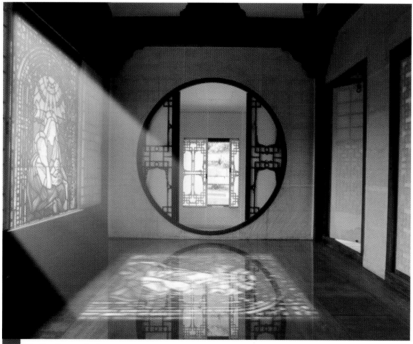

20 Finally change the layer *Opacity* to 40% for the finished effect.

18 Press Ctrl (Cmd) + J to copy and paste the selection to a new layer and name the layer *Wall*.

REFLECTIONS

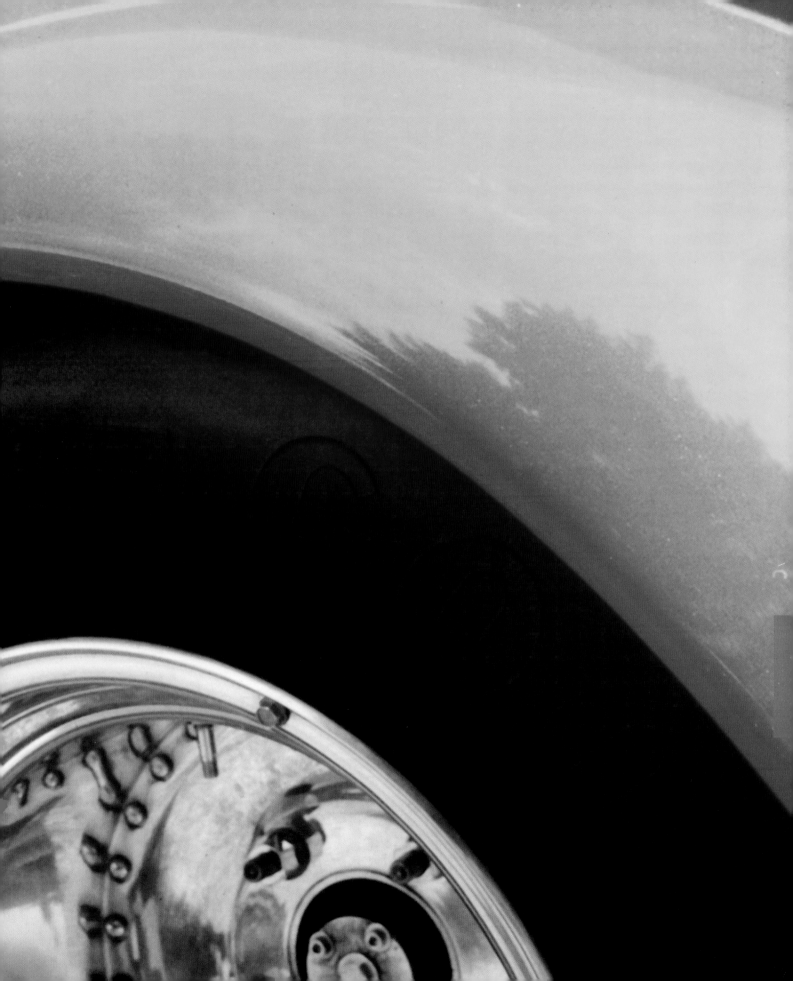

CREATING REFLECTIONS IN WATER

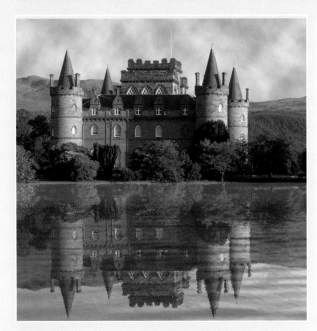

1 Begin by renaming the *Background* layer so we can drag other layers below it. Double-click the *Background* layer and rename it *Castle*.

2 The canvas needs to be increased to accommodate the false reflection. To do this, go to *Image > **Canvas Size***. The amount of canvas you add, will depend upon how much reflection you would like to see. I am adding about half of the original document height to make the new total image height 1800 pixels.

Reflections in water have their own characteristics quite distinct from the perfect image reflected in a mirror. The calmer the body of water, the greater its ability to reflect an image, so a reflection in a smooth lake with no currents on a fine day would not be a very difficult task for Photoshop. At the other extreme, a stormy, turbulent sea would produce very little in the way of reflection. Complications set in when we start thinking about a body of water somewhere in between these two extremes. It's this in-between stage that accounts for most of the reflected water surfaces which we encounter in everyday life, whether it is a puddle in the street, the rippled surface of a lake, or water running into a bath. Add to this mixture the ambient light, the sky conditions, and what lies at the bottom of the water, and suddenly we have a bit more work on our hands than a simple flip vertical command.

If you have an image with a body of water already in place, things are much easier, but we are going to do something much more demanding and far more satisfying by creating the water as well.

3 Create another white-filled layer that sits below the *Castle* layer.

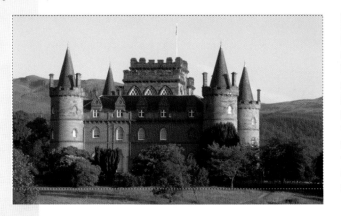

4 Make a rectangular selection from the top of the document to just below the bottom of the castle. Try to line up with an element that should look natural as the starting point of the water, such as where the grass begins. My selection height is 970 pixels, which should convincingly simulate the division between the grassy bank and the water.

5 Now we need to copy and paste the selected area onto a new layer. Press Ctrl (Cmd) + J and name this new layer *Reflections*.

6 Ctrl (Cmd) click the *Reflections* layer in the *Layers* palette to load its selection and then inverse it (Ctrl (Cmd) + Shift + I).

7 Now activate the *Castle* layer and hit the Backspace key. This action trims away the lower portion of the *Castle* layer, which will not be needed, and enables the reflected layer to butt up to it perfectly. It also means we can reduce the opacity of the *Reflections* layer later without any unwanted elements showing through.

8 Activate the *Reflections* layer, then go to *Edit > Transform > **Flip Vertical***. Drag the reflected image to the bottom half of the document, keeping the Shift key pressed as you drag. This keeps the dragging movement perfectly vertical. Position the image so the edges meet in the center. It already looks quite convincing, but a little too perfect. One of the first casualties of water-reflected images is the depth of color. We need to desaturate the overall color of the reflection a little to add some authenticity.

9 Use *Image > Adjustments > **Hue/Saturation***. Drag the *Hue* slider to the left to reduce the saturation equally across the whole layer. I'm using a value of –40.

10 To reduce the strength of the reflection a little more, reduce the *Reflections* layer's *Opacity* to 80%

11 Now for some surface distortion to break up the uniformity: go to *Filter > Distort > **Ocean Ripple***. Some experimentation is required here. You can create everything from a gentle breeze over the water to a prelude to a hurricane. For this image, I have used fairly modest settings to create just a little surface disturbance.

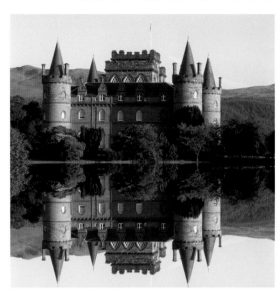

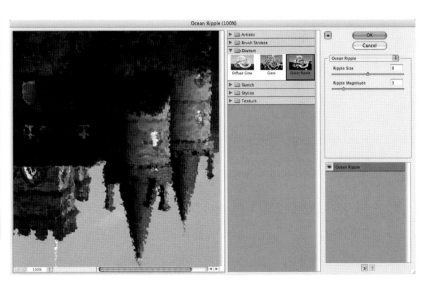

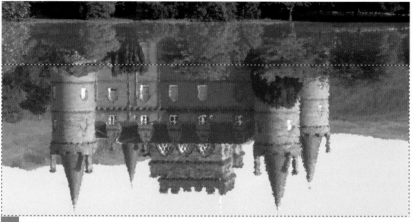

12 Although the *Ocean Ripple* filter is good for appearing to break the surface tension of water, it doesn't really convey the impression of the rhythmic pattern of undulating ripples as the wind strokes the surface. For more convincing realism, we can use any grayscale image to simulate the current or ripple on the surface, but if you already have some rippled water in an existing image, why not use that and save yourself the tedium of creating a ripple pattern? This image of a canoe has a good ripple texture that will work well as a ready-made pattern for our reflection.

14 Make a feathered rectangular selection covering the lower ¾ of the *Reflections* layer. The amount of feather you use, will depend upon the resolution of your document. The higher the resolution, the higher the feather setting needs to be. I am working on a 300ppi image, so I have used a feather of 20 pixels.

15 Press Ctrl (Cmd) +J to copy and paste the selected area onto a new layer. Name the layer *Ripples* and reduce the layer *Opacity* to 82%.

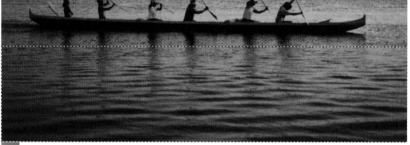

13 Make a rectangular selection of some of the ripples, then go to *Edit > Define Pattern*. Give the pattern a name and click *OK*. The pattern you have just made will be used as a pattern overlay in a moment, but before it is applied, some thought needs to be given to the characteristics of the reflection. In a body of water of this size, the reflection would typically be stronger closer to the bank where the water meets the land. Additionally, the ripples would appear to be less distinct as they travel farther away from the eye until the water appears almost flat. With this in mind, it will be more realistic if the pattern overlay is applied to only a selection of the water, leaving the water farthest from the eye unaffected.

16 With the *Ripples* layer selected, click the *Layer Style* button at the bottom of the *Layers* palette, and select *Pattern Overlay*.

20 Use the *Magic Wand* tool to select the sky. It's quite uniform, so will be easy to select.

17 Select the last pattern from the *Pattern* drop-down box—this is the one you have just created. Use *Hard Light* as the blend mode, set to 74% *Opacity* and 234% *Scale*. Finally, click the *Snap to Origin* button. This positions the pattern in the top-left corner of the image. All these settings are displayed in the accompanying image. You may want to tweak these settings based on the images you are using and the depth of effect you are trying to achieve.

21 Make a new layer called *Sky* and position it at the top of the *Layers* palette.

18 To further reduce the opacity of the pixels on the layer, strengthening the reflection effect but keeping the full opacity of the overlaid pattern, drag the *Fill* opacity slider to 10%. The only problem we are left with is the fact that the overriding color of the water should be dominated by the color of the sky. As we manufactured the water, there is a clear mismatch. Luckily, the sky is a little insipid anyway, so we are going to make a moodier sky color that would in real life inspire the darker color of the water.

19 Use the *Eyedropper* tool to sample a couple of blues from the water, one for foreground and one for background color. Use a deep blue and a pale blue. If you can't sample a blue that is pale enough, you can always manually adjust it to make it lighter.

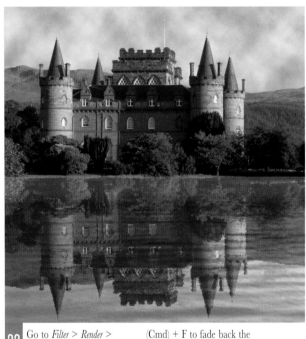

22 Go to *Filter > Render > **Clouds***. If the effect is too strong, press Shift + Ctrl (Cmd) + F to fade back the effect to the desired level.

CREATING METAL REFLECTIONS

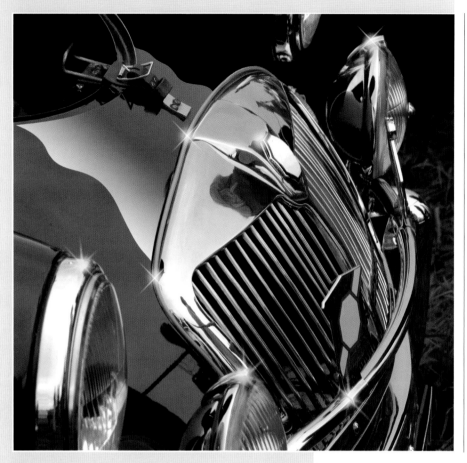

Although the chrome element of the example image is highly reflective, the black bodywork isn't contributing greatly to the image. I really want to create a lustrous feel, with the black metal depicting an almost glasslike quality. We are going to create a false reflection that will simulate some distant hills with a sharp transition of light above the horizon.

1 Create a path with the *Pen* tool, as illustrated. You could alternatively use the *Lasso* selection tool, but the *Pen* will create smoother curves, and that is important for the effect we are trying to achieve.

2 Convert the path to a selection by pressing Ctrl (Cmd) + Enter (Return).

Far from being a standardized material, metal can possess a wide range of properties, each distinctive in the kind of reflection it displays. All of these properties can be simulated in Photoshop, from matte, dull surfaces to highly finished chrome. Car advertisements, in particular, are good examples of how a mundane metal shape can be made to look exotic and sophisticated by good use of light and reflection.

The environment in which metal is photographed is therefore critical, but conditions may not always be perfect for your particular project. This needn't necessarily be a problem, however, as some relatively simple techniques can completely transform your image.

3 Create a new layer called *Gradient*.

4 Drag a *White to Transparent* linear gradient as directed by the arrow, then deselect.

5 A *White to Transparent* gradient creates just the lustrous effect I was looking for, but pure black can add

an equally glossy finish. Create another path with the *Pen* tool, converting it to a selection as before.

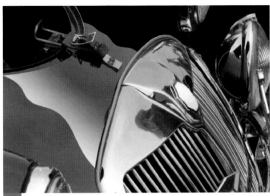

6 Create a new layer called *Black* and fill the selection with pure black.

7 The black bodywork now has a smooth glassy finish, but to add some real impact we need some additional specular highlights reflecting imaginary points of light in the surrounding environment. Select the *Airbrush* tool and apply the settings as in the example. You will have to use a smaller brush size if you are working on a low resolution file.

8 On a new layer called *Highlights*, apply bursts of white paint to some chrome areas, pressing the mouse button for half a second. We need only a subtle, soft circle of white. For the most dramatic effect, apply the airbrush to areas of the chrome that are dark or midtoned.

9 For that just polished feel, we are going to add a few sparkles that emanate from the center of some of the airbrushed highlights. From the *Brushes* palette, load the brush set called *Assorted Brushes*.

10 From within this brush set, select the brush called *Crosshatch 4* and increase the size to 125 pixels for a high resolution file.

11 On new layer called *Sparkles*, click once with the *Brush* tool (not the *Airbrush*) over the center of one of the airbrushed highlights.

12 For a multisided sparkle, use the brush called *Starburst Large* from within the same brush set.

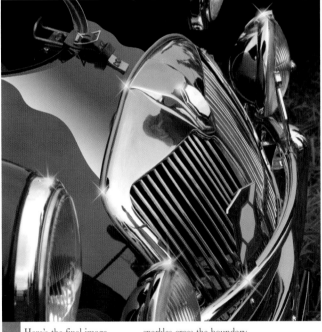

13 Here's the final image. You'll need to make a judgement on how many sparkles cross the boundary of good taste.

CREATING REFLECTIONS IN CURVED GLASS

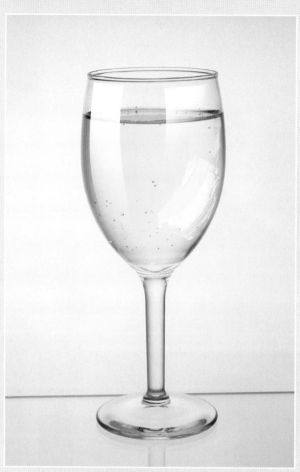

Some of the most attractive forms of glass reflections can be found in curved glass. Objects such as wine glasses, bottles, and bowls make perfect candidates for creating elegant reflected distortions of the surrounding environment. In the example of the rounded wine glass that we are going to work on, the glass itself is composed of a number of different surfaces, each acting as a separate entity, unlike a flat piece of glass such as a window. The bowl of the glass, the stem, and the base will all reflect the environment in their own unique way, molding the surrounding objects to conform to their own particular curves.

The cylindrical shape of the glass means that an area equal to approximately 180° is available for reflections from the viewer's standpoint. This offers the potential for multiple light sources to be reflected, often stemming from more than one window in different parts of the room.

Although the permutations are many and varied, Photoshop enables you to incorporate all these real world elements in photorealistic and controlled way.

1 We'll decide first of all that our room has three windows, two plain with glass and one colored glass. Begin by making a selection describing the first reflected shape. Although you can use the *Lasso* tool, the *Pen* tool will give you smoother curves and the smoothness is critical for the effect.

3 Select the *Gradient* tool and choose the *Foreground to Transparent* gradient using the linear gradient mode with white as the foreground color.

4 With the *Left reflect* layer active, drag a gradient through the selection from top to bottom. The white color should gradually fade out toward the bottom of the glass. If the effect isn't achieved first time, undo it and drag the gradient again. Deselect the selection (Ctrl (Cmd) + D).

2 In the *Paths* palette, click the *Load Path as Selection* icon to convert the path to a selection. Make a new layer and name it *Left reflect*.

5 For the colored glass reflection, we are going to use an actual image of an ornate window. Make a selection of just the window portion of the image.

6 Using the *Move* tool, drag the selected artwork into the wine glass image, giving the automatically created layer the name *Window*.

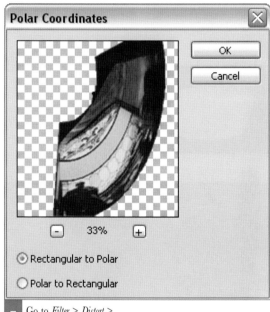

7 Go to *Filter > Distort > **Polar Coordinates***, and choose the *Rectangular to Polar* option.

8 Position the distorted artwork over the bottom right of the glass and create a path defining the final reflected shape.

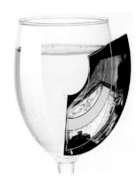

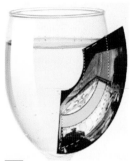

9 Load the path as a selection as you did in step 2. Activate the *Background* layer and press Ctrl (Cmd) + J. This copies and pastes part of the *Background* layer based on the selection onto a new layer.

10 Name the newly created layer *Clip* and position it below the *Window* layer. This layer will be used as the basis for a clipping group combining it with the *Window* layer.

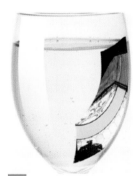

11 Activate the *Window* layer and go to *Layer > **Create Clipping Mask*** to make the clipping group.

12 Change the blending mode of the *Window* layer to *Screen* for the full effect.

13 For the third and last window reflection, we need to repeat the process from step 1. Create a path toward the top of the glass.

14 Load the path as a selection.

15 Create a new layer named *Top reflect* positioned at the top of the *Layers* palette. Using the *Gradient* tool and the same *White to Transparent* gradient, drag through the selected area at a 45° angle from top-left to bottom-right. This achieves a realistic fall-off of light as the glass curves away from the viewer.

CREATING REFLECTIONS IN SUNGLASSES

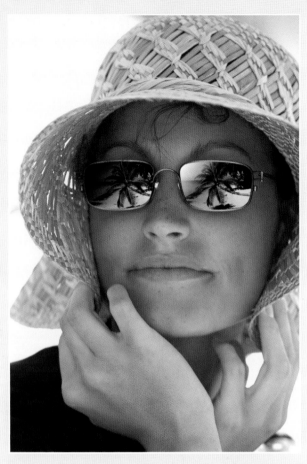

1 Make a selection of the sunglass lens on the right of the image.

2 Create a new layer called *Right lens*.

I t's one of the all-time great movie and photographic clichés—the world as viewed through the eyes of another person, witnessed through a reflection in the darkened lenses of their sunglasses. The creative possibilities are endless, ranging from a startling juxtaposition to the recreation of a real scene.

Of course, to avoid the finished image looking like a couple of pictures stuck on top of the sunglasses, there are a number of factors to take into account, including curvature of the lens, reflection properties, light, shadow, and parallax, all of which will be considered as we work through the next steps.

3 Fill the selection with white and deselect.

4 Drag the palm tree image into the sunglasses image and name the layer *Palm tree*.

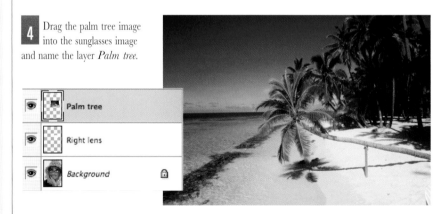

5 We are going to use the white shape on the *Right lens* layer as a mask for the image of the palm tree. This combination, known as a clipping mask or group, is ideal for the kind of illusion we are creating. One of its great benefits is the fact that it enables you to reposition one image within the other to get the right placement. With the *Palm tree* layer active, go to *Layer > **Create Clipping Mask***.

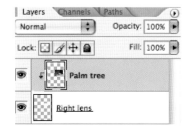

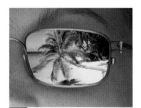

6 If necessary, you can reposition the image within the sunglasses shape so the palm tree is fully visible.

7 The lens is fairly flat, but is slightly convex in the horizontal plane. We need to distort the image accordingly to reflect this. With the *Palm tree* layer still selected, go to *Filter > Distort > **Spherize***. Set the mode to *Horizontal only* and the *Amount* to 29%.

8 If you wanted a mirror type lens, we could leave it at that, but we'll make the lens a more conventional dark glass. Duplicate the *Palm tree* layer.

9 Change the duplicated layer blend mode to *Multiply*. You can now control the precise degree of lightness of the lens by editing the layer's opacity.

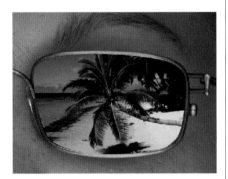

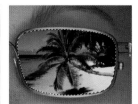

10 We need to emphasize the convex shape of the lens a little more and also strengthen the illusion of reflection. Press Ctrl (Cmd) and click the *Right lens* layer to load its selection.

11 Create a new layer called *Gradient* positioned at the top of the *Layers* palette.

12 Drag a *White to Transparent* linear gradient diagonally from the top-left corner of the lens to about one quarter of the way through the selection.

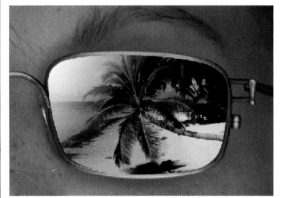

13 Repeat the whole process for the other lens. Because the two lenses are viewing the scene from a slightly different angle, parallax should be visible in the lenses. Parallax is the apparent different position of objects when viewed from different angles, such as when viewing a scene through a compact camera. I have taken this into account and altered the position of the palm tree accordingly in the left lens. The left lens is also under the shade of the brim of the hat, which would prevent a bright highlight striking the top corner with the right lens. Therefore I have compensated by

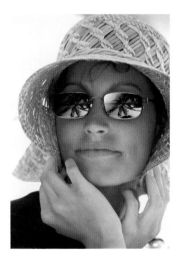

substituting the white gradient used on the first lens with a *Black to Transparent* gradient.

REMOVING UNWANTED REFLECTIONS

Removing reflections is as necessary a part of digital image manipulation as adding reflections can be. Before a scene has been photographed, the use of a polarizing filter is traditionally used to aid the removal of unwanted reflections, but you are presented with a different problem if the photograph has already been taken. So we are going to look at some techniques for eliminating reflections after the event.

1 This otherwise striking close-up image is ruined by the unwanted reflection of people nearby. We'll start by tackling the man's reflection on the wheel arch. Select the *Patch* tool, making sure the *Source* option is selected from the *Tool Options* bar.

2 Drag around the area to be removed.

3 Drag the selection to a nearby area from where you want to copy pixels, then release the mouse.

4 The result should be a smooth finish with no trace of the original reflection.

5 The *Patch* tool is a powerful addition to the Photoshop tool set, but of course every tool has its limitations. The bulk of the image is dominated by the main reflection of the man and boy. The *Patch* tool will be of little use here as we don't have enough suitable image area from which to copy pixels, so we'll use a different technique. Create a path around the area to be replaced. You could use a *Lasso* tool, but the finished result of a path created with the *Pen* tool will be much smoother. The path has been given a black stroke in the example just for greater visibility.

6 Convert the path to a selection by pressing Ctrl (Cmd) + Enter (Return).

7 Using the *Eyedropper* tool, sample a pale pink from the car for the foreground color and a deeper red for the background color. I am using R241 G111 B149 for the foreground and R187 G0 B17 for the background color.

8 Set up the *Gradient* tool to use the *Foreground to Background* radial gradient.

Foreground to Background

Mode: Normal

9 On a new layer called *Gradient*, drag the gradient as shown, then deselect the selection.

10 The completed gradient should leave you with a smooth, natural looking surface.

If the gradient doesn't have the right look, just drag again until you achieve a pleasing effect.

11 The gradient has hidden part of the original white specular highlight near the yellow and blue stripe. To

replace this, use the *Airbrush* with a low pressure setting and an off-white paint color. Paint onto a new layer.

12 Change the layer's blending mode to *Linear Light* to add a little more radiance to the highlight.

13 One more area remains with an unwanted reflection at the bottom of the wheel arch. This area is in a difficult position for the *Patch* tool as there are many colors in close proximity. The simplest and most effective tool to use here is the *Airbrush* tool.

14 Make a feathered selection of the area to be hidden.

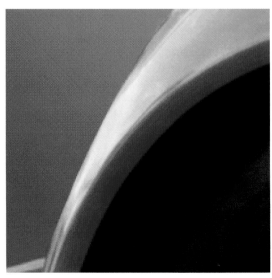

15 Sample an off-white color from within the selection, and use a low-pressure airbrush to brush several short strokes onto a new layer.

16 We could leave it at that, with a nice showroom finish to the car.

17 However, at this stage you may want to actually add a little reflection—nothing obvious, just a general reflection that adds to the sheen and realism. Press Ctrl (Cmd) + click the *Gradient* layer to load its selection.

18 Set up the *Lasso* tool with a high number pixel feather and in *Subtract* mode.

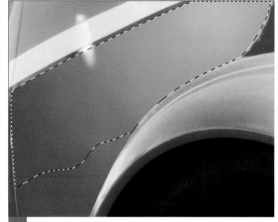

19 Draw a selection that subtracts an area from the bottom of the current loaded selection. This will result in a soft, wavy edge at the bottom of the edited selection, leaving the other edges crisp and well-defined.

20 Set up the foreground and background colors with the same values as we used in step 7 for the gradient.

21 Create a new layer called *Clouds*, which sits between the *Highlight* and *Gradient* layers.

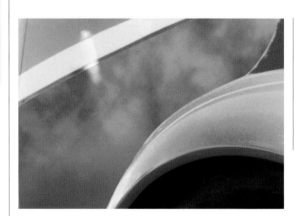

22 Go to *Filter > Render > **Clouds*** to give the reflection some texture.

23 Change the layer blending mode to *Screen* and reduce the *Opacity* to 93%.

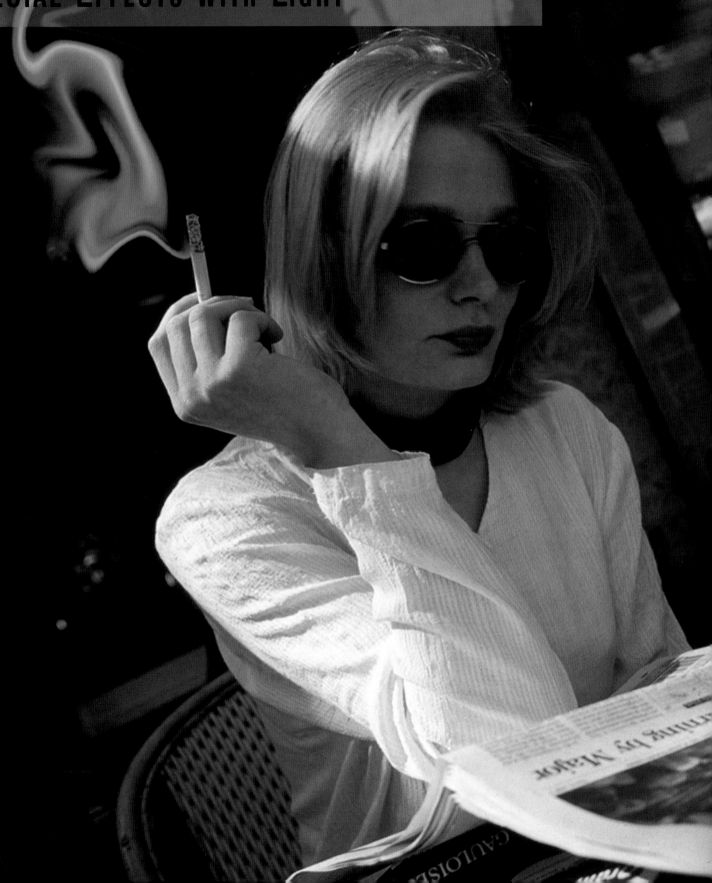

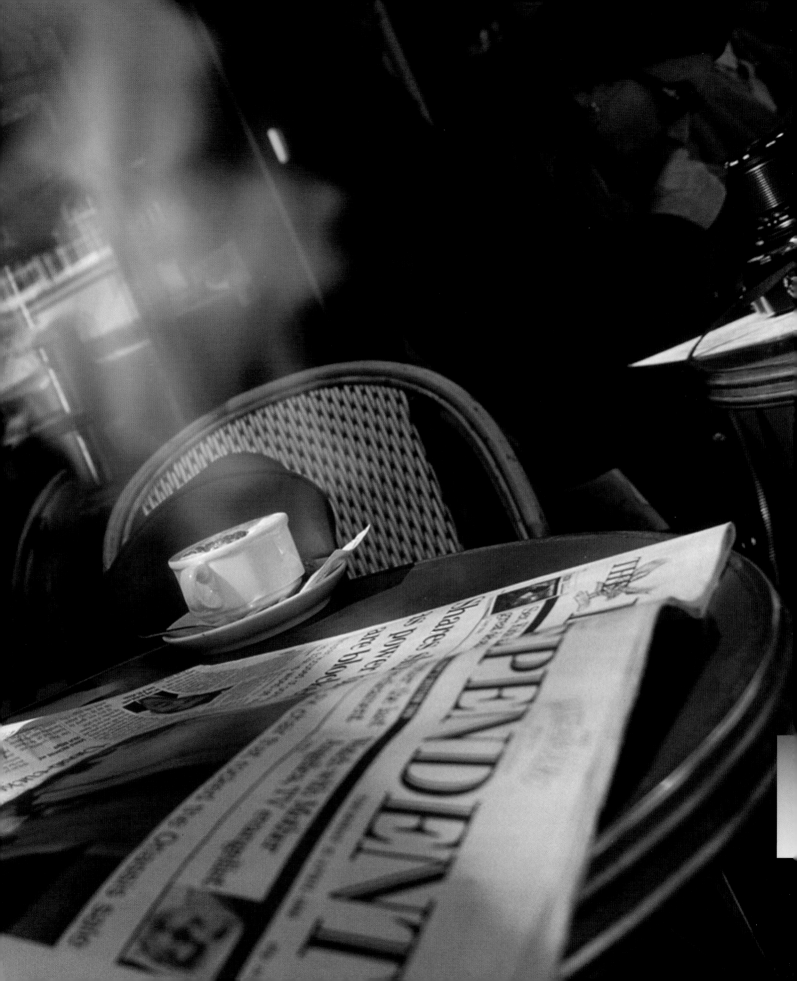

CREATING MULTIPLE COLORED LIGHTS

1 Duplicate the *Background* layer, and name the duplicate *Omni Light*.

Directing more than one light source at the subject provides a degree of lighting options that could never be achieved with a single light. Add color filters to the lights, and an infinite variety of dynamic lighting possibilities opens up.

Photoshop, as we know, enables multiple and colored lights to be used within a single scene, but each additional light will impact on all the other lights that have been used. This can make it difficult to control the integrity of each light, sometimes resulting in over- or underexposing areas.

The technique we are going to use will overcome that problem, providing subtle transitions between each light and complete creative control.

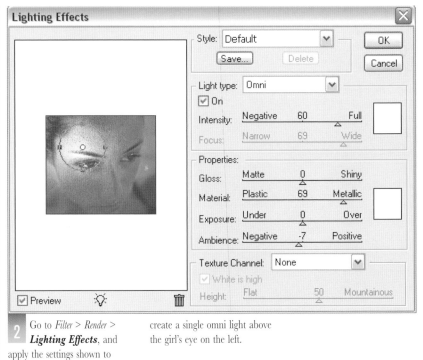

2 Go to *Filter > Render > Lighting Effects*, and apply the settings shown to create a single omni light above the girl's eye on the left.

3 Duplicate the *Background* layer again, and position it at the top of the *Layers* palette, calling it *Blue Light*.

5 This layer now hides the layer beneath it containing the omni light effect. Add a layer mask to the *Blue Light* layer.

6 Using a large, soft-edged brush, paint with black on the mask to hide the left side of the layer, thereby revealing the left side of the *Omni Light* layer beneath.

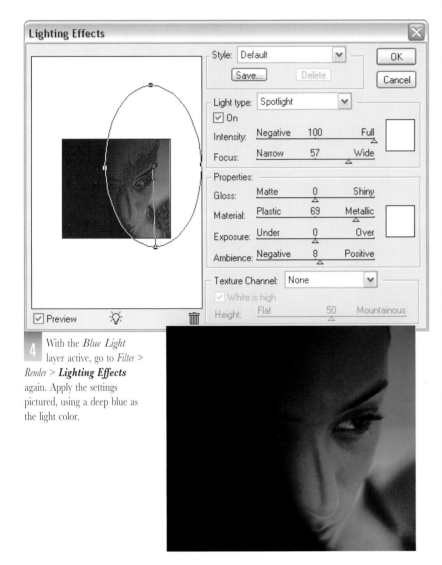

Lighting Effects

Style: Default

Save... Delete

OK Cancel

Light type: Spotlight

☑ On

Intensity: Negative 100 Full

Focus: Narrow 57 Wide

Properties:

Gloss: Matte 0 Shiny

Material: Plastic 69 Metallic

Exposure: Under 0 Over

Ambience: Negative 8 Positive

Texture Channel: None

☑ White is high

Height: Flat 50 Mountainous

☑ Preview

4 With the *Blue Light* layer active, go to *Filter > Render > Lighting Effects* again. Apply the settings pictured, using a deep blue as the light color.

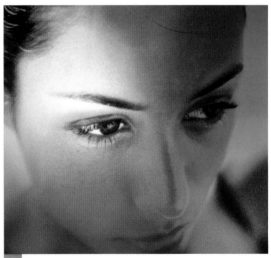

7 Using different *Opacity* settings for the brush, you can now control exactly how much of each layer is revealed to achieve the perfect blend of both lights.

CREATING RETRO STUDIO PORTRAIT LIGHTING

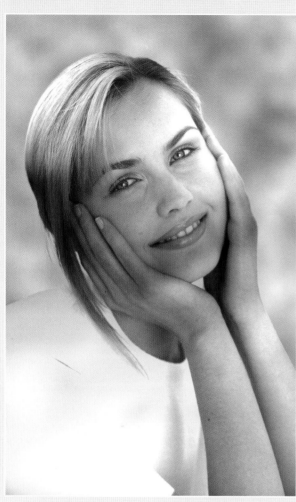

1 Make a selection of the white background area surrounding the girl.

The studio lighting setup for portrait photography is an entire and absorbing subject in itself. Some of the best examples of classic studio portraiture come from the film industry's heyday between the 1930's and 40's when the icons of Hollywood were immortalized on photographic paper as publicity material.

These black-and-white images were characterized by flattering lighting that drew sympathetic shadows, softening the skin tones and emphasizing the key features that transformed the artist into a star.

2 Rename the *Background* layer by double-clicking it, and call it *Base image*.

3 Press Backspace to remove the white selected area, revealing the transparency.

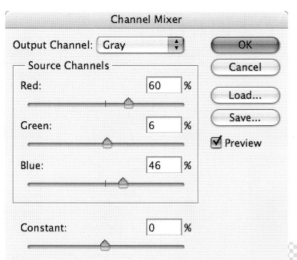

Channel Mixer

Output Channel: Gray

OK
Cancel
Load...
Save...
☑ Preview

Source Channels

Red: 60 %

Green: 6 %

Blue: 46 %

Constant: 0 %

☑ Monochrome

6 To achieve the retro look, our choice of background will be critical. Create 2 layers, one called *Backdrop* and the other, filled with white, called *White*. Position them below the existing layers with the *White* layer right at the bottom of the *Layers* palette.

Layers Channels Paths

Normal Opacity: 100%

Lock: ☐ ✎ ✛ ⌘ Fill: 100%

👁 Hair light
👁 Right light
👁 Base image
👁 Backdrop
👁 White

4 We need to make the image grayscale. There are a number of ways of doing this. The method we are using is quick and offers great control over the distribution of grayscale values, from the shadows right through to highlights. Go to *Image > Adjustments > **Channel Mixer***. Enable the *Monochrome* checkbox to create grayscale output. Apply the other settings as shown.

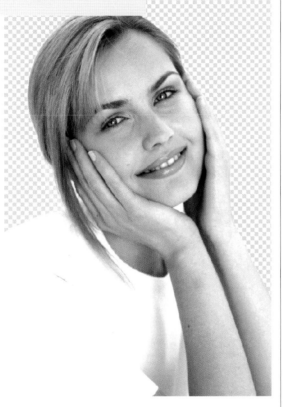

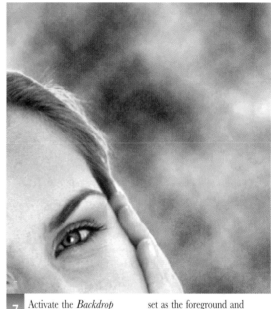

7 Activate the *Backdrop* layer and, making sure black and white are set as the foreground and background colors, go to *Filter > Render > **Clouds***.

Fade

Opacity: 75 %

OK
Cancel

Mode: Normal ☑ Preview

5 Duplicate the layer twice and name them from the top *Hair light* and *Right light*.

8 To weaken the effect, go to *Edit > **Fade Clouds***, and reduce the *Opacity* to 75%.

Layers Channels Paths

Normal Opacity: 100%

Lock: ☐ ✎ ✛ ⌘ Fill: 100%

👁 Hair light
👁 **Right light**
👁 Base image

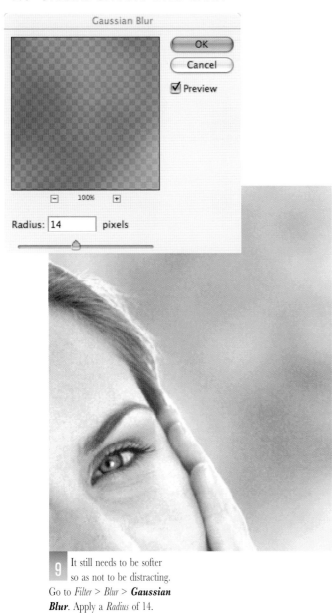

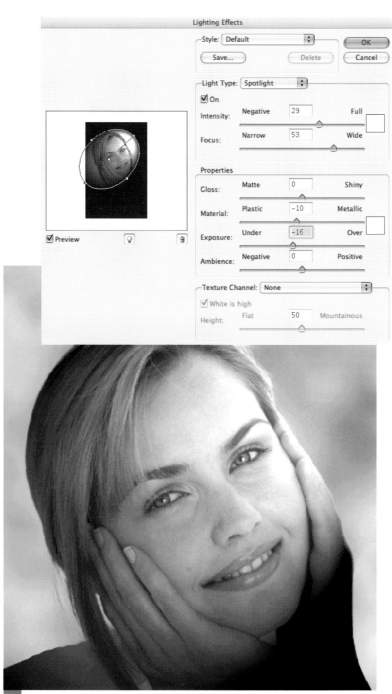

9 It still needs to be softer so as not to be distracting. Go to *Filter > Blur > **Gaussian Blur***. Apply a *Radius* of 14.

10 The stage is now set to bring in the lights. Activate the *Right light* layer, and hide the *Hair light* layer.

11 Go to *Filter > Render > **Lighting Effects***. Create a single spotlight with its source originating from just to the right of the girl's forehead. All the settings used are displayed.

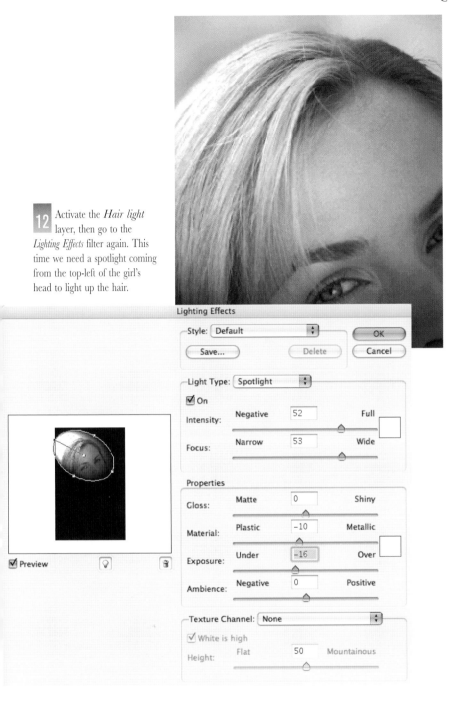

12 Activate the *Hair light* layer, then go to the *Lighting Effects* filter again. This time we need a spotlight coming from the top-left of the girl's head to light up the hair.

Lighting Effects

Style: Default

Save... Delete Cancel OK

Light Type: Spotlight

☑ On

Intensity: Negative 52 Full

Focus: Narrow 53 Wide

Properties

Gloss: Matte 0 Shiny

Material: Plastic −10 Metallic

Exposure: Under −16 Over

Ambience: Negative 0 Positive

Texture Channel: None

☑ White is high

Height: Flat 50 Mountainous

☑ Preview

14 Using a soft-edged brush, paint with black on the mask of the *Hair light* layer to hide all but the spotlight area in the top-left corner.

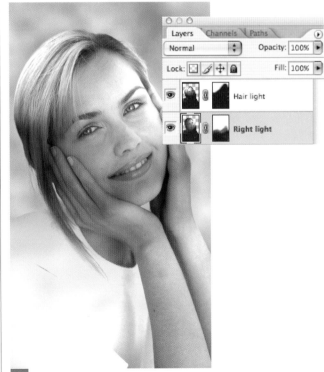

Layers Channels Paths

Normal Opacity: 100%

Lock: ☒ ◢ ✛ 🔒 Fill: 100%

Hair light

Right light

13 Both of the lights we are going to use are in place, and now we can selectively reveal parts of each layer as desired. Add layer masks to both of the light layers.

15 Now paint on the mask of the *Right light* layer, hiding the bottom half of it. This reveals some of the base layer, completing the image.

CREATING A FILM NOIR LIGHTING STYLE

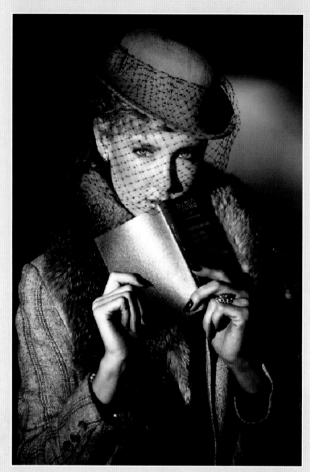

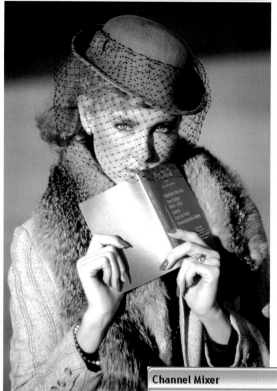

1 We need a good strong grayscale image to give us a head start, and using the channel mixer offers a great degree of control. Go to *Image > Adjustments > **Channel Mixer***. Select the *Monochrome* checkbox to create gray output. Adjust the percentages of the *Red*, *Blue*, and *Green* sliders to achieve the required contrast. The settings shown will achieve a good range of tones for our working image.

That most evocative of movie genres, film noir, has left us with a legacy of imagery that inspires visions of dark secrets, espionage, and femmes fatales. Shadow is an integral part of this style, where the dark, ominous recesses invoke a sense of mystery and the soft, strategically placed light appears almost accidental. Of course, the success of this style is no accident. Careful planning and balancing the contradictions of light and dark are critical if the feel is to be faithfully reproduced.

2 Film posters and publicity photographs of the period are sometimes seen with a blue tint. This elegant touch is still used today to add sophistication to grayscale images. Add a *Color Balance* adjustment layer.

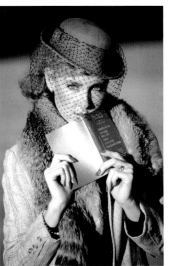

3 Apply the settings shown independently to the *Shadows*, *Midtones*, and *Highlights*.

7 Finally we can enhance the focal point and deepen the shadows further to add a little more mystery by creating a directional light. This light can also be used to create a small ghostly blur of light in the background behind the girl's head. Create a new layer called *Direct light*.

4 The drama and enigmatic atmosphere is achieved through extremes of lighting. Strong directional light on the chosen focal points and heavy shadow elsewhere. The girl's face is going to be the main focal point. Create a new layer called *Face light*.

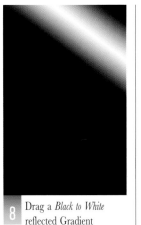

8 Drag a *Black to White* reflected Gradient through the top-right corner of the image.

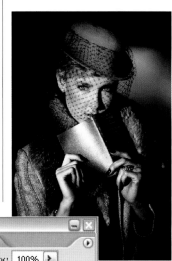

5 Drag a *White to Black* diamond gradient, starting from the center of the girl's face to the outside of her hat.

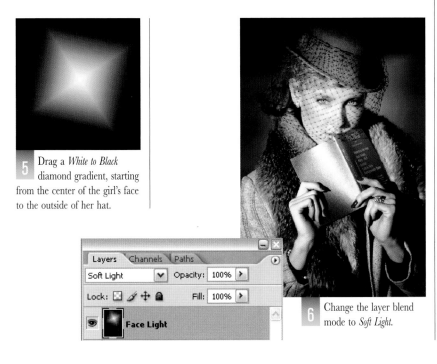

6 Change the layer blend mode to *Soft Light*.

9 Change the layer blend mode to *Soft Light*. The gradient has the effect of throwing the nonfocal areas of the image into deeper shadow and simulating a soft directional light across the girl's face and hat. It also interacts with the diamond gradient below it, creating a nice play of light in the background.

CREATING SMOKE & STEAM

As with all intangible entities, smoke and steam create some unique problems when trying to simulate them in an image. Hard-edged objects can be relatively easy to create with great realism, but the nebulous qualities of smoke and steam can leave you hovering between something vague and watery and a solid, computer-generated object. With the techniques that follow, you'll be able to master the creation of both steam and smoke with a high degree of realism.

1 We'll be creating pale-colored smoke and steam, so we need a darker background to help it stand out. Add a *Curves* adjustment layer to the *Background* layer.

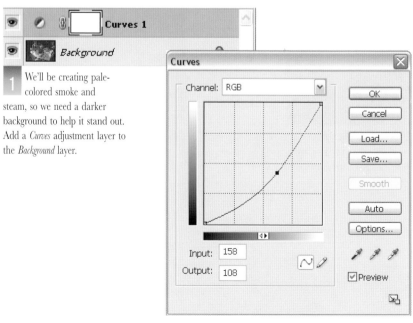

2 Using the *Rectangular Marquee* tool, create a feathered selection above the cup. I'm using a 15 pixel feather with a high resolution file.

3 Set up the foreground and background colors with midgray and white respectively.

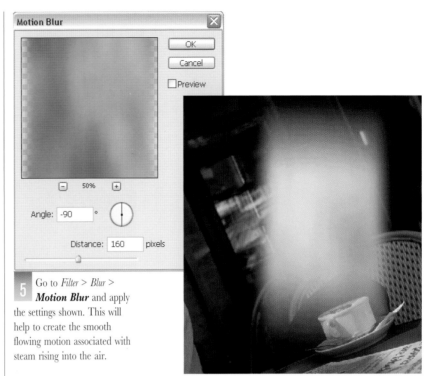

5 Go to *Filter > Blur > Motion Blur* and apply the settings shown. This will help to create the smooth flowing motion associated with steam rising into the air.

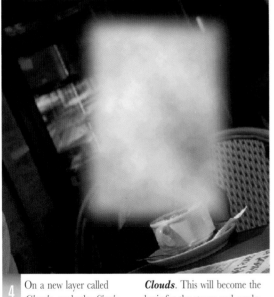

4 On a new layer called *Clouds*, apply the *Clouds* filter. Go to *Filter > Render >* **Clouds**. This will become the basis for the steam and smoke.

6 The lightness of steam makes it very susceptible to even low levels of air currents, so a prevailing breeze at an outdoor café, the turning of a newspaper page, and a waiter walking by will all impact on the rising steam in their own way. This can result in a chaotic mass of steam fighting to flow in different directions. The *Wave* filter is an ideal method for simulating this condition. Go to *Filter > Distort >* **Wave**, and apply the settings displayed. The results can appear highly volatile, and small adjustments can make what appear to be disproportionate changes. Your result may be different to the one shown because the effect is influenced by many factors, including the degree of streakiness in the original clouds, the contrast between the colors, the feathering, and the resolution of the file.

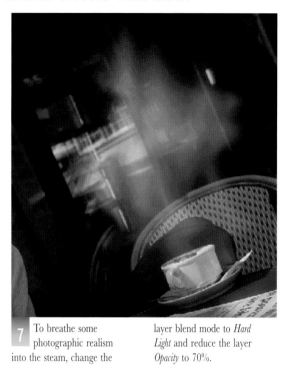

7 To breathe some photographic realism into the steam, change the layer blend mode to *Hard Light* and reduce the layer *Opacity* to 70%.

8 For a little more emphasis, and even more erratic movement as the steam rises higher, duplicate the *Clouds* layer.

9 It's important to avoid repeating patterns when using duplicate artwork, so to create a random appearance, go to *Edit > Transform > **Flip Horizontal*** and drag the flipped artwork to the top of the screen.

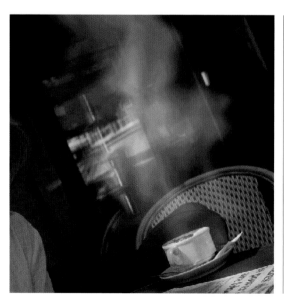

10 Reduce the *Clouds copy* layer's *Opacity* to 50% to keep the effect subtle.

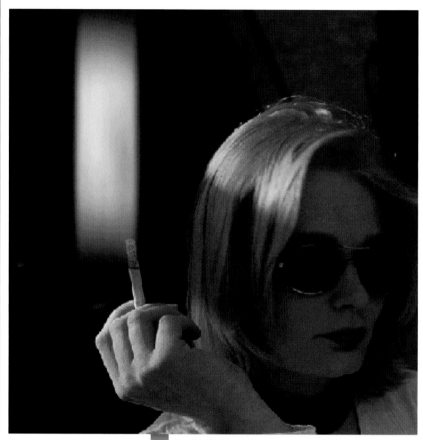

11 Now for the cigarette smoke: repeat steps 2 to 5 so you are left with some motion blurred clouds roughly approximating the area you wish the cigarette smoke to cover. This artwork should be on a new layer called *Smoke*.

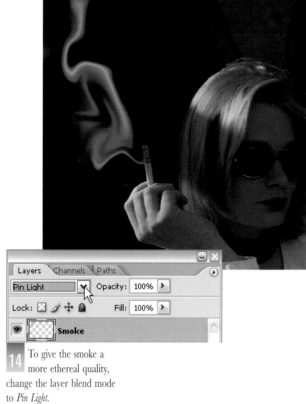

Go to *Filter > Distort > **Shear***, and drag the black line into roughly the shape displayed.

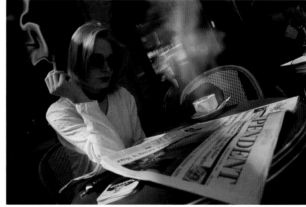

To give the smoke a more ethereal quality, change the layer blend mode to *Pin Light*.

The thin wispy strands of cigarette smoke are unmistakable and the *Liquify* filter will help us achieve this illusion. Go to *Filter > **Liquify***. Using the *Warp* tool from within the *Liquify* filter, click and drag the artwork in the preview window to distort it into a contorted shape resembling cigarette smoke. Don't try to achieve the exact effect as pictured; the result is based on many factors just as with the *Wave* filter earlier, not to mention your own, fine hand movements. Click *OK* when you have a suitable shape.

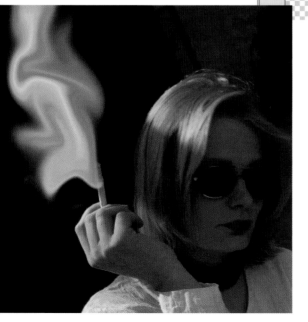

CREATING LIGHT THROUGH SMOKE & STEAM

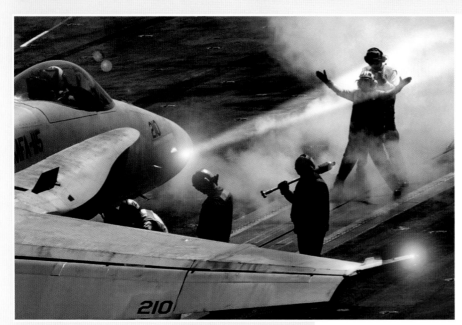

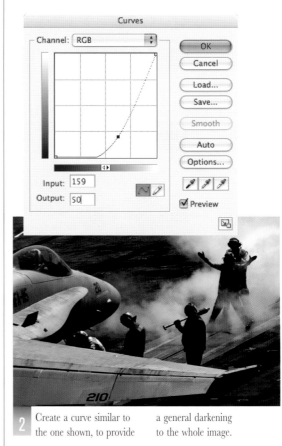

Due to the inherent qualities of smoke—which range from full opacity to degrees of transparency and an ever-changing mass—creating a false light that appears to shine onto smoke can suffer greatly with credibility. The same may be said of any visible entity that is less than tangible. We are going to use a simple but effective technique to achieve this goal and then add some atmosphere to provide interest in the finished image.

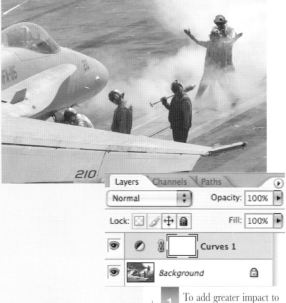

1 To add greater impact to the final image, we're going to start by darkening the overall tone. Not only will this provide for a more dramatic scene but it will also offer a better platform for the light we create. Add a *Curves* adjustment layer to the *Background* layer. Using an adjustment layer enables you to change the level of brightness later in relation to the additional lighting effects.

2 Create a curve similar to the one shown, to provide a general darkening to the whole image.

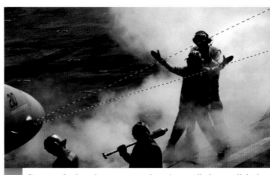

3 Create a feathered selection defining a beam of light emanating from the landing light near the nose of the aircraft. This type of aircraft doesn't actually have a light in the position I have chosen, but a certain amount of creative license needs to be used for the benefit of the image.

4 Activate the *Background* layer and press Ctrl (Cmd) + J to copy and paste the selection to a new layer.

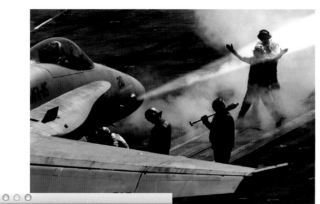

5 Drag the layer to the top of the *Layers* palette, then rename it *Beam* and change the layer blending mode to *Screen*.

6 At the farthest point from the source of the light, the beam appears too white and washed out. We need to create the illusion of the light punching through some areas of the smoke. Add a layer mask to the *Beam* layer and use black to paint out some random areas on the mask.

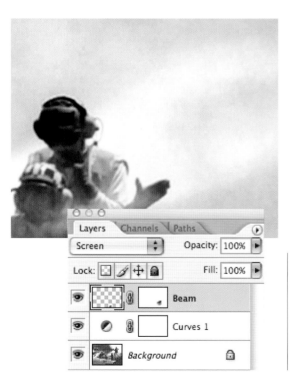

7 The light needs a bright point of source to add realism. This is a good opportunity for the *Lens Flare* filter. Create a new black-filled layer called *Light source*, positioned at the top of the *Layers* palette.

8 Go to *Filter > Render > **Lens Flare***, and apply the settings as shown.

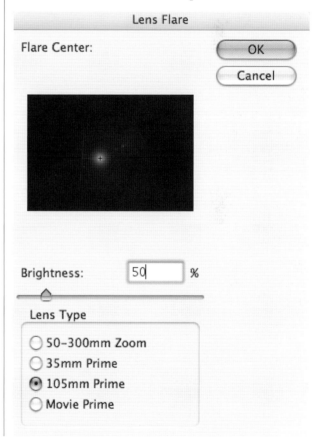

9 Change the layer blending mode to *Screen*. This lets only the flare be seen, and not the black area.

10 Now position the flare at the start of the light beam.

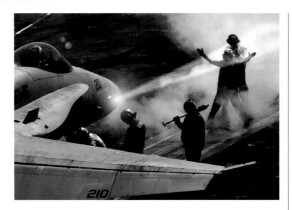

11 The light shining through the smoke effect is complete, but some further effects typically found in this sort of environment will really make the image stand out. We're going to switch on the starboard wing navigation light. Create a new black-filled layer called *Starboard* at the top of the *Layers* palette, and set the blend mode to *Screen* as you did in step 9.

12 Go to *Filter > Render > Lens Flare*, and apply the same settings as in step 8. To change the color, go to *Image > Adjustments > Hue/Saturation* and apply the settings in the example to achieve a green color.

13 Position the lens flare over the navigation light of the wing.

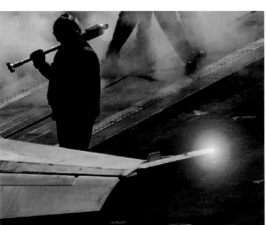

14 Any source of light will have an effect on the ambient light conditions in the area. We would expect to see a green glow on the ground immediately below the light and on some of the wing. Create a feathered selection on the ground below the light.

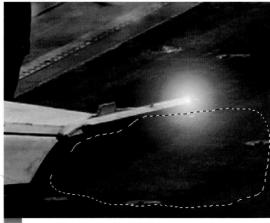

15 Activate the *Background* layer and press Ctrl (Cmd) + J to copy the selection to a new layer.

16 Rename the layer *Ground glow*.

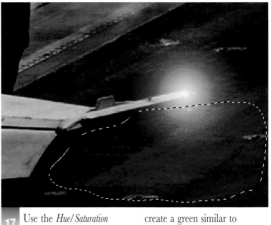

17 Use the *Hue/Saturation* command again to create a green similar to the navigation light.

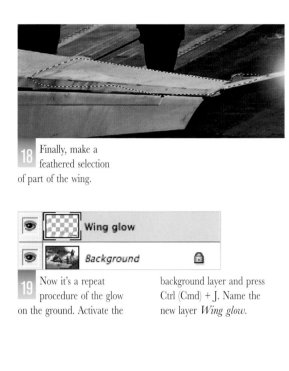

18 Finally, make a feathered selection of part of the wing.

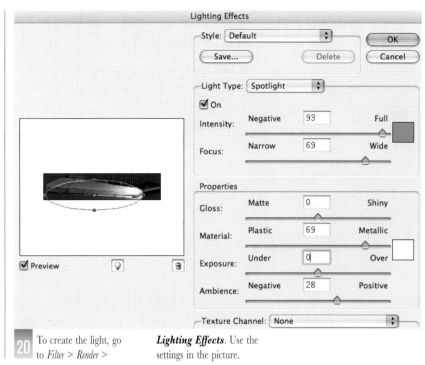

19 Now it's a repeat procedure of the glow on the ground. Activate the background layer and press Ctrl (Cmd) + J. Name the new layer *Wing glow*.

20 To create the light, go to *Filter > Render >* **Lighting Effects**. Use the settings in the picture.

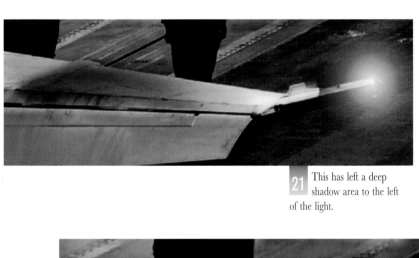

21 This has left a deep shadow area to the left of the light.

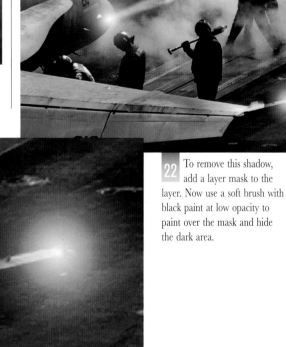

22 To remove this shadow, add a layer mask to the layer. Now use a soft brush with black paint at low opacity to paint over the mask and hide the dark area.

CREATING FILTERED LIGHT THROUGH DUST

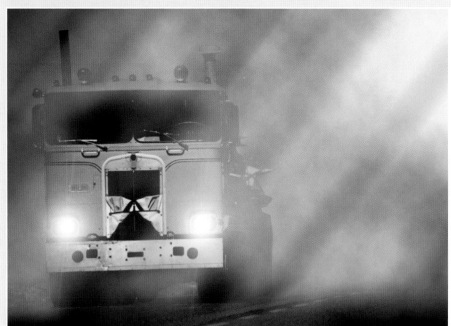

The image of the truck I am using for this effect provides plenty of scope for a dramatic picture. We can create the illusion of the truck throwing up clouds of billowing dust in its wake as strong evening sunlight is filtered randomly through the cloud. The composition of the original image is equally as important as the finished effect. In this example, the truck's placement within the image enables a broad area to the right to be used for the dust, making the dust cloud an integral part of the image rather than just some simple embellishment.

Dust, in a similar way to smoke, is composed of myriad tiny particles, each particle being light enough to be suspended in the air before slowly falling back to earth. Rarely does the density of a dust cloud form a solid uniform mass. Typically, random patches of dense dust are interspersed with more sparsely distributed particles. This phenomenon gives rise to some dramatic effects when strong directional light is applied to a dust cloud, resulting in the characteristic filtered effect as light falls on areas of different density. Where the dust is dense, light is completely or partially blocked, while in less packed areas light penetrates unhindered, revealing strong stripes or beams of light. Therefore to create this effect with any degree of photographic realism, we need to avoid uniformity at all costs.

1 We need to start by isolating the truck and placing it on its own layer. Use whichever tools you are most comfortable with to make a selection of the truck. There's not much color uniformity in this image, but the contrast between the truck and the background is reasonable, so the *Magnetic Lasso* will provide a good staring point. Alternatively, use the *Extract* command or *Pen* tool for most accuracy. With the selection completed, go to *Layer > New > **Layer via Copy*** or press Ctrl (Cmd) + J. This copies and pastes the selected artwork to a new layer. Name this layer *Truck*. To create more dramatic contrast between the truck and the dust and suggest

evening light, we need to darken both the *Background* and *Truck* layers by the same degree. Add a *Levels* adjustment layer to both the *Background* and *Truck* layers. Using adjustment layers enables you to fine-tune the level of brightness at a later stage within the context of the finished image. In the *Levels* dialog box, drag the black input slider to the right in both of the adjustment layers.

2 Here's how your *Layers* palette should be looking with 2 *Levels* adjustment layers applied.

3 We're now ready to make some dust. Create a new layer named *Dust* and position it below the *Truck* layer.

4 Set the foreground and background colors to two contrasting colors that reflect the sandy tones of a desert road. I am using R244, G224 B165 for the foreground, and R59, G55, B38 for the background color. Make sure the *Dust* layer is active and go to *Filter > Render > Clouds*.

Ideally we need a good random spread of light and dark areas. If you are not happy with the effect, just keep pressing Ctrl (Cmd) + F. This will keep reapplying the clouds in a different random configuration each time. When you are happy with the result, set the layer *Opacity* to 80%.

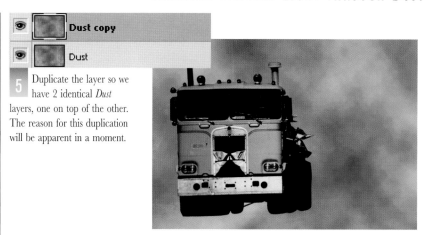

5 Duplicate the layer so we have 2 identical *Dust* layers, one on top of the other. The reason for this duplication will be apparent in a moment.

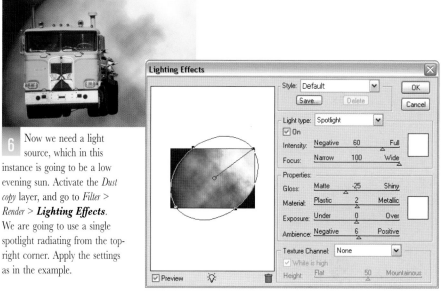

6 Now we need a light source, which in this instance is going to be a low evening sun. Activate the *Dust copy* layer, and go to *Filter > Render > Lighting Effects*. We are going to use a single spotlight radiating from the top-right corner. Apply the settings as in the example.

7 The lighting filter has left us with black areas on the *Dust copy* layer in the bottom-right and top-left corners. These areas will ruin the final effect, so we are going to get rid of them

first. This was the reason for duplicating the *Dust* layer. Apply a layer mask to the duplicated *Dust copy* layer, then paint on the mask in black until all the black areas have been hidden.

8 Once the corners have been painted out, merge the 2 dust layers together, using Ctrl (Cmd) + E. Duplicate the newly merged *Dust* layer and drag the duplicate layer to the top of the *Layers* palette. Make sure it is right at the top, above the *Levels* adjustment layer.

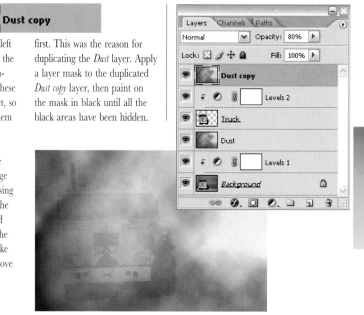

Dust copy

9 This *Dust copy* layer partially obscures the truck, so we need to reveal parts of it in such a way as to create the illusion of the dust cloud being generated from the rear and sides of the vehicle with just a little scattered around the front. Add a layer mask to the *Dust copy* layer, then paint on the mask with black, using a very low *Opacity* setting for the brush until the front of the truck starts to show through. You will need to use some creative license here, switching between black and white paint to reveal or hide the layer until the right degree of subtlety is achieved.

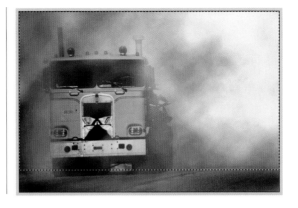

12 Make a rectangular feathered selection that goes from the top of the document to the horizon.

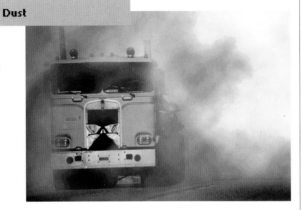

Dust

10 Add a layer mask to the original *Dust* layer too, and in the same way as before paint away some of the dust effect from the road area in front of the truck.

13 Make sure the *Sun* layer is active, then drag a linear gradient diagonally from top-left to bottom-right at about a 45° angle. If you are not happy with the spread of the gradient, keep dragging until you get the look that you want.

Gradient Editor

Presets

OK
Cancel
Load...
Save...

Name: Custom New

Gradient Type: Solid

Smoothness: 100 ▸ %

Stops

Opacity: ▸ % Location: % Delete

Color: ▸ Location: % Delete

11 To create the streaks of filtered sunlight, make a new layer called *Sun* and position it below the *Truck* layer. Create a gradient similar to the one in the example using black and white. More instances of black and white results in more beams of light. Tightly packed black and white markers will create thinner beams with greater contrast.

Layers Channels Paths

Darken Opacity: 100% ▸

Lock: ☒ ✎ ✛ ⊞ Fill: 100% ▸

👁 Dust copy

👁 Levels 2

👁 Truck

👁 Sun

👁 Dust

👁 Levels 1

👁 Background

14 Set the *Sun* layer's blending mode to *Darken*.

15 To add a finishing touch, and reflect the fact that the sun is going down, we are going to turn on the headlights. Create a new layer called *Headlights* at the top of the layer stack and fill it with black. Go to *Filter > Render > Lens Flare*, and use the settings as in the example.

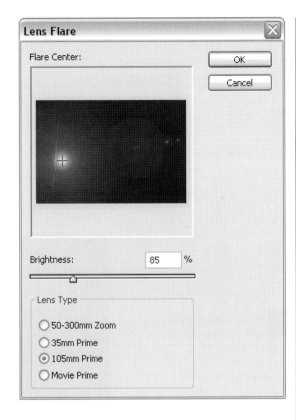

17 The lens flare has the effect of brightening the whole layer, though, which impacts negatively on the rest of the image. All we really want is the immediate burst of light from the headlight. Double-click the *Headlights* layer to reveal the *Layer Options* dialog box. At the bottom of the dialog box are the channel blending range mixers. We are going to use these to reduce the radiance of the lens flare. The *Blend If* field should be set to *Gray*. Working with the top row of range sliders and the left-hand pair, press and hold down the Alt key and then click and drag the right half of the pair to the right as in the example. The farther to the right you drag, the smaller the expanse of light from the lens flare becomes.

16 Set the layer blending mode of the *Headlights* layer to *Screen*. This removes the black areas of the layer, revealing only the headlights.

18 For the second headlight, duplicate the *Headlights* layer and drag the second light into position over the truck headlight.

19 If necessary, you may want to use the 2 *Levels* adjustments layers that are linked to the *Background* and *Truck* layers to fine-tune the brightness level now that you can see the finished image in its full context with the sunlight and headlights.

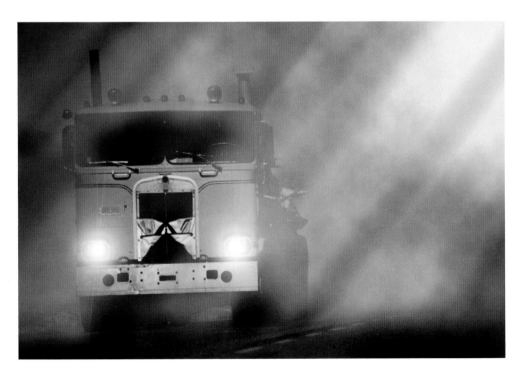

CREATING FIRE

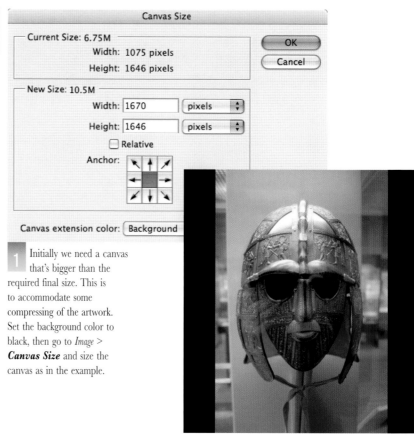

Initially we need a canvas
that's bigger than the
required final size. This is
to accommodate some
compressing of the artwork.
Set the background color to
black, then go to *Image >*
Canvas Size and size the
canvas as in the example.

Creating fire in Photoshop can
be as satisfying as it probably
was when man (or woman)
created real fire for the very first
time. The shapeless, random, and
ever-changing form of fire makes
it a challenging task for even the
most accomplished of Photoshop
users. Not only must we create
the entity of fire itself, but also its
inevitable generation of light as
it paints the objects around it.

Make a selection of
the mask and save it
for later use.

Inverse the selection and
fill the canvas with black
before deselecting.

4 Now to create the fire: make a selection that covers the full width of the canvas but only 532 pixels in height. Position it at the bottom of the canvas.

5 Make a new layer called *Fire*.

6 Set up the foreground color with red R232 G44 B0 and the background color with yellow R255 G222 B3.

7 Go to *Filter* > *Render* > **Clouds**.

8 The *Clouds* filter works quite well as fire, but we need it to be a bit more streaky.

Go to *Filter* > *Render* > **Difference Clouds**.

9 Press Ctrl (Cmd) + F. This will reapply the *Difference Clouds* filter, each time inverting the colors and applying a different random configuration. Keep doing this until you achieve a bold red/yellow pattern with fairly strong streaks. It may require around 10 repetitions or more.

10 Deselect and press Ctrl (Cmd) + T to bring up the *Transform* bounding box. Drag the top-middle handle of the bounding box to the top of the canvas.

11 Now drag the bounding box's right handle to the left, and the left handle to the right, without revealing the mask picture beneath. The final width of the fire needs to be around 1275 pixels and roughly in the center of the canvas. Press the Enter (Return) key to confirm the transformation.

12 The red is too strong and flat and we need to create some breaks in the flames in order to see through them. Go to *Select* > **Color Range**.

Select *Shadows* from the drop-down box. This selects all the shadow areas, which picks up all the red.

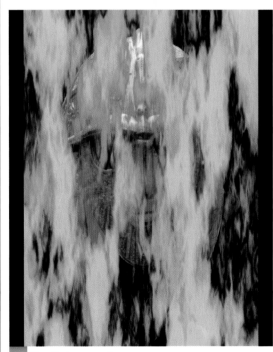

13 Press Backspace on the keyboard to delete the red areas.

14 I want the flames to appear to mingle and dance around the image of the metal mask, so we need to cut it out from the background. Load the mask that you saved earlier. I've hidden the *Fire* layer so as not to complicate the image.

18 To help avoid any repeated patterns from appearing, go to *Edit > Transform > Flip Horizontal* and drag the artwork down about 100 pixels.

15 With the *Background* layer active, press Ctrl (Cmd) + J to copy and paste the selection to a new layer. Name the new layer *Metal Mask*.

16 Drag the *Metal Mask* layer above the revealed *Fire* layer.

17 Duplicate the *Fire* layer and drag the duplicate above the *Metal Mask* layer.

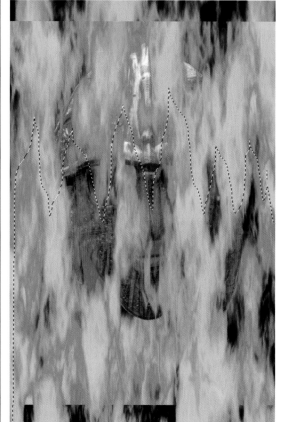

19 This has revealed a straight edge at the top of the canvas. With the *Lasso* tool, make a feathered selection describing some tapered flame shapes. Use a 15 pixel feather for high resolution files.

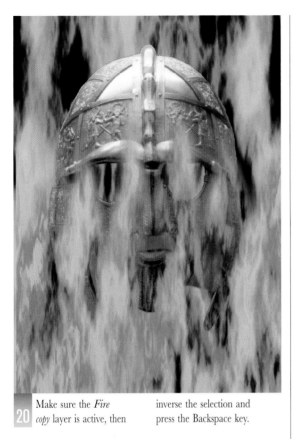

20 Make sure the *Fire copy* layer is active, then inverse the selection and press the Backspace key.

21 What gives the game away is the fact that the metal should be reflecting the color of the surrounding flames. We can use a quick and easy method to fix this. Duplicate one of the fire layers, naming the duplicate *Mask color*. Position this layer between the *Metal Mask* layer and the *Fire copy* layer.

22 Load the *Mask* selection that you saved earlier.

23 With the *Mask Color* layer active, inverse the selection and press Backspace. You won't see too much difference here, as we have only deleted the area around the outside of the metal mask. Change the layer blending mode to *Overlay* to create the effect of the metal reflecting the flames.

24 As a finishing touch, use a *Color Balance* adjustment layer to add some yellow to the highlights of one or all of the fire layers. This helps break up any uniformity of color and adds to the realism.

CREATING SILHOUETTES

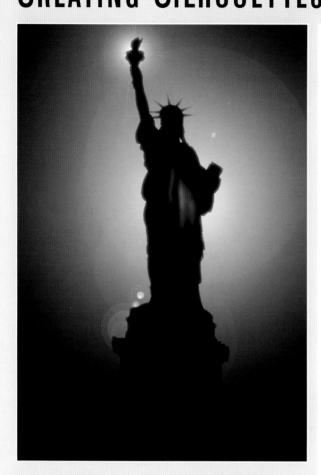

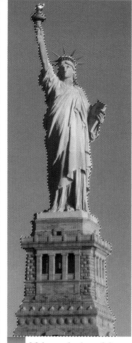

1 Make a selection of the blue sky. We actually need a selection of the statue, but it's much easier to select the sky. Inverse the selection once made.

2 Press Ctrl (Cmd) + J to copy and paste the selection to a new layer. Name the layer *Statue*.

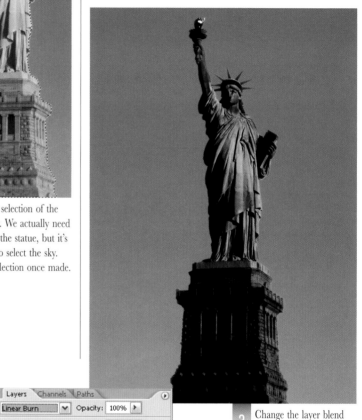

3 Change the layer blend mode to *Linear Burn* to darken the statue.

4 Although the statue is darker, it's not dark enough to qualify as a silhouette. Add a *Curves* adjustment layer that's clipped to the *Statue* layer.

It may be fair to say that many silhouette images are taken purely by accident, often when anything but a silhouette is desired. Strong backlighting and insufficient light on the subject, or setting the exposure for the wrong part of the image, can all result in an inadvertent silhouette.

However, if you do want to create a silhouette and it's based on an existing image, it could be very simple: just put a black cutout over the object and technically that's a silhouette. But it would also be very flat and boring, resembling a lifeless cardboard cutout with little artistic merit. Photographically, what makes a much more interesting silhouette is when a fraction of light is illuminating the subject, not really showing any detail, but enough to suggest we are looking at a 3-D form and not a flat 2-D cut-out.

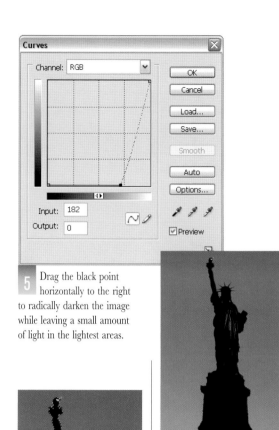

5 Drag the black point horizontally to the right to radically darken the image while leaving a small amount of light in the lightest areas.

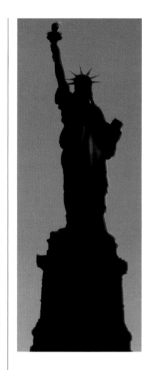

6 The extreme curves setting has resulted in some unflattering harshness and rough texture, but we can easily blur this away. Press Ctrl (Cmd) and click the *Statue* layer to load its selection, then inverse it so that the statue is the selected part of the layer.

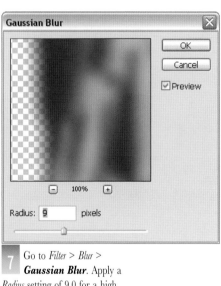

7 Go to *Filter > Blur > **Gaussian Blur**. Apply a *Radius* setting of 9.0 for a high resolution file, and lower for a low resolution file.

8 Loading the selection before blurring meant the *Gaussian Blur* did not extend beyond the limits of the selection, so the statue is left with a well-defined edge with all the softening being applied to the inner of the statue where it is meant to be. The light areas now suggest a soft shaft of light falling on the statue.

9 Our present blue background would not generate a silhouette of this kind as its intensity is not great enough. Create a new black filled layer below the *Statue* layer, and call it *Light*, then set its blend mode to *Screen*.

10 Go to *Filter > Render > **Lens Flare**. Apply the setting shown and click *OK*.

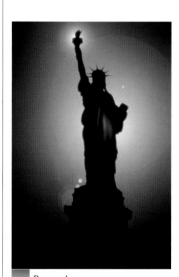

11 Repeat the process a second time to apply a second lens flare at 90% brightness and toward the top of the preview window to complete the effect.

CASTING STAGE LIGHTING

It may be argued that the lighting for any concert or stage production is almost as important as the stage event itself. Just visit an afternoon rehearsal session to witness the difference that a full blown lighting setup makes to the impact of the overall performance. We are going to use just that scenario to turn a rehearsal session into the big night complete with laser show.

1 The ambient light pictured here is typical of a rehearsal session, so we need to darken the whole scene in such a way that it enables us to adjust the final lighting later, after the effects have been applied.

2 Add a *Curves* adjustment layer and create a curve as shown to darken the whole image.

3 Duplicate the *Background* layer and drag the copy above the *Curves* layer.

4 The duplicate layer will be used to place some footlights along the front of the stage. Go to *Filter > Render > Lighting Effects*. Select *Five Lights Up* from the *Style* drop-down box, and apply the other settings as shown. Position each light so that the source is just above the bottom edge of the window.

5 The lights have created the right effect for footlights, but the rest of the image is now underexposed. Change the layer blend mode to *Screen* to reduce the visibility of the black.

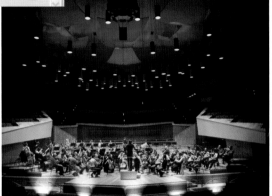

6 One of the problems with the *Lighting Effects* filter is the inability to adjust the lights once they have been applied, but we can easily overcome that problem by using adjustment layers. Add a *Levels* adjustment layer that is clipped to the *Background copy* layer.

7 Apply a setting similar to the one shown to darken the image still further. The white and gray points can be adjusted to increase or decrease the strength of the footlights as desired.

8 Now to create the spotlights: create a black-filled layer, naming the layer *Spot 1*.

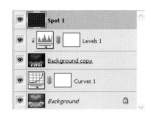

9 Go to *Filter > Render > Lens Flare*. Click in the bottom-left quarter of the preview window and use the other settings as shown.

10 Set the layer blend mode to *Screen* to hide the black area.

11 To save any repetition, we can make more lights by duplicating. Duplicate *Spot 1* and position it to the right of the original spot.

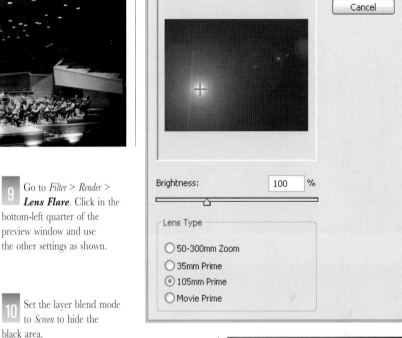

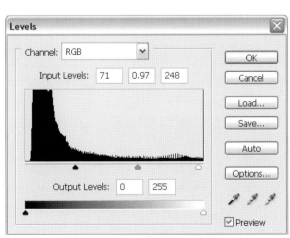

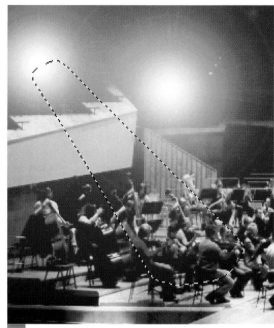

12 Stage lights are typically different colors, so we are going to tint the spotlights. Select the original *Spot 1* layer and go to *Image > Adjustments > Hue/Saturation*. Apply the settings, making sure that the *Colorize* checkbox is enabled.

15 Make a feathered selection describing the shape of the beam of light from the first spotlight.

13 Do the same with the duplicated spotlight layer, applying a different color this time.

16 Using the *Eyedropper*, sample a color from the area of the spotlight.

17 Drag a linear gradient through the selection, using *Foreground to Transparent* colors, then deselect.

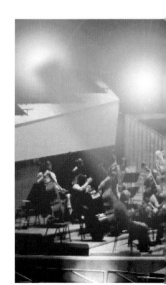

14 For greater impact, we can make a beam of light that emanates from the spotlights. Create a layer called *Beam 1* above the *Spot 1* layer.

20 Repeat the same process until you have the desired amount of lights. The layers that contain the 2 spotlights shining on the conductor are set to the *Lighten* blend mode rather than *Screen*, as this mode generates less ambient light and prevents the scene becoming overly bright.

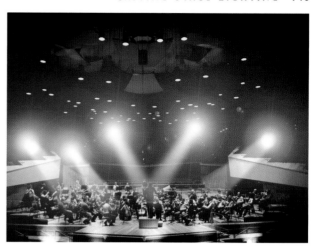

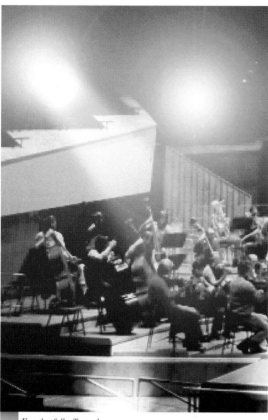

18 For the full effect, change the layer blend mode to *Linear Dodge*.

21 Smoke and atmospheric dust are particularly visible when caught in the light of a strong, vertical down-pointing beam. The result commonly manifests as a sharply defined outer edge to the light beam with a radically faded inner core. As well as being an interesting characteristic of light, this effect will add a subtle variation to our developing image. Create a new layer called *Downlight* at the top of the *Layers* palette.

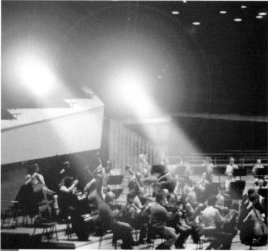

19 Repeat steps 14 to 18 to create a similar beam for the other spotlight.

22 Create a feathered selection outlining the beam of light as if emanating from one of the ceiling lights. I'm using a pixel feather of 10 in my high resolution file.

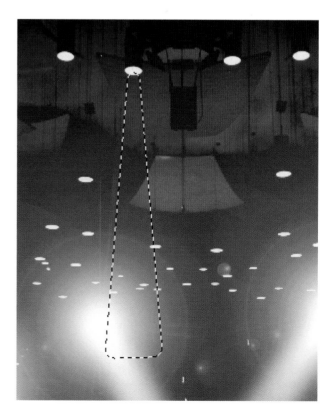

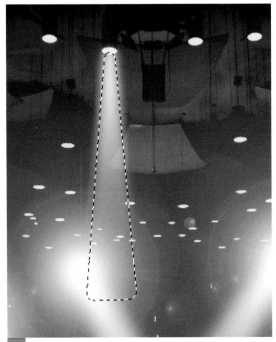

23 Drag a *White to Transparent* linear gradient through the selection.

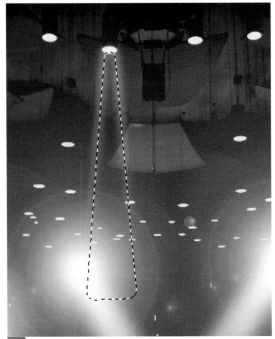

24 Delete the gradient you just applied, but leave the selection. Because of the high feather setting, a soft fringe of pixels has been left behind.

25 Using a different pale color, drag a *Foreground to Transparent* gradient through the selection, but drag only one quarter of the way through the selection.

26 Duplicate this layer and position the duplicate under one of the other ceiling lights.

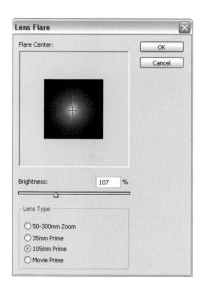

29 Apply the *Lens Flare* filter, using *105mm Prime* set to 107%.

30 Press Ctrl (Cmd) + T to bring up the *Transform* bounding box, and scale the rectangle vertically and horizontally, resulting in a long thin rectangle.

31 Change the layer blend mode to *Linear Dodge*.

32 Using *Levels*, increase the contrast significantly. This will make the laser more radiant. The black will visually diminish as the layer is in *Linear Dodge* mode.

33 The most dominant characteristic of laser light is its high radiance and intense color. This final step will provide that visual burst of energy. Use *Hue/Saturation* to select a bold color with a high saturation setting. Make sure that *Colorize* is enabled.

27 No concert would be complete without a laser light show, and Photoshop is very adept at creating highly convincing lasers. On a new layer, create a rectangular selection approximately 400 pixels square.

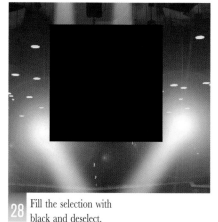

28 Fill the selection with black and deselect.

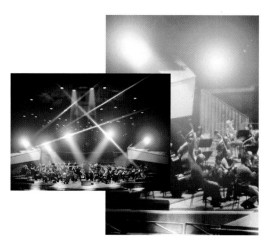

34 In the final step I have duplicated, rotated, scaled, and recolored the original laser. What really adds to the realism is the fact that real laser light will appear to merge and smudge when lights cross over each other, and this exact effect has been achieved through the use of the *Linear Dodge* layer blend mode.

CREATING GLASS AND REFRACTION

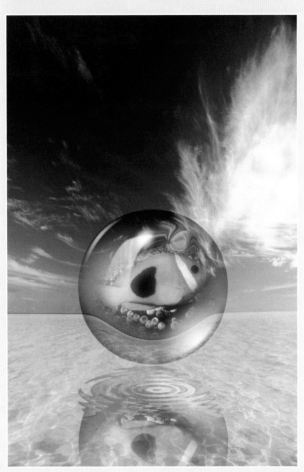

1 Make a circular selection defining the outline of the glass sphere.

2 Press Ctrl (Cmd) + J to copy the selection a new layer. Name the layer *Distort*.

The way light refracts or bends through glass is an art form in itself. The wild, seemingly chaotic contortions of objects as their image is weaved through a glass shape seem to eclipse the imagination of even the most creative of abstract artists. Our task here is not only to distort the environment through a glass sphere, but actually to create the glass sphere itself.

3 A popular method of distorting an image to simulate light refraction in glass is to use the *Spherize* filter. Although this gives acceptable results, it can result in blurring and too much degradation of the image. An alternative that we are going to use is the *Liquify* filter. While achieving similar results, the *Liquify* filter offers far greater control and a wider variety of distortions. Go to *Filter > **Liquify***. Use the *Bloat* tool to create a similar distortion to the one shown.

4 Now use the *Forward Warp* tool and distort just one element of the clouds to a rounded point. This will help with the illusion of the clouds bending to conform to the shape of the glass sphere.

5 Finally, use the *Mirror* tool to increase the mass of the clouds and click *OK*.

6 The thing that defines a glass sphere to the viewer is a faint shadow around the perimeter. This needs to be subtle to avoid it looking like an outline. Click the *Layer Style* icon at the bottom of the *Layers* palette and select *Inner Shadow*.

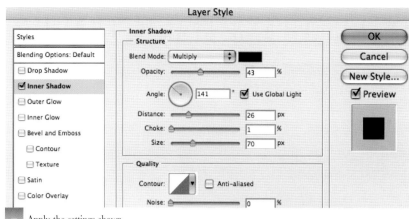

7 Apply the settings shown.

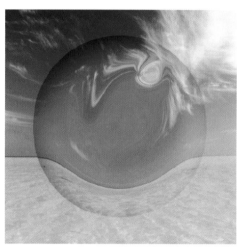

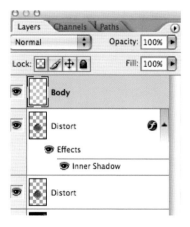

8 The shape already has a kind of bubble appearance, but a glass sphere would have a little more substance. Create a layer called *Body*.

9 Press Ctrl (Cmd) and click the *Distort* layer to load its selection.

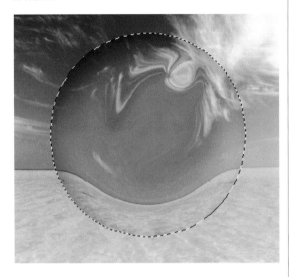

12 The shape is too dull to be highly polished glass, so we are going to add some highlights. On a new layer called *Left Highlight*, create a feathered selection that outlines a highlight area.

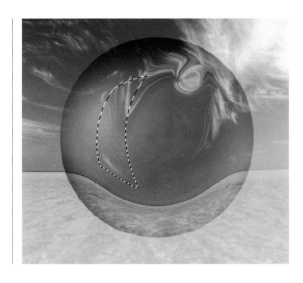

13 Drag a *White to Transparent* radial gradient halfway through the selection from top to middle.

10 Drag a *White to Black* radial gradient through the selection, then deselect.

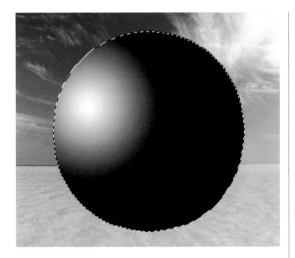

11 Change the layer blend mode to *Soft Light* and reduce the layer *Opacity* to 63%. This creates a more tangible object, and the visual strength can be controlled to taste.

14 On a new layer called *Airbrush*, add a burst of white with the *Airbrush* tool to create a specular highlight over the gradient.

18 The image has quite a surreal feel, but we'll go one step farther and put a fish in the glass to finish. Add a fish image to the document, positioning the layer between the *Body* layer and the *Distort* layer.

19 Add a layer mask to the *Fish* layer.

15 A similar highlight is needed for the bottom-right area. Make a feathered, crescent-shaped selection, leaving a gap of a few pixels between the selection and the outer edge of the glass.

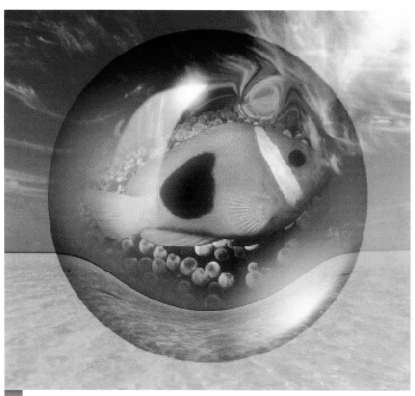

16 Drag a *White to Transparent* radial gradient a short distance to reveal a soft burst of white light.

17 Repeat the process to create another small eclipse of white in the top-left corner of the glass.

20 Using black paint, paint on the mask to subtly hide the rectangle edges so we see mainly the fish and some of the coral fading away.

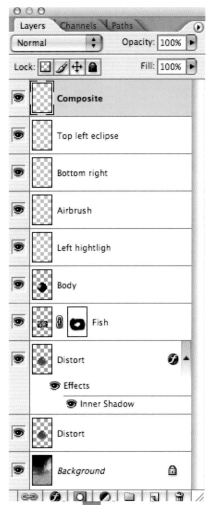

21 To help unify the whole image, we'll create a reflection and some ripples in the water just below the glass to suggest it is just bouncing along the surface. We need to make a composite layer from all the layers that make up the fish and glass. Hide the *Background* layer and create a new layer at the top of the palette, called *Composite*.

23 We now have a copy of the fish in a glass ball. Flip the copy vertically, using *Edit > Transform > **Flip Vertical***, and position it in the water.

22 Press Ctrl (Cmd) + Alt + Shift + E. This copies all visible layers and pastes them as one *Composite* layer into the layer at the top of the palette. It's now OK to reveal the *Background* layer.

24 Reduce the layer *Opacity* to about 62% and add a layer mask.

25 Drag a *Black to White* gradient on the mask to hide the bottom portion of the fish reflection. This looks more realistic as water reflections fade away as the object moves farther away from the water surface.

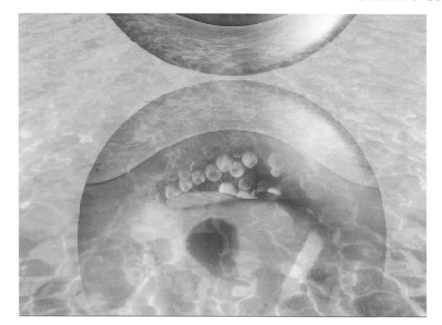

26 We are going to apply a ripple effect to both the water and the reflection at the same time. Reposition the *Composite* layer so it sits above the *Background* layer and press Ctrl (Cmd) + E to merge the two layers together.

27 Make a feathered selection outlining the perimeter of the water ripples.

28 Go to *Filter > Distort > ZigZag* and apply the settings displayed.

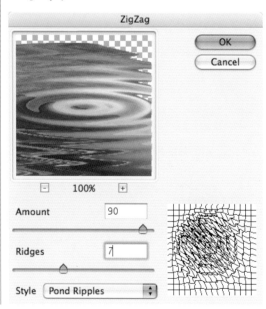

SIMULATING THE EFFECTS OF LIGHT UNDERWATER

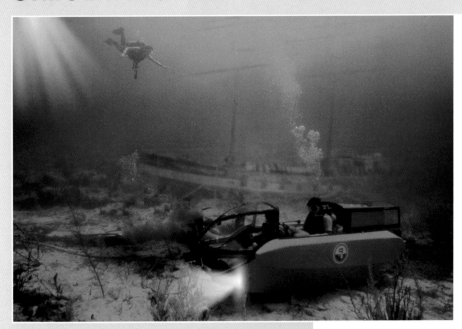

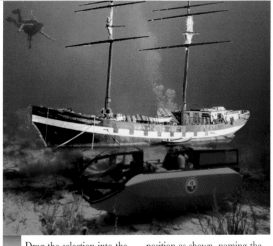

2 Drag the selection into the underwater image and position as shown, naming the layer *Ship*.

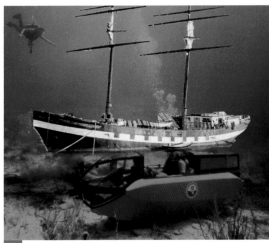

3 You can probably see that a fair degree of work is required to make this ship look like an aging underwater wreck. The first casualty will be most of the color and the sunlight. Go to *Image > Adjustments > **Desaturate***.

The different wavelengths of light are absorbed differently depending on the depth of water. Red wavelengths are absorbed first, followed by green and lastly blue. This accounts for the predominant blue cast at greater depths underwater. Underwater photographers need to introduce artificial light at all but the shallowest depths if they are to capture the vivid colors that adorn marine flora and fauna.

In this section, we are going to create an image of an old ship wreck, simulating how its true color would be affected by the diminished light underwater. We'll also create some artificial light to reawaken some color in some coral.

1 Make a selection of the ship. You can ignore the rigging, as it's safe to assume this would not have survived many years on the ocean floor.

Gaussian Blur

Radius: 3.0 pixels

4 The crisp clarity of the ship is also a giveaway, so we need to apply a little judicial blurring. Go to *Filter > Blur >*

Gaussian Blur and apply a *Radius* setting of 3.0 for a high resolution file.

5 To destroy clarity further, reduce the layer *Opacity* to 55%.

6 The ship is beginning to look a little more at home, but a very well-known characteristic of underwater visibility is how objects appear to fade out the farther they are from the eye. This ship has equal visibility from bow

to stern, making it stand out too much. A layer mask will give us complete control over the visibility and apparent distance of the ship. Press Ctrl (Cmd) + click the *Ship* layer to load its selection.

7 Now go to *Layer > Add Layer Mask >* **Reveal Selection**.

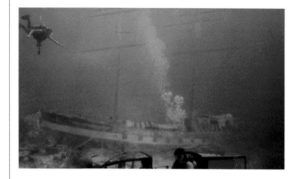

8 Now it's time to get creative with the paintbrush. Use a large, soft-edged brush at very low opacity. Using black, paint on the mask to reduce the ship's visibility at different intensities. The rear of the ship should be less visible than the front. The relative clarity of the divers also helps to strengthen the illusion that the ship is farther away from the camera.

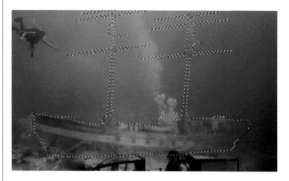

9 To unify the whole image, we are going to add a general color cast from the surrounding water. Load the ship's selection once again—Ctrl (Cmd) + clicking the ship thumbnail in the *Layers* palette.

10 Use the *Eyedropper* to select a middle tone blue. I have used R0 G99 B159.

11 Create a new layer called *Color cast*.

 Fill the selection with the sampled color and change the layer blend mode to *Pin Light*. The effect is subtle, but adds considerably to the realism.

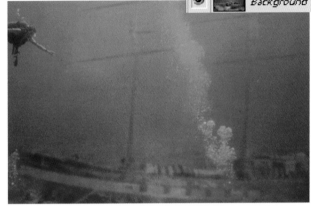

13 The blue tone of underwater images can often appear monotonous, so we'll introduce some relief. The fall-off of light as the water depth increases is usually perceptible in wide-angle images such as this one. This effect can be visually appealing and provide a harmonious range of blues to lift the scene. Create a new layer called *Light fall off*.

14 Choose a strong turquoise color for the foreground color; R7 G180 B196 works well. Set up the *Gradient* tool with the *Foreground to Transparent* linear option, and drag from the top of the screen to about one quarter of the way down.

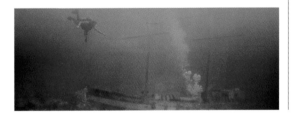

15 To make the gradient appear more radiant, change the layer blend mode to *Linear Light*.

16 Rays from the sun, or any other large light source, can add dynamism to an image. The top-left corner of the image is a perfect background for some light rays. Create a new layer called *Beam*.

17 Create a feathered selection describing a beam of light.

18 Using a pale blue/white color, drag a *Foreground to Transparent* linear gradient through the selection, then deselect.

19 Duplicate the *Beam* layer.

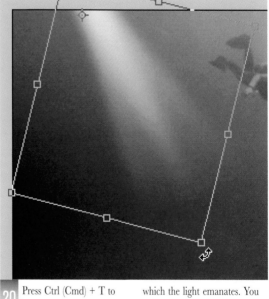

20 Press Ctrl (Cmd) + T to bring up the *Transform* bounding box, and change the point of origin to the point from which the light emanates. You can now rotate the selection clockwise to create a fanning out effect.

21 Change the layer *Opacity* to 65%.

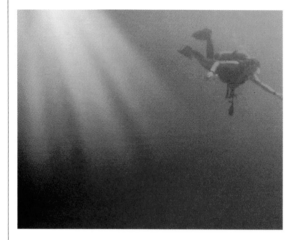

22 Repeat this process, duplicating the last layer, rotating it from the new point of origin, and repositioning it if necessary to create a fan effect. Keep the layer *Opacity* at 100% until you have completed the sequence.

23 Now you can experiment with different opacity and layer blend modes for each of the beam layers. I changed the *Opacity* of just one layer to 65% and changed the blend mode of another to *Overlay*. This accounts for the nonuniform effect, which would be typical of light being filtered through water in this way.

27 Go to *Filter > Render > **Lens Flare*** and apply the settings as shown.

Lens Flare

Flare Center:

OK

Cancel

Brightness: 80 %

Lens Type
- ○ 50-300mm Zoom
- ○ 35mm Prime
- ● 105mm Prime
- ○ Movie Prime

24 Artificial sources of light are critical for underwater photography, not only in terms of seeing but also to bring out the colors that don't appear at depth such as reds. We'll create a light source from the mini-sub to illuminate some coral. Create a new layer called *Sub light* and draw a feathered selection describing the shape of the cast light.

28 Press Ctrl (Cmd) + T to bring up the bounding box, and scale the layer non-proportionately so it is flattened in the vertical plane. This removes the roundness of the flare and gives the illusion that the light source is being viewed side on. The example picture's layer mode is *Normal*, so you can see the bounding box around the perimeter of the actual pixels.

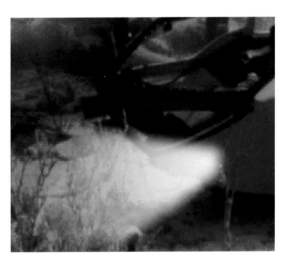

25 Drag a *White to Transparent* linear gradient through the selection.

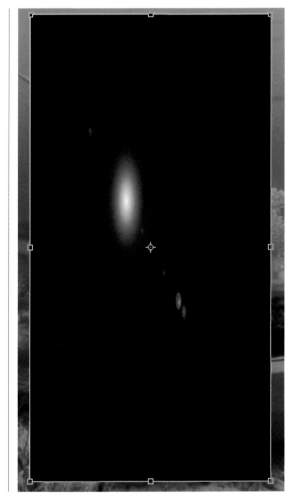

26 To make a more definite source of light for the beam, we'll add a distorted lens flare. Create a new black-filled layer called *Light source* set to *Screen* mode.

Layers Channels Paths

Screen Opacity: 100%

Lock: ☐ ✎ ✛ 🔒 Fill: 100%

👁 ■ **Light source**

👁 Beam 65%

👁 Beam 100%

👁 Beam 100%

👁 Beam 100%

29 Position the lens flare as shown.

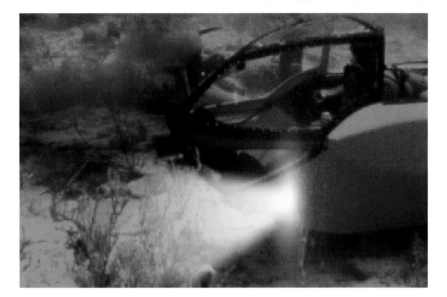

30 The underwater plant life or coral being illuminated by the light can now reveal its true colors. In this case, we'll make it red. Make a feathered selection of the plant area.

31 Activate the background layer and press Ctrl (Cmd) + J to copy and paste the selection to a new layer. Go to *Image > Adjustments > **Replace Color***. Use the *Eyedropper* tools to select just the branches of the plant, and apply the color settings as shown.

Replace Color

Selection

Color:

Fuzziness: 32

Selection Image

OK
Cancel
Load...
Save...

Preview

Replacement

Hue: -180

Saturation: -14 Result

Lightness: 0

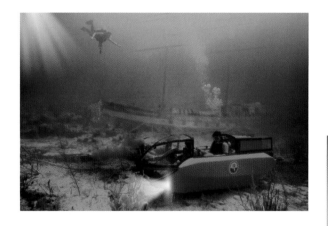

CREATING CAR LIGHT TRAILS

Moving lights captured with a slow exposure provide an infinite variety of seemingly hand drawn patterns. These "beams" of light seem almost independent from their source such as a car or aircraft. This phenomenon is due to the image of the light registering on film far quicker than the darker car, which requires either more light or a longer time exposure in order to register on film with equal intensity.

1 Although the picture was taken as the sun was setting, it needs to be darker overall to add more impact to the light trails we are going to create. Add a *Levels* adjustment layer to the *Background* layer, and darken the image a little.

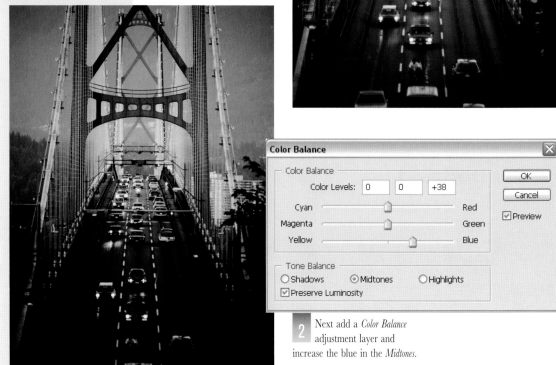

2 Next add a *Color Balance* adjustment layer and increase the blue in the *Midtones*.

3 There are a number of ways of creating light trails. One of the most realistic photographically is by using the *Pattern Stamp* tool. First make a rectangular selection of one of the car headlights.

4 Go to *Edit > Define Pattern* and give the pattern a name in the dialog box that appears.

5 Select the *Pattern Stamp* tool and choose the last pattern from the *Pattern* drop-down on the *Tool Options* bar.

6 Create a new layer called *Headlights*, positioned at the top of the *Layers* palette.

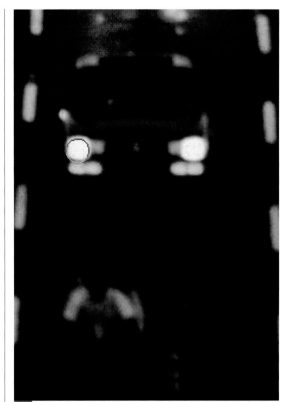

7 Using a brush size about the same size as the original headlight, click with the *Pattern Stamp* tool exactly on top of one of the car headlights.

8 Holding down the Shift key, click again a short distance below the original click.

9 Repeat the process for the other headlight.

10 Go to *Filter > Blur > **Motion Blur*** and apply the settings as shown.

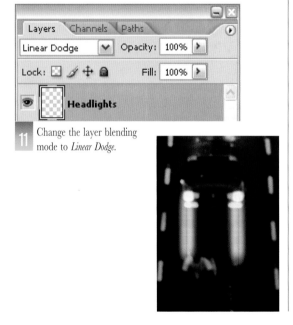

11 Change the layer blending mode to *Linear Dodge*.

12 Repeat the process for the other headlights on a separate layer.

13 An alternative method of creating light streaks is to create a custom brush. This is particularly useful when creating a streak of light in one color. We'll use this method for the rear red lights. On a new layer, create a rectangular, 3 pixel, feathered selection and fill it with bright red. Use one of the rear red lights as a guide to how big to make the selection.

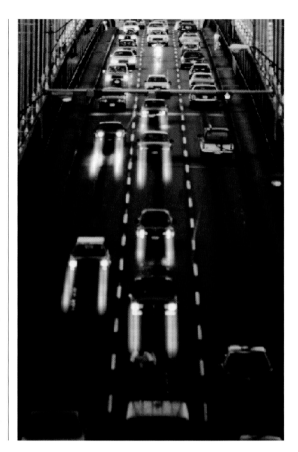

14 Go to *Edit > **Define Brush*** and type a name for the brush.

15 Delete the layer on which the brush was created, as this is no longer needed. Select the *Brush* tool and open the *Brushes* palette. The last brush in the palette is the one you just created.

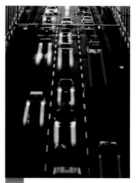

16 When traffic stops and starts during a time exposure, the light streak will have a characteristic staggered effect. To simulate this, we will adjust the brush spacing. Click the *Brush Tip Shape* option in the *Brushes* palette and set the *Spacing* to 69%.

19 Repeat the process for the other light, and apply motion blur as with the white headlight. Do the same for a few of the other cars.

21 With the *Background* layer active, press Ctrl (Cmd) + J to copy and paste the selection onto a new layer. Name the new layer *Road* and drag it to the top of the *Layers* palette.

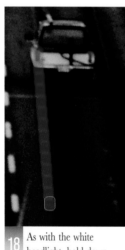

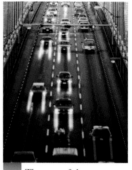

17 On a new layer, apply one click with the *Brush* tool in red. Click on top of one of the existing rear lights.

18 As with the white headlight, hold down the Shift key and click a short distance below the first click to make a connecting brush stroke.

20 The type of slow exposure needed to generate light streaks of this kind would also result in a little more light being generated in the immediate vicinity of the main focus of car lights. If the camera was not on a tripod, there could also be a little camera shake. This is normally undesirable, but in this instance a little simulated camera shake will add to the dynamism of the image and emphasize the motion of the cars. Make a selection of the road area as pictured. I've hidden the adjustment layers in order to be able to see the road more clearly.

22 Change the layer blending mode to *Linear Dodge* and reduce the *Opacity* to 80%.

23 Using the keyboard arrow key, nudge the *Road* layer down by 12 pixels for the finished effect.

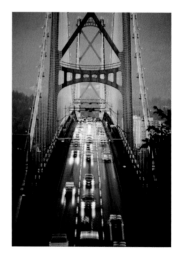

LIGHTING AND SWITCHING OFF TRAFFIC SIGNALS

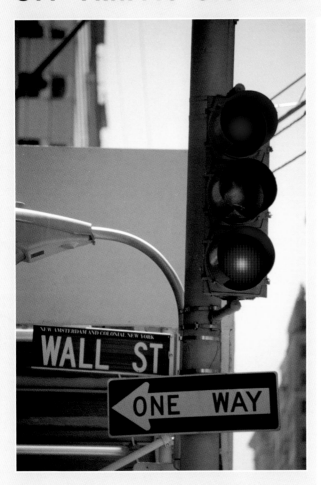

Although we are going to illuminate a traffic signal, this technique could apply equally to any kind of warning or hazard signal found on roads, airports, railroads, and other public areas. Lights of this kind are not designed to perform as a source of light to aid visibility, but rather to focus all their energy in one small point. No beam is created and, because of the intensity of the color, ambient light emission is limited.

In addition, we are going to extinguish a light that is currently switched on. This may appear as simple as slapping a black circle over it, but for the sake of realism we're going to do a more professional job.

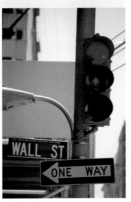

The original picture.

1 Make a circular selection of the green light area.

2 Some of the brown metal hood intersects with the circular selection, so create another selection of this element to subtract from the circle selection.

3 Create a layer called *Green Light.*

4 Using a 3-color radial gradient consisting of white, green, and dark green, drag from the center to the outside of the selection.

5 Lights such as traffic lights have a textured or grid-like surface to the glass. This texture is usually visible and is a strong characteristic of lights of this type. Creating this texture will add greatly to the realism. Make a rectangular selection of the texture in the amber light.

6 Go to *Edit > **Define Pattern*** and name the pattern *Traffic light.*

7 Activate the *Green Light* layer, and add a *Pattern Overlay* from the *Layer Style* button at the bottom of the *Layers* palette.

8 Select the last pattern from the *Pattern* dropdown box. This is the one you have just created. Apply the other settings shown.

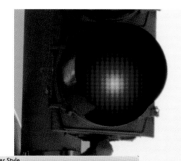

9 As the hood is made of metal, there should be a faint green glow from the light on the inside of the hood. Make a feathered selection similar to the one shown.

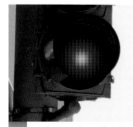

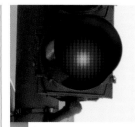

10 Create a new layer called *Glow* and fill the selection with green to match the light.

11 Now to switch the red light off: make a selection of the red area.

12 Use the *Eyedropper* to sample 2 shades from the amber light. Choose a light and a dark shade.

13 On a new layer called *Gradient*, use these colors to drag a radial gradient through the selection from the center outward.

14 To create a hint of red from the unlit light, add a *Levels* adjustment layer that is clipped to the *Gradient* layer.

15 Increase the contrast by using the settings shown.

16 Finally, some of the red glow remains around the hood from the original illuminated red light. Use the *Burn* tool set to *Highlights* to darken most the red reflection.

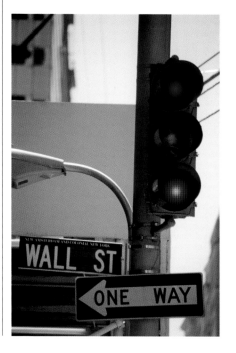

CREATING PROJECTED COMPUTER LIGHT

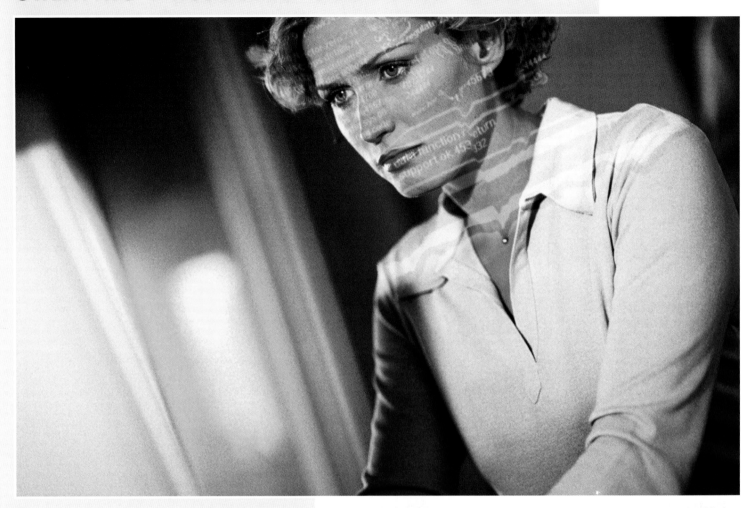

There are times when real life just doesn't live up to the expectations of film makers. Picture the scene for a moment: a computer hacker or a secret agent sits covertly at a computer terminal in a darkened room. The state secrets on the screen in front of her are tantalizingly projected onto her face. We can see the vivid text, but can't quite read it and the suspense mounts.

But it's all an illusion. No matter how dark the room or how bright the screen, the image just won't be projected onto the user's face. Does it really matter, though? It's visually a very striking effect, so let's see how it's done.

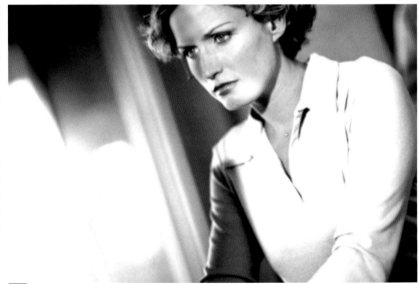

1 Duplicate the file, converting it to grayscale. The image needs to have fairly good contrast, so use *Levels* if necessary and apply a small amount of *Gaussian Blur* to soften edges. Save the file, naming it *Displacemap*, then close it.

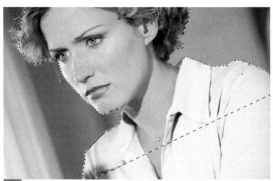

2 Make a selection of the girl's head and shoulders, and save it for later use.

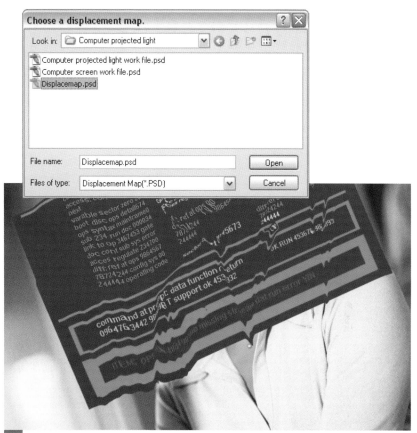

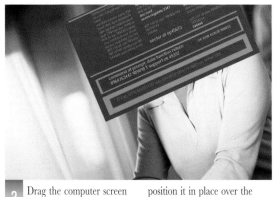

3 Drag the computer screen image into the working document, and rotate and position it in place over the girl's face and shoulders.

5 After clicking *OK*, the *Choose a displacement map* dialog box opens. Select the file called *displacemap* that you saved in step 1.

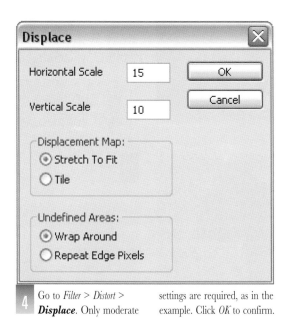

4 Go to *Filter > Distort > **Displace***. Only moderate settings are required, as in the example. Click *OK* to confirm.

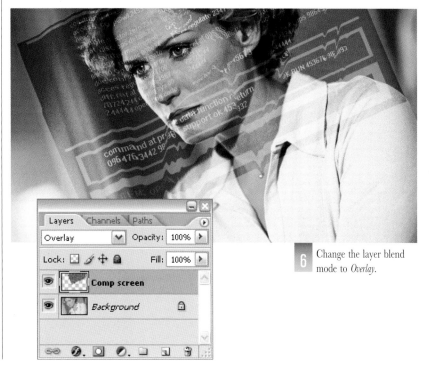

6 Change the layer blend mode to *Overlay*.

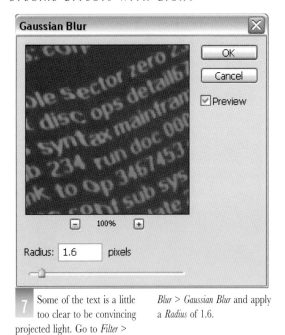

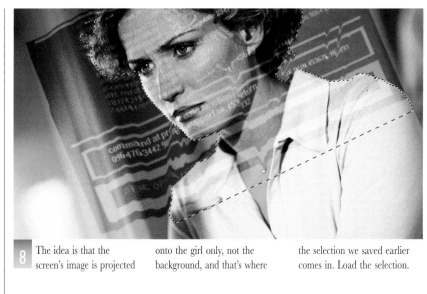

7 Some of the text is a little too clear to be convincing projected light. Go to *Filter > Blur > Gaussian Blur* and apply a *Radius* of 1.6.

8 The idea is that the screen's image is projected onto the girl only, not the background, and that's where the selection we saved earlier comes in. Load the selection.

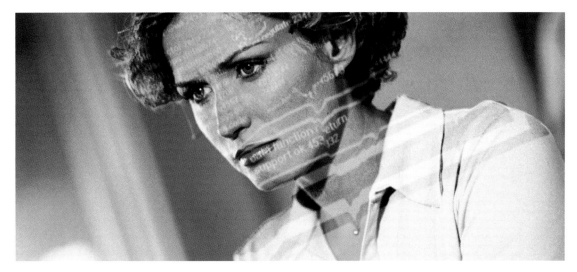

9 Inverse the selection and press Backspace to remove the outer area of the computer screen image.

10 Even though we have distorted the screen image, some areas are a bit flat and straight, but we can easily fix that with the *Liquify* tool. Go to *Filter > **Liquify***. Use the *Liquify* filter's *Warp* tool to distort some text and make the straight edge at the bottom wavy. Don't overdo it, though: we still need most of the text to be recognizable as text.

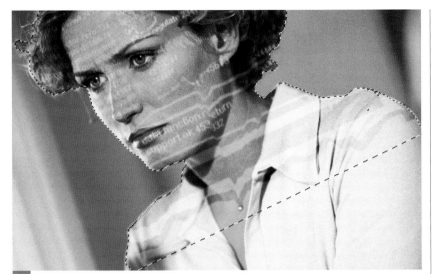

11 Any projected light would be much more obvious if the room's ambient light levels were low, so we are going to make the room darker and bluer, which will also enhance the impression of warm electronic light from the monitor. We want to affect only the room and the lower half of the girl, though. Load the selection and inverse it.

12 Create a *Curves* adjustment layer above the *Comp screen* layer. The selection is automatically made into a mask linked to the *Curves* layer. Now we can make changes to the selected area only.

13 First edit the *RGB* curve to darken the image.

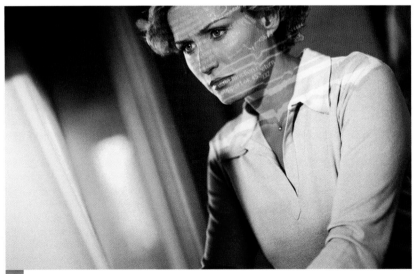

14 Now edit the *Red* and *Blue* curves independently to create the blue cast.

CREATING A RADIOACTIVE GLOW

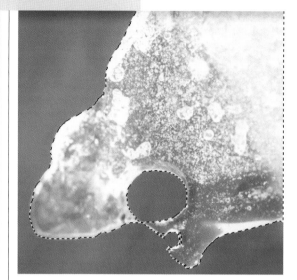

1 Make a selection of the ice.

2 Press Ctrl (Cmd) + J to copy and paste the selection to a new layer. Name the layer *Ice*.

3 Press Ctrl (Cmd) and click the *Ice* layer to load the selection again. Add a *Color Balance* adjustment layer that is clipped to the *Ice* layer.

Although we are going to create what I loosely describe as a radioactive glow, the effect would be equally convincing with far less controversial (and safer) subject matter, such as deep sea marine life that emit vibrant light or any intense light trained on ice glass or other translucent materials.

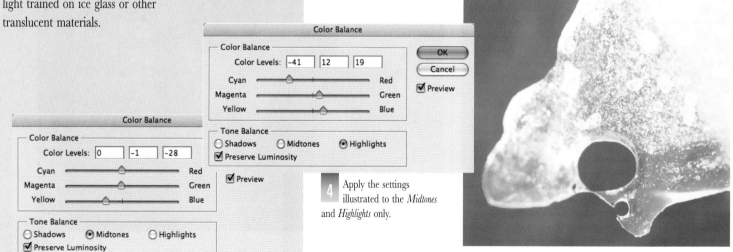

4 Apply the settings illustrated to the *Midtones* and *Highlights* only.

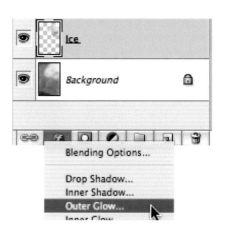

5 The intense light at the core of the object should give rise to a soft luminous glow around its perimeter, so apply an *Outer Glow* layer style to the *Ice* layer to achieve this.

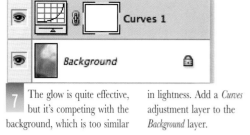

7 The glow is quite effective, but it's competing with the background, which is too similar in lightness. Add a *Curves* adjustment layer to the *Background* layer.

6 Apply the settings displayed. Use a color sampled from the ice itself as the glow color.

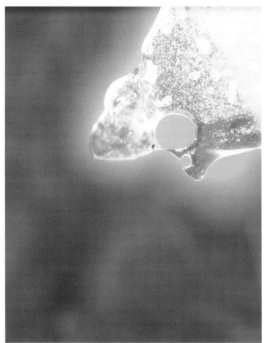

8 Adjust the curve to darken just the background.

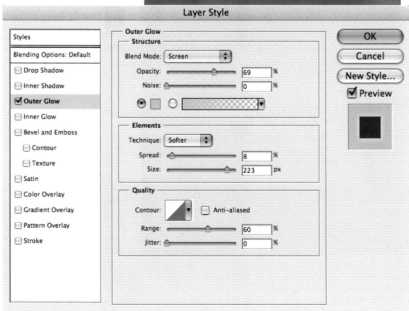

CREATING A STAR-FILLED NIGHT SKY

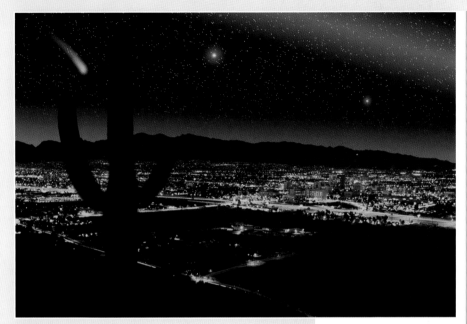

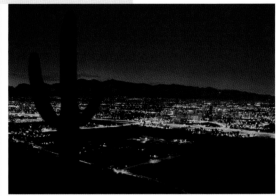

This desert city image is perfect for simulating a starry sky. There's a nice broad area of sky with relatively low levels of light emanating from the city. The low light level is achieved with the aid of the camera position, being far enough away for the ambient light to diminish sufficiently.

Photographing a star-studded night sky can be a daunting task at the best of times. Those stunning heavenly vistas can all too easily be transformed into a black void or a washed-out landscape when viewed on screen. The surreal, magical night sky scenes common to so many Hollywood movies are more often a product of clever software rather than a reflection of nature's own efforts. Apart from the technical pitfalls, location plays a major role in your ability to capture a good night sky. City-dwellers see only a fraction of what's really out there in deep space, due to the inherent ambient light of a city. If you're in the country or out at sea, or happen to find yourself in the middle of a desert, then with the right conditions you have the ultimate night sky at your disposal. For everyone else, there's Photoshop, and we will use it now to go one better than Mother Nature, by adding the Milky Way and a meteor on demand.

1 Double-click the *Background* layer and name it *City*.

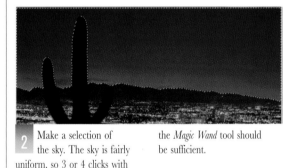

2 Make a selection of the sky. The sky is fairly uniform, so 3 or 4 clicks with the *Magic Wand* tool should be sufficient.

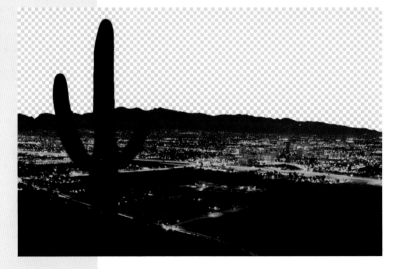

3 Press the Backspace key to delete the selected sky, then deselect the selection.

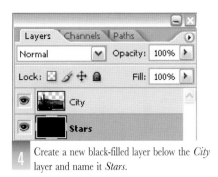

4 Create a new black-filled layer below the *City* layer and name it *Stars*.

5 In order for us to concentrate on the creation of the stars, it's easier if we hide the *City* layer before going any farther.

6 Make sure the *Stars* layer is active, and go to *Filter > Noise > **Add Noise***. Apply the settings as in the example.

7 To soften the effect, go to *Filter > Blur > **Gaussian Blur***, and apply a *Radius* setting of 0.3.

8 The result is a bit of a confused mass, so we need to pick out a random range of individual stars from it. Go to *Image > Adjustments > **Threshold***, and use a *Threshold Level* of 162. Dragging the slider to the left increases the amount of stars, and dragging to the right decreases.

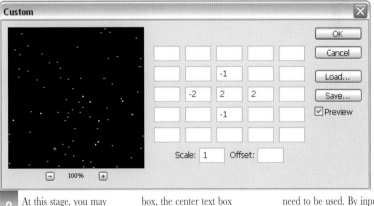

9 At this stage, you may decide you want either more or less, or bigger or smaller stars. This step lets you take control over the quantity and distribution of stars within the star field. Go to *Filter > Other > **Custom***. In the dialog box, the center text box represents the pixel being evaluated. This pixel's brightness value can be multiplied by a range from –999 to +999. The other text boxes represent the adjacent pixels. Not all of the text boxes need to be used. By inputting different numeric values, we can create what appears to be a random distribution of stars at different sizes. Negative values reduce brightness and positive values increase brightness. Enter the values as in the example.

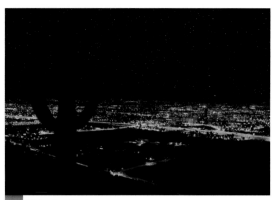

10 Make the *City* layer visible again to see how our image is developing.

11 Now to create the Milky Way: the Milky Way is that band of heavily clustered stars which appear to form one gaseous mass. Make a new layer called *Milky way* and hide the *City* layer again. This is to prevent you creating the Milky Way over the top of the cactus.

12 Set up the *Gradient* tool with the following settings: *Foreground to Transparent*, *Reflected*, and a pale blue color as the foreground color. I am using R147 G163 B198.

13 Make sure the *Milky way* layer is active, and drag the gradient through the top-right corner of the image, as in the example, following the red arrow.

14 Switch on the *City* layer's visibility, and set the *Milky Way* layer's *Opacity* to 70%.

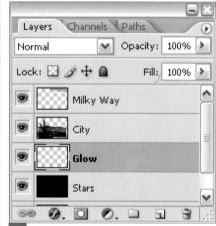

15 To introduce some real authenticity, we need to break up the large black background area a little. The perfect way to do this is to drop in the dying glow left by the sun as it sinks deeper below the horizon. Create a new layer called *Glow* and position it between the *Stars* and *City* layers.

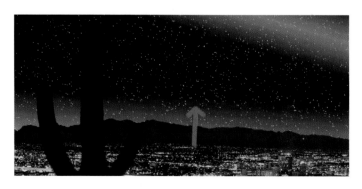

16 Set up the *Gradient* tool with the following settings: *Foreground to Transparent*, *Linear*, and a pale cyan/blue for the foreground color. I am using R173 G211 B211. Drag the gradient a short distance over the mountains as in the example.

17 Use the layer *Opacity* to control the strength of the glow. I have set the this to 75%.

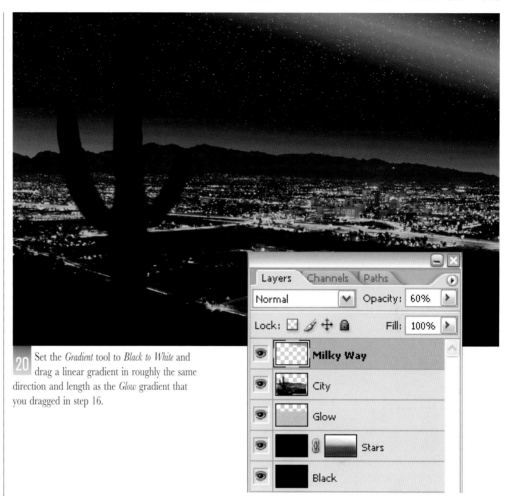

18 The visibility of stars usually begins to wane nearer to the horizon, especially over brightly lit cities. Our star field is a little too uniform in this respect, so we need to add a little fading. Create a new black-filled layer at the bottom of the *Layers* palette called *Black*.

20 Set the *Gradient* tool to *Black to White* and drag a linear gradient in roughly the same direction and length as the *Glow* gradient that you dragged in step 16.

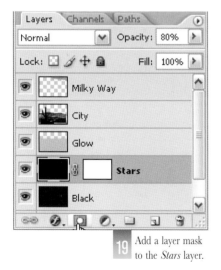

19 Add a layer mask to the *Stars* layer.

21 There's usually at least a couple of stars that outshine the others. We'll use a lens flare to depict one of these. At the top of the *Layers* palette, create a black-filled layer called *Bright star* and set the blend mode to *Screen*. The reason for this is because the *Lens Flare* filter can be applied only to an area filled with pixels. Applying *Screen* mode renders the black invisible, but allows the light-colored lens flare to show through.

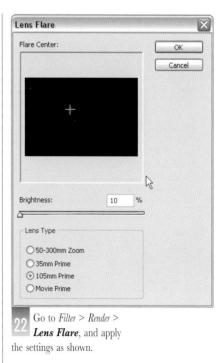

22 Go to *Filter > Render > **Lens Flare***, and apply the settings as shown.

23 Use the *Move* tool to position the lens flare to your liking.

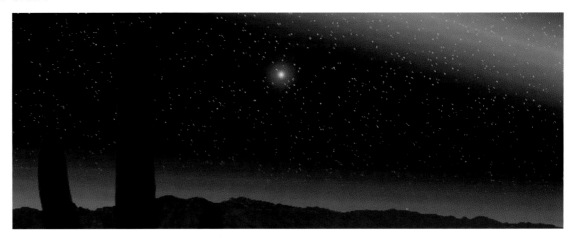

24 No star field is complete without a meteor, and the *Airbrush* is the perfect tool to create this particular illusion. Select the *Brush* tool and, using a soft-edged round brush, apply the settings from the *Tool Options* bar as pictured.

25 In the *Brushes* palette, select the *Other Dynamics* option and apply the settings as shown in the example. This creates a brush stroke that will fade out after 25 steps—perfect for the trailing tail of a meteor or comet.

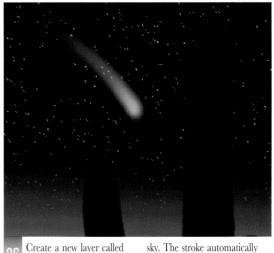

26 Create a new layer called *Meteor* and drag a slightly curved brush stroke through the sky. The stroke automatically fades out into a subtle taper.

27 You may have noticed a faint pale outline around the cactus. This is a remnant from the original background. We can make light work of removing unwanted highlights such as these by using the *Burn* tool. Select this tool and apply the settings in the *Options* bar as pictured.

28 Start to drag over the highlight edge with the *Burn* tool, and the highlight will start to gradually disappear.

29 Finally, the mountains in the distance now look out of place with the new darker sky, so we need to gently darken the whole mountain range, concentrating chiefly on the midtones to give us a subtle effect. Make a selection of the mountains and go to *Image > Adjustments > **Curves***. Create a curve similar to the one pictured.

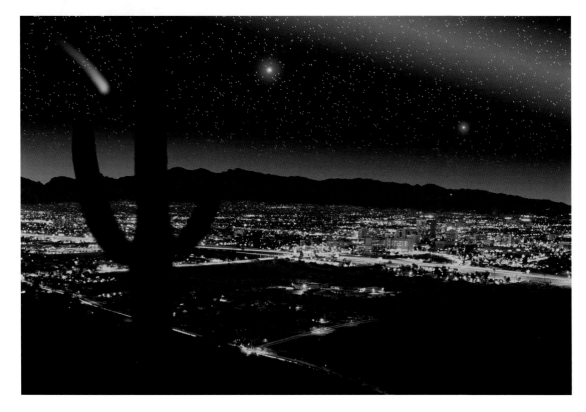

30 This is the finished result with an additional bright star applied using the *Lens Flare* filter again. Remember, the beauty of this process is that you have full control over the lightness and opacity of each element by simply changing the layer *Opacity*. This enables you to fine-tune each layer in relation to the other layers.

CREATING CHROME TEXT WITH THE LIGHTING EFFECTS FILTER

2 Type the words *club 100* in the channel in white. Large, rounded fonts work best for this effect. I'm using Arial rounded MT bold, point size 90 with anti-aliasing set to smooth.

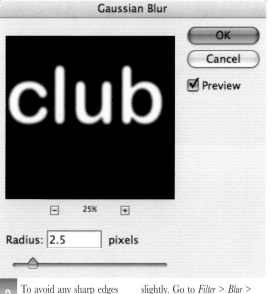

3 To avoid any sharp edges appearing and to increase the height and roundness of the text, we need to blur the edges slightly. Go to *Filter > Blur > **Gaussian Blur***, and apply a *Radius* setting of 2.5.

A s well as using the *Lighting Effects* filter in its more traditional role as a method for casting light onto a scene, it can also be used for other less obvious applications. When used in combination with a grayscale channel, it turns Photoshop into a simple form of 3D program. Using the 3D concept of highlights and shadows to depict raised and depressed areas, the grayscale channel acts as a texture map. As light is applied via the *Lighting Effects* filter, the varying shades of gray are molded into a 3-D form.

We will use this technique now to create a 3-D text object, and then turn it into shiny chrome as part of a company logo image.

1 I am starting with a background image taken half in and half out of water. Create a new black-filled channel called *text*.

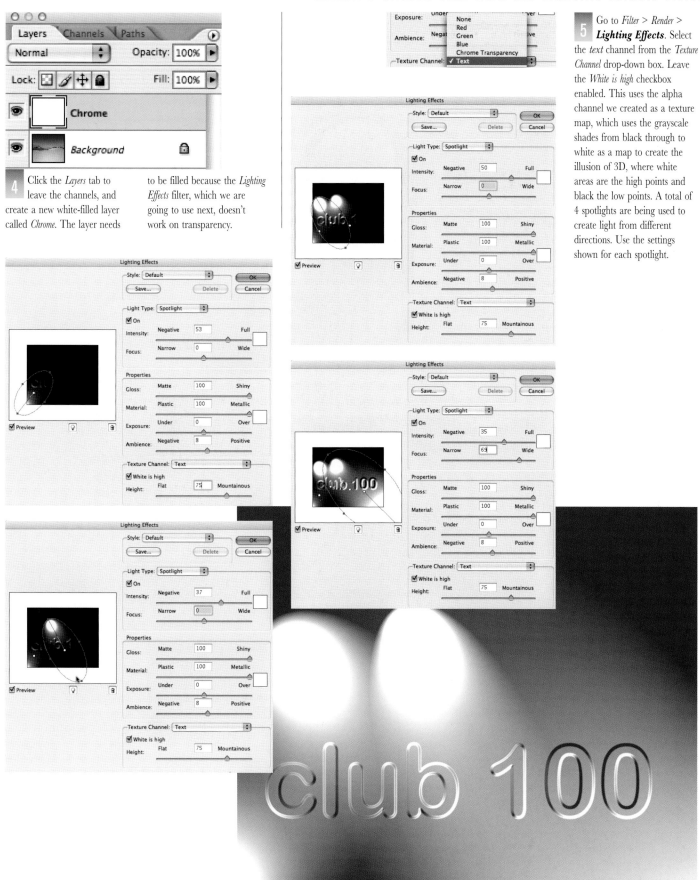

4 Click the *Layers* tab to leave the channels, and create a new white-filled layer called *Chrome*. The layer needs to be filled because the *Lighting Effects* filter, which we are going to use next, doesn't work on transparency.

5 Go to *Filter > Render > **Lighting Effects***. Select the *text* channel from the *Texture Channel* drop-down box. Leave the *White is high* checkbox enabled. This uses the alpha channel we created as a texture map, which uses the grayscale shades from black through to white as a map to create the illusion of 3D, where white areas are the high points and black the low points. A total of 4 spotlights are being used to create light from different directions. Use the settings shown for each spotlight.

6 To create the shiny reflective surfaces of chrome, go to *Image > Adjustments > **Curves***. By creating the erratic shaped curve shown, we will be making extreme highlight and shadow areas in close proximity, which perfectly simulates the way light reacts when falling on chrome surfaces.

7 Now we need to cut the chrome text from its background. Load the selection from the original *text* channel. You can do this quickly by pressing Ctrl (Cmd) + Alt + 4, assuming that channel number 4 is your *text* channel.

8 As a consequence of the text becoming embossed, it is now bigger than its original selection. To increase the size of the selection, go to *Select > Modify > **Expand***. Expand by small increments to avoid softening the edge of the selection. For this text, I'm applying the command 4 times, expanding by 2 pixels 3 times, and by 1 pixel for the last time.

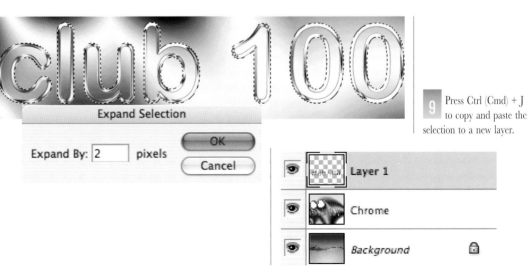

9 Press Ctrl (Cmd) + J to copy and paste the selection to a new layer.

10 Drag the original *Chrome* layer into the bin, and name the newly created layer *Chrome text*.

11 Position the text above the water line.

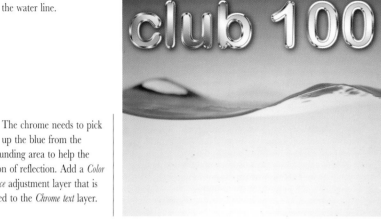

12 The chrome needs to pick up the blue from the surrounding area to help the illusion of reflection. Add a *Color Balance* adjustment layer that is clipped to the *Chrome text* layer.

14 A drop shadow will help to lift the text from the background, so click the *Layer Style* button at the bottom of the *Layers* palette and choose the *Drop Shadow* style.

13 Add small amounts of blue and cyan to the *Midtones* and *Highlights* only.

15 Use the settings shown to create a soft shadow.

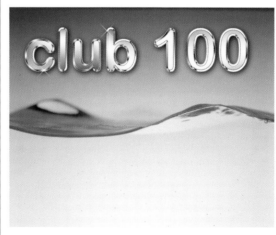

16 In the final image, a couple of star-shaped brush strokes have been applied for added sparkle.

PHOTOSHOP KEYBOARD SHORTCUTS

Menu Command	Photoshop CS Macintosh	Photoshop CS Windows
Auto Color	Cmd+Shift+B	Ctrl+Shift+B
Auto Contrast	Cmd+Option+Shift+L	Ctrl+Alt+Shift+L
Auto Levels	Cmd+Shift+L	Ctrl+Shift+L
Bring Forward/Send Backward	Cmd+[or]	Ctrl+[or]
Bring to Front/Send to Back	Cmd+Shift+[or]	Ctrl+Shift+[or]
Browse	Cmd+Option+O	Ctrl+Alt+O
Clear Selection	Backspace	Backspace
Close	Cmd+W	Ctrl+W
Close All	Cmd+Option+W	Ctrl+Alt+W
Color Balance	Cmd+B	Ctrl+B
Color Balance, use previous settings	Cmd+Option+B	Ctrl+Alt+B
Color Settings	Cmd+Shift+K	Ctrl+Shift+K
Copy	Cmd+C or F3	Ctrl+C or F3
Copy Merged	Cmd+Shift+C	Ctrl+Shift+C
Create Clipping Mask	Cmd+Option+G	Ctrl+Alt+G
Curves	Cmd+M	Ctrl+M
Curves, use previous settings	Cmd+Option+M	Ctrl+Alt+M
Cut	Cmd+X or F2	Ctrl+X or F2
Desaturate	Cmd+Shift+U	Ctrl+Shift+U
Deselect	Cmd+D	Ctrl+D
Edit in ImageReady	Cmd+Shift+M	Ctrl+Shift+M
Exit	Cmd+Q	Ctrl+Q
Extract	Cmd+Option+X	Ctrl+Alt+X
Extras, show or hide	Cmd+H	Ctrl+H
Fade Filter	Cmd+Shift+F	Ctrl+Shift+F
Feather Selection	Cmd+Option+D or Shift+F6	Ctrl+Alt+D or Shift+F6
File Info	Cmd+Option+Shift+I	Ctrl+Alt+Shift+I
Fill	Shift+F5	Shift+F5
Fill from History	Cmd+Option+Delete	Ctrl+Alt+Backspace
Filter, repeat last	Cmd+F	Ctrl+F
Filter, repeat with new settings	Cmd+Option+F	Ctrl+Alt+F
Fit on Screen	Cmd+0 (zero)	Ctrl+0 (zero)
Free Transform	Cmd+T	Ctrl+T
Gamut Warning	Cmd+Shift+Y	Ctrl+Shift+Y
Grid, show or hide	Cmd+' (quote)	Ctrl+' (quote)

Menu Command	Photoshop CS Macintosh	Photoshop CS Windows
Guides, show or hide	Cmd+; (semicolon)	Ctrl+; (semicolon)
Help contents	Help	F1
Hue/Saturation	Cmd+U	Ctrl+U
Hue/Saturation, use previous settings	Cmd+Option+U	Ctrl+Alt+U
Inverse Selection	Cmd+Shift+I or Shift+F7	Ctrl+Shift+I or Shift+F7
Invert	Cmd+I	Ctrl+I
Keyboard Shortcuts	Cmd+Option+Shift+K	Ctrl+Alt+Shift+K
Layer Via Copy	Cmd+J	Ctrl+J
Layer Via Cut	Cmd+Shift+J	Ctrl+Shift+J
Levels	Cmd+L	Ctrl+L
Levels, use previous settings	Cmd+Option+L	Ctrl+Alt+L
Liquify	Cmd+Shift+X	Ctrl+Shift+X
Lock Guides	Cmd+Option+; (semicolon)	Ctrl+Alt+; (semicolon)
Merge Layers	Cmd+E	Ctrl+E
Merge Visible	Cmd+Shift+E	Ctrl+Shift+E
New	Cmd+N	Ctrl+N
New Layer	Cmd+Shift+N	Ctrl+Shift+N
Open	Cmd+O	Ctrl+O
Open As	-	Ctrl+Alt+Shift+O
Page Setup	Cmd+Shift+P	Ctrl+Shift+P
Paste	Cmd+V or F4	Ctrl+V or F4
Paste Into	Cmd+Shift+V	Ctrl+Shift+V
Path, show or hide	Cmd+Shift+H	Ctrl+Shift+H
Pattern Maker	Cmd+Option+Shift+X	Ctrl+Alt+Shift+X
Preferences	Cmd+K	Ctrl+K
Preferences, last panel	Cmd+Option+K	Ctrl+Alt+K
Print	Cmd+P	Ctrl+P
Print One Copy	Cmd+Option+Shift+P	Ctrl+Alt+Shift+P
Print with Preview	Cmd+Option+P	Ctrl+Alt+P
Proof colors	Cmd+Y	Ctrl+Y
Release Clipping Mask	Cmd+Option+G	Ctrl+Alt+G
Reselect	Cmd+Shift+D	Ctrl+Shift+D
Revert	F12	F12
Rulers, show or hide	Cmd+R	Ctrl+R

Painting	Photoshop CS Macintosh	Photoshop CS Windows
Save	Cmd+S	Ctrl+S
Save for web	Cmd+Shift+Option+S	Ctrl+Shift+Alt+S
Save As	Cmd+Shift+S	Ctrl+Shift+S
Select All	Cmd+A	Ctrl+A
Snap	Cmd+Shift+; (semicolon)	Ctrl+Shift+; (semicolon)
Step Backwards	Cmd+Option+Z	Ctrl+Alt+Z
Step Forwards	Cmd+Shift+Z	Ctrl+Shift+Z
Transform Again	Cmd+Shift+T	Ctrl+Shift+T
Undo/Redo, toggle	Cmd+Z or F1	Ctrl+Z
View Actual Pixels	Cmd+Option+0 (zero)	Ctrl+Alt+0 (zero)
Zoom In	Cmd++ (plus) or Cmd+= (equals)	Ctrl++ (plus) or Ctrl+= (equals)
Zoom Out	Cmd+- (minus)	Ctrl+- (minus)
Brush size, decrease/increase	[or]	[or]
Brush softness/hardness, decrease/increase	Shift+[or]	Shift+[or]
Cycle through Healing Brush tools	Option+click Healing Brush tool icon or Shift+J	Alt+click Healing Brush tool icon or Shift+J
Cycle through Paintbrush tools	Option+click Paintbrush tool icon or Shift+B	Alt+click Paintbrush tool icon or Shift+B
Cycle through Eraser functions	Option+click Eraser tool icon or Shift+E	Alt+click Eraser tool icon or Shift+E
Cycle through Focus tools	Option+click Focus tool icon or Shift+R	Alt+click Focus tool icon or Shift+R
Cycle through Rubber Stamp options	Option+click Rubber Stamp tool icon or Shift+S	Alt+click Rubber Stamp tool icon or Shift+S
Cycle through Toning tools	Option+click Toning tool icon or Shift+O	Alt+click Toning tool icon or Shift+O
Delete shape from Brushes palette	Option+click brush shape	Alt+click brush shape
Display crosshair cursor	Caps Lock	Caps Lock
Display Fill dialog box	Shift+Delete	Shift+Backspace
Paint or edit in a straight line	Click and then Shift+click	Click and then Shift+click
Reset to normal brush mode	Shift+Option+N	Shift+Alt+N
Select background color tool	Option+Eyedropper tool+click	Alt+Eyedropper tool+click
Set opacity, pressure or exposure	Any painting or editing tool+ number keys (e.g. 0=100%, 1=10%, 4 then 5 in quick succession=45%)	Any painting or editing tool+ number keys (e.g. 0=100%, 1=10%, 4 then 5 in quick succession=45%)

Applying Colors	Photoshop CS Macintosh	Photoshop CS Windows
Add new swatch to palette	Click in empty area of palette	Click in empty area of palette
Color palette, show/hide	F6	F6
Cycle through color choices	Shift+click color bar	Shift+click color bar
Delete swatch from palette	Option+click swatch	Alt+click swatch
Display Fill dialog box	Shift+Delete or Shift+F5	Shift+Backspace or Shift+F5
Fill layer with background color but preserve transparency	Shift+Cmd+Delete	Shift+Ctrl+Backspace
Fill layer with foreground color but preserve transparency	Shift+Option+Delete	Shift+Alt+Backspace
Fill selection on any layer with background color	Cmd+Delete	Ctrl+Backspace
Fill selection or layer with foreground color	Option+Delete	Alt+Backspace
Fill selection with source state in History palette	Cmd+Option+Delete	Ctrl+Alt+Backspace
Lift background color from color bar at bottom of Color palette	Option+click color bar	Alt+click color bar
Lift background color from Swatches palette	Cmd+click swatch	Ctrl+click swatch
Lift foreground color from color bar at bottom of Color palette	Click color bar	Click color bar
Lift foreground color from Swatches palette	Click swatch	Click swatch

PHOTOSHOP KEYBOARD SHORTCUTS

Type	Photoshop CS Macintosh	Photoshop CS Windows
Align left, centre or right	Horizontal type tool +Shift+Cmd+L, C or R	Horizontal type tool +Shift+Ctrl+L, C or R
Align top, centre or bottom	Vertical type tool +Shift+Cmd+L, C or R	Horizontal type tool +Shift+Ctrl+L, C or R
Edit text layer	Double-click on 'T' in Layers palette	Double-click on 'T' in Layers palette
Move type in image	Cmd+drag type when Type is selected	Cmd+drag type when Type is selected
Leading, increase/decrease by 2 pixels	Option+arrow key	Alt+arrow key
Leading, increase/decrease by 10 pixels	Cmd+Option+ ← or → (left or right arrow)	Ctrl+Alt+ ← or → (left or right arrow)
Select all text	Cmd+A	Ctrl+A
Select word, line, paragraph or story	Double-click, triple-click, quadruple-click or quintuple-click	Double-click, triple-click, quadruple-click or quintuple-click
Select word to left or right	Cmd+Shift+ ← or → (left or right arrow)	Ctrl+Shift+ ← or → (left or right arrow)
Toggle Underlining on/off	Cmd+Shift+U	Ctrl+Shift+U
Toggle Strikethrough on/off	Cmd+Shift+/	Ctrl+Shift+/
Toggle Uppercase on/off	Cmd+Shift+K	Ctrl+Shift+K
Toggle Superscript on/off	Cmd+Shift++ (plus)	Ctrl+Shift++ (plus)
Toggle Subscript on/off	Cmd+Option+Shift++ (plus)	Ctrl+Alt+Shift++ (plus)
Type size, increase/decrease by 2 pixels	Cmd+Shift+< or >	Ctrl+Shift+< or >
Type size, increase/decrease by 10 pixels	Cmd+Shift+Option+< or >	Ctrl+Shift+Alt+< or >

Making Selections	Photoshop CS Macintosh	Photoshop CS Windows
Add point to Magnetic selection	Click with Magnetic Lasso tool	Click with Magnetic Lasso tool
Add or subtract from selection	Any Selection tool+Shift or Option+drag	Any Selection tool+Shift or Alt+drag
Cancel Polygon or Magnetic selection	Escape	Escape
Change lasso tool to irregular Polygon tool	Option+click with Lasso tool	Alt+click with Lasso tool
Clone selection	Option+drag selection with Move tool or Cmd+Option+drag with other tool	Alt+drag selection with Move tool or Ctrl+Alt+drag with other tool
Clone selection in 1-pixel increments	Cmd+Option+arrow key	Ctrl+Alt+arrow key

Making Selections	Photoshop CS Macintosh	Photoshop CS Windows
Clone selection in 10-pixel increments	Cmd+Shift+Option+arrow key	Ctrl+Shift+Alt+arrow key
Close magnetic selection with straight segment	Option+double-click or Option+ Return	Alt+double-click or Alt+Enter
Close polygon or magnetic selection	Double-click with respective Lasso tool or press Return	Double-click with respective Lasso tool or press Enter
Constrain marquee to square or circle	Press Shift while drawing shape	Press Shift while drawing shape
Constrain movement vertically, horizontally, or diagonally	Press Shift while dragging selection	Press Shift while dragging selection
Cycle through Lasso tools	Option+click Lasso tool icon or Shift+L	Alt+click Lasso tool icon or Shift+L
Cycle through Marquee tools	Option+click Marquee tool icon or Shift+M	Alt+click Marquee tool icon or Shift+M
Delete last point added with Magnetic Lasso tool	Delete	Backspace
Deselect all	Cmd+D	Ctrl+D
Draw out from centre with Marquee tool	Option+drag	Alt+drag
Feather selection	Cmd+Option+D or Shift+F6	Ctrl+Alt+D or Shift+F6
Increase or reduce magnetic lasso detection width	[or] (square brackets)	[or] (square brackets)
Move copy of selection	Drag with Move tool+Option	Drag with Move tool+Alt
Move selection in 1-pixel increments	Move tool+arrow key	Move tool+arrow key
Move selection in 10-pixel increments	Move tool+Shift+arrow key	Move tool+Shift+arrow key
Move selection area in 1-pixel increments	Any selection+arrow key	Any selection+arrow key
Move selection area in 10-pixel increments	Any selection+Shift+arrow key	Any selection+Shift+arrow key
Reposition selection while creating	Spacebar+drag	Spacebar+drag
Reselect after deselecting	Cmd+Shift+D	Ctrl+Shift+D
Reverse selection	Cmd+Shift+I or Shift+F7	Ctrl+Shift+I or Shift+F7
Select all	Cmd+A	Ctrl+A
Select Move tool	V	V
Subtract from selection	Option+drag	Alt+drag

Layers and Channels	Photoshop CS Macintosh	Photoshop CS Windows
Add spot color channel	Cmd+click page icon at bottom of Channels palette	Ctrl+click page icon at bottom of Channels palette
Add to current layer selection	Shift+Cmd+click layer or thumbnail in Layers palette	Shift+Ctrl+click layer or thumbnail in Layers palette
Clone selection to new layer	Cmd+J	Ctrl+J
Convert floating selection to new layer	Cmd+Shift+J	Ctrl+Shift+J
Copy merged version of selection to Clipboard	Cmd+Shift+C	Ctrl+Shift+C
Create new layer, show layer options dialog box	Option+click page icon at bottom of Layers palette or Cmd+Shift+N	Alt+click page icon at bottom of Layers palette or Ctrl+Shift+N
Create new layer below target layer	Cmd+click page icon at bottom of Layers Palette	Ctrl+click page icon at bottom of Layers Palette
Create new layer below target layer, show layer options dialog box	Cmd+Option+click page icon at bottom of Layers palette	Ctrl+Alt+click page icon at bottom of Layers palette
Display or hide Layers palette	F7	F7
Disable specific layer effect/style	Option+choose command from Layer > Effects submenu	Alt+choose command from Layer > Effects submenu
Move layer effect/style	Shift+drag effect/style to target layer	Shift+drag effect/style to target layer
Duplicate layer effect/style	Option+drag effect/style to target layer	Alt+drag effect/style to target layer
Edit layer style	Double click layer	Double click layer
Edit layer effect/style	Double-click on layer effect/style	Double-click on layer effect/style
Select current layer and layer below	Shift+Option+[Shift+Alt+[
Select current layer and layer above	Shift+Option+]	Shift+Alt+]
Group neighbouring layers	Cmd+G	Ctrl+G
Intersect with current layer selection	Shift+Option+Cmd+click layer or thumbnail in Layers palette	Shift+Alt+Ctrl+click layer or thumbnail in Layers palette
Load layer as selection	Cmd+click layer or thumbnail in Layers palette	Ctrl+click layer or thumbnail in Layers palette
Create Clipping Mask	Option+click horizontal line in Layers palette	Option+click horizontal line in Layers palette

Layers and Channels	Photoshop CS Macintosh	Photoshop CS Windows
Merge all visible layers	Cmd+Shift+E	Ctrl+Shift+E
Merge layer with next layer down	Cmd+E	Ctrl+E
Move contents of a layer	Drag with Move tool or Cmd +drag with other tool	Drag with Move tool or Ctrl +drag with other tool
Move contents of a layer in 1-pixel increments	Cmd+arrow key	Ctrl+arrow key
Move contents of a layer in 10-pixel increments	Cmd+Shift+arrow key	Ctrl+Shift+arrow key
Move shadow when Effect dialog box is open	Drag in image window	Drag in image window
Move to next layer above	Option+]	Alt+]
Move to next layer below	Option+[Alt+[
Moves target layer down/up	Cmd+[or]	Ctrl+[or]
Moves target layer back/front	Cmd+Shift+[or]	Ctrl+Shift+[or]
Preserve transparency of active layer	/	/
Retain intersection of transparency mask and selection	Cmd+Shift+Option+click layer name	Ctrl+Shift+Alt+click layer name
Subtract transparency mask from selection	Cmd+Option+click layer name	Ctrl+Alt+click layer name
Subtract from current layer selection	Option+Cmd+click layer or thumbnail in Layers palette	Alt+Ctrl+click layer or thumbnail in Layers palette
Switch between independent color and mask channels	Cmd+1 through Cmd+9	Ctrl+1 through Ctrl+9
Switch between layer effects in Effects dialog box	Cmd+1 through Cmd+0 (zero)	Ctrl+1 through Ctrl+0 (zero)
Switch to composite color view	Cmd+~ (tilde)	Ctrl+~ (tilde)
Ungroup neighboring layers	Cmd+Shift+G	Ctrl+Shift+G
View single layer by itself	Option+click eyeball icon in Layers palette	Alt+click eyeball icon in Layers palette

PHOTOSHOP KEYBOARD SHORTCUTS

Masks	Photoshop CS Macintosh	Photoshop CS Windows
Add channel mask to selection	Cmd+Shift+click channel name	Ctrl+Shift+click channel name
Add layer mask to selection	Cmd+Shift+click layer mask thumbnail	Ctrl+Shift+click layer mask thumbnail
Change Quick Mask color overlay	Double-click Quick Mask icon	Double-click Quick Mask icon
Convert channel mask to selection outline	Cmd+click channel name in Channels palette or Cmd+Option+ number (1 through 0)	Ctrl+click channel name in Channels palette or Ctrl+Alt+number (1 through 0)
Convert layer mask to selection outline	Cmd+click layer mask thumbnail or Cmd+Option+\ (backslash)	Ctrl+click layer mask thumbnail or Ctrl+Alt+\ (backslash)
Create channel mask filled with black	Click page icon at bottom of Channels palette	Click page icon at bottom of Channels palette
Create channel mask filled with black and set options dialog	Option+click page icon at bottom of Channels palette	Alt+click page icon at bottom of Channels palette
Create channel mask from selection outline	Click mask icon at bottom of Channels palette	Click mask icon at bottom of Channels palette
Create channel mask from selection outline and set options dialog	Option+click mask icon at bottom of Channels palette	Alt+click mask icon at bottom of Channels palette
Create layer mask from selection outline	Click mask icon	Click mask icon
Create layer mask that hides selection	Option+click mask icon	Alt+click mask icon
Disable layer mask	Shift+click layer mask thumbnail	Shift+click layer mask thumbnail
Enter or exit Quick Mask mode	Q	Q
Intersect a channel mask and selection	Cmd+Shift+Option+click channel name	Ctrl+Shift+Alt+click channel name
Subtract channel mask from selection	Cmd+Option+click channel name	Ctrl+Alt+click channel name
Subtract layer mask from selection	Cmd+Option+click layer mask thumbnail	Ctrl+Alt+click layer mask thumbnail
Switch focus from image to layer mask	Cmd+\ (backslash)	Ctrl+\ (backslash)
Switch focus from layer mask to image	Cmd+~ (tilde)	Ctrl+~ (tilde)
Toggle link between layer and layer mask	Click between layer and mask thumbnails in Layers palette	Click between layer and mask thumbnails in Layers palette
View channel mask as Rubylith overlay	Click eyeball of channel mask in Channels palette	Click eyeball of channel mask in Channels palette
View layer mask as Rubylith overlay	Shift+Option+click layer mask thumbnail or press \ (backslash)	Shift+Alt+click layer mask thumbnail or press \ (backslash)
View layer mask independently of image	Option+click layer mask thumbnail in Layers palette or press \ (backslash) then ~ (tilde)	Alt+click layer mask thumbnail in Layers palette or press \ (backslash) then ~ (tilde)
View Quick Mask independently of image	Click top eyeball in Channels palette or press ~ (tilde)	Click top eyeball in Channels palette or press ~ (tilde)

Paths	Photoshop CS Macintosh	Photoshop CS Windows
Add cusp to path	Drag with Pen tool, then Option+ drag same point	Drag with Pen tool, then Alt+drag same point
Add point to magnetic selection	Click with Magnetic Pen tool	Click with Magnetic Pen tool
Add smooth arc to path	Drag with Pen tool	Drag with Pen tool
Cancel magnetic or freeform selection	Escape	Escape
Close magnetic selection	Double-click with Magnetic Pen tool or click on first point in path	Double-click with Magnetic Pen tool or click on first point in path
Close magnetic selection with straight segment	Option+double-click	Alt+double-click
Deactivate path	Click in empty portion of Paths palette	Click in empty portion of Paths palette
Delete last point added with Pen tool or Magnetic Pen tool	Delete	Backspace
Draw freehand path segment	Drag with Freeform Pen tool or Option+drag with Magnetic Pen tool	Drag with Freeform Pen tool or Alt+drag with Magnetic Pen tool
Hide path toggle (it remains active)	Cmd+Shift+H	Ctrl+Shift+H
Move selected points	Drag point with Direct Selection tool or Cmd+drag with Pen tool	Drag point with Direct Selection tool or Ctrl+drag with Pen tool
Save path	Double-click Work Path item in Paths palette	Double-click Work Path item in Paths palette
Select arrow (direct selection) tool	A	A
Select entire path	Option+click path in Paths palette	Alt+click path in Paths palette
Select multiple points in path	Cmd+Shift+click with pen	Ctrl+Shift+click with pen
Select Pen tool	P	P
Make active path a selection	Cmd+Return	Ctrl+Enter

Crops and Transformations	Photoshop CS Macintosh	Photoshop CS Windows
Accept transformation	Double-click inside boundary or press Return	Double-click inside boundary or press Enter
Cancel crop	Escape	Escape
Cancel transformation	Escape	Escape
Constrained distort for perspective effect	Cmd+Shift+drag corner handle	Ctrl+Shift+drag corner handle
Constrained distort for symmetrical perspective effect	Cmd+Shift+Option+drag corner handle	Ctrl+Shift+Alt+drag corner handle
Freely transform with duplicate data	Cmd+Option+T	Ctrl+Alt+T
Replay last transformation with duplicate data	Cmd+Shift+Option+T	Ctrl+Shift+Alt+T
Freely transform selection or layer	Cmd+T	Ctrl+T
Replay last transformation	Cmd+Shift+T	Ctrl+Shift+T
Rotate image (always with respect to origin)	Drag outside boundary	Drag outside boundary

Crops and Transformations	Photoshop CS Macintosh	Photoshop CS Windows
Select Crop tool	C	C
Constrain axis	Shift+drag handle	Shift+drag handle

Rulers, measurements and Guides	Photoshop CS Macintosh	Photoshop CS Windows
Create guide	Drag from ruler	Drag from ruler
Display or hide grid	Cmd+' (quote)	Ctrl+' (quote)
Display or hide guides	Cmd+; (semicolon)	Ctrl+; (semicolon)
Display or hide Info palette	F8	F8
Display or hide rulers	Cmd+R	Ctrl+R
Lock or unlock guides	Cmd+Option+; (semicolon)	Ctrl+Alt+; (semicolon)
Snap guide to ruler tick marks	Press Shift while dragging guide	Press Shift while dragging guide
Toggle snapping	Cmd+Shift+; (semicolon)	Ctrl+Shift+; (semicolon)
Toggle horizontal guide to vertical or vice versa	Press Option while dragging guide	Press Alt while dragging guide

Slicing and Optimizing	Photoshop CS Macintosh	Photoshop CS Windows
Draw square slice	Shift+drag	Shift+drag
Draw from centre outward	Option+drag	Alt+drag
Draw square slice from centre outward	Option+Shift+drag	Alt+Shift+drag
Open slice's contextual menu	Control+click on slice	Right mouse button on slice
Reposition slice while creating slice	Spacebar+drag	Spacebar+drag
Toggle snap to slices on/off	Control while drawing slice	Ctrl while drawing slice
Toggle between Slice tool and Slice selection tool	Cmd	Ctrl

Filters	Photoshop CS Macintosh	Photoshop CS Windows
Adjust angle of light without affecting size of footprint	Cmd+drag handle	Ctrl+drag handle
Clone light in Lighting Effects dialog box	Option+drag light	Alt+drag light
Delete Lighting Effects light	Delete	Delete
Repeat filter with different settings	Cmd+Option+F	Ctrl+Alt+F
Repeat filter with previous settings	Cmd+F	Ctrl+F
Reset options inside Corrective Filter dialog boxes	Option+click Cancel button	Alt+click Cancel button

Hide and Undo	Photoshop CS Macintosh	Photoshop CS Windows
Display or hide Actions palette	Option+F9	F9 or Alt+F9
Display or hide all palettes, toolbox, status bar	Tab	Tab
Display or hide palettes except toolbox	Shift+Tab	Shift+Tab
Hide toolbox and status bar	Tab, Shift+Tab	Tab, Shift+Tab
Move a panel out of a palette	Drag panel tab	Drag panel tab
Revert to saved image	F12	F12
Undo or redo last operation	Cmd+Z	Ctrl+Z

Viewing	Photoshop CS Macintosh	Photoshop CS Windows
100% magnification	Double-click Zoom tool or Cmd+Option+0 (zero)	Double-click Zoom tool or Ctrl+Alt+0 (zero)
Applies zoom percentage and keeps zoom percentage box active	Shift+Return in Navigator palette	Shift+Enter in Navigator palette
Fits image in window	Double-click Hand tool or Cmd+0 (zero)	Double-click Hand tool or Ctrl+0 (zero)
Moves view to upper left corner or lower right corner	Home or End	Home or End
Scrolls image with hand tool	Spacebar+drag or drag view area box in Navigator palette	Spacebar+drag or drag view area box in Navigator palette
Scrolls up or down 1 screen	Page Up or Page Down	Page Up or Page Down
Scrolls up or down 10 units	Shift+Page Up or Page Down	Shift+Page Up or Page Down
Zooms in or out	Cmd++ (plus) or - (minus)	Ctrl++ (plus) or - (minus)
Zooms in on specified area of an image	Cmd+drag over preview in Navigator palette	Ctrl+drag over preview in Navigator palette

Function keys	Photoshop CS Macintosh	Photoshop CS Windows
Undo/redo, toggle	F1	
Help		F1
Cut	F2	F2
Copy	F3	F3
Paste	F4	F4
Display or hide Brushes palette	F5	F5
Display or hide Color palette	F6	F6
Display or hide Layers palette	F7	F7
Display or hide Info palette	F8	F8
Display or hide Actions palette	F9	F9
Revert to saved image	F12	F12

GLOSSARY

Adjustment layer A specialized layer that can be handled as a conventional layer but designed to enact effects upon all those layers below it in the image "stack." Effects that can be applied via an adjustment layer include changes in levels, brightness/contrast, color balance, and even posterization. These changes do not actually affect the underlying pixels. If the adjustment layer is removed the image will revert to its previous appearance. Conversely, an adjustment layer's adjustments can be permanently embedded in the image (or in the underlying layers) by selecting the appropriate layer merge command (such as Merge Down).

Alpha channel A specific channel in which information on the transparency of a pixel is kept. In image files, alpha channels can be stored as a separate channel additional to the standard three RGB or four CMYK channels. Image masks are stored in alpha channels.

Ambient light An alternate name for available light. This is the light (natural, artificial or both) that lights the photographic subject. It is specifically that illumination not provided by the photographer.

Artificial light Strictly, any light source not naturally occurring in the environment, but usually a term to describe incandescent, tungsten or fluorescent lighting.

Backlighting The principal light sources shine from behind the subject and are directed (broadly) towards the camera lens. This tends to produce results that have a lot of contrast, with silhouettes. A specific form of backlighting is called contre jour. Many cameras feature backlight controls that increase aperture (or exposure time) to compensate for backlighting and to prevent the silhouetting of foreground objects.

Base lighting Sometimes known as "ground lighting," this is the technique of lighting a subject from below with an upward-pointing light source. Often used for still-life photography of glassware and metallic objects to provide full lighting but without the flash highlights that would occur with front or side lighting. Causes a reversal of normal shadow profiles. Synonymous with ground light, although the latter term is sometimes reserved for ground-mounted lighting designed to up-light a background, rather than the subject.

Bézier curve A curved line between two Bézier control points. Each point is a tiny database, or "vector," which stores information about the line, such as its thickness, color, length, and direction. Complex shapes can be applied to the curve by manipulating "handles," which are dragged out from the control points. In image-editing applications, Bézier curves are used to define very precise shapes on a path.

Blending mode In Photoshop, individual layers can be blended with those underneath using blending modes. Some examples of these mode are: Normal, Behind, Clear, Dissolve, Multiply, Screen, Soft Light, Hard Light, Color Dodge, Color Burn, Darken, Lighten, Difference, Exclusion, Overlay, Saturation, Color, and Luminosity. Blending modes enact changes upon the original pixels in an image (sometimes called the base layer) by means of an applied blend color (or "paint" layer). This produces a resultant color based on the original color and on the nature of the blend. Many users find that blending mode results can be unpredictable and use trial and error to get the desired effects.

Blur filter The conventional blur effect filter, designed to detect noise around color transitions and remove it. It does this by detecting pixels close to boundaries and averaging their values, effectively eliminating noise and random color variations. Blur More is identical but applies the effect more strongly. Somewhat crude, the Blur filter is now joined in many image-editing filter sets with more controllable filters such as the Gaussian Blur and Smart Blur filters.

Brightness The relative lightness or darkness of the color, usually measured as a percentage from 0% (black) all the way up to 100% (white).

Capture The action of "getting" an image, by taking a photograph, scanning an image into a computer, or "grabbing" an image using a frame grabber.

Channels A conventional RGB color image is usually composed of three separate single-color images, one each for red, green, and blue, called channels. Each color channel contains a monochrome representation of the parts of the image that include that color. In the case of the RGB image channels containing the red, green, and blue colors, images are combined to produce a full-color image, but each of these individual channels can be manipulated in much the same way as a complete image. Channels can be merged or split using the Merge Channels or Split Channels commands. Additional channels exist to perform specific tasks: grayscale channels that save selections for masking are known as alpha channels; spot color channels are used to provide separate channels for specific ink colors known as spot colors (premixed inks used either in addition to or in place of CMYK inks).

CIE L*a*b* color space Three-dimensional color model based on a system devised by the CIE organization for measuring color. The L*a*b* color model is designed to be device independent when it comes to maintaining consistent color. Results should be consistent regardless of the device used, whether scanner, monitor or printer.

L*a*b* color consists of a luminance or lightness component (L) and two chromatic components: a (green to red) and b (blue to yellow).

Clipping Limiting an image or piece of art to within the bounds of a particular area.

Clipping group A stack of image layers that produce a resultant image or effect that is a net composite of the constituents. For example, where the base layer is a selection shape (say, an ellipse), the next layer a transparent texture (such as craquelure) and the top layer a pattern, the clipping group would produce a textured pattern in the shape of an ellipse.

Clipping path A Bézier outline that can be drawn around a subject or image element to determine which areas of an image should be considered transparent or "clipped." Using a clipping path, an object can be isolated from the remainder of the image, which is then rendered transparent, enabling background elements in an image composite to show through. A particular application is when cut-out images are to be placed on top of a tint background in a page layout. When a clipping path is created it can be embedded into the image file, normally when saved to the EPS format.

Clouds filter Creates a cloudscape using random values between those of the foreground and background colors. Care is therefore needed in selecting sensible colors in order to create a realistic effect. When aiming to create a realistic sky, background and foreground colors are completely interchangeable. This filter does not depend on the currently active image, unlike the Difference Clouds filter, which subsequently blends the clouds with the underlying image.

Color The visual interpretation of the various wavelengths of reflected or refracted light.

Color cast A bias in a color image which can be either intentionally introduced or the undesirable consequence of a lighting problem. Intentional color casts tend to be introduced to enhance an effect (such as accentuating the reds and oranges of a sunset, or applying a sepia tone to imply an aged photo) and can be done via an appropriate command in an image-editing application. Alternatively it can be done at the proof stage to enhance the color in an image. Undesirable casts arise from a number of causes but are typically due to an imbalance between the lighting source and the response of the film (or that of the CCD in the case of a digital camera). Using daylight film under tungsten lighting causes an amber color cast while setting the color balance of a digital camera for indoor scenes can give a flat blue cast outdoors.

Color temperature A measure of the composition of light. This is defined as the temperature—measured in degrees Kelvin—to which a black object would need to be heated to produce a particular color of light. The color temperature is based on a scale that sets zero as absolute darkness and increases with an object's—for example a light bulb filament's—brightness. A tungsten lamp, for example, has a color temperature of 2,900K, while the temperature of direct sunlight is around 5,000K and is considered the ideal viewing standard in the graphic arts.

Color wheel The complete spectrum of visible colors represented as a circular diagram and used as the basis of some color pickers. The HSB (hue, saturation, brightness) color model determines hue as the angular position on the color wheel and saturation as the corresponding radial position.

Complementary colors Any pair of colors directly opposite each other on a color wheel, that, when combined, form white (or black depending on the color model, subtractive or additive).

Contrast The degree of difference between adjacent tones in an image (or computer monitor) from the lightest to the darkest. "High contrast" describes an image with light highlights and dark shadows, but with few shades in between, while a "low contrast" image is one with even tones and few dark areas or highlights.

Crop To trim or mask an image so that it fits a given area, or to discard unwanted portions of an image.

Definition The overall quality—or clarity—of an image, determined by the combined subjective effect of graininess (resolution in a digital image) and sharpness.

Density The darkness of tone or color in any image. In a transparency this refers to the amount of light which can pass through it, thus determining the darkness of shadows and the saturation of color. A printed highlight cannot be any lighter in color than the color of the paper it is printed on, while the shadows cannot be any darker than the quality and volume of ink that the printing process will allow.

Density range The maximum range of tones in an image, measured as the difference between the maximum and minimum densities (the darkest and lightest tones).

Difference Clouds filter A Render filter like the "Clouds" filter, Difference Clouds creates cloudscapes using random color values between those of the foreground and background colors. It then blends these "clouds" with the underlying image using the same technique as the Difference blending mode.

Diffuse lighting Light that has low contrast and no obvious highlights or "hotspots." Bounce lighting can be diffuse if well spread. Overcast skies also represent a natural diffuse light source.

Dots Per Inch (dpi) A unit of measurement used to represent the resolution of devices such as printers and imagesetters. The closer the dots or pixels (the more there are to each inch) the better the quality. A typical resolution for a laser printer is 600dpi .

Drop shadow Effect (available as a filter, plug-in or layer feature) that produces a shadow beneath a selection conforming to the selection outline. This shadow (depending on the filter) can be moved relative to the selection, given variable opacity or even tilted. In the last case a drop shadow can be applied to a selection (say, a person) and that shadow will mimic a sunlight shadow.

Existing light Alternative name for available light, the term describes all natural and environmental light sources (those not specifically for the purpose of photography).

Eyedropper tool Conventionally used to select the foreground or background color from those colors in the image or in a selectable color swatch set. Eyedroppers can normally be accurate to one pixel or a larger area (such as a 3 x 3 pixel matrix) which is then averaged to give the selected color.

Feather Command or option that blurs or softens the edges of selections. This helps blend these selections when they are pasted into different backgrounds, giving less of a "cut-out" effect.

Flat lighting Lighting that is usually low in contrast and low in shadows.

Gaussian Blur filter Blur filter that applies a weighted average (based on the bell-shaped curve of the Gaussian distribution) when identifying and softening boundaries. It also introduces low-frequency detail and a mild "mistiness" to the image which is ideal for covering (blending out) discrete image information, such as noise and artefacts. A useful tool for applying variable degrees of blur and a more controllable tool than conventional blur filters. It can be accessed through the Filter > Blur > Gaussian Blur menu.

Gradient tool Tool permitting the creation of a gradual blend between two or more colors within a selection. There are several different types of gradient fills offered, those of Photoshop are typical: Linear, Radial, Angular, Diamond, and Reflected. A selection of gradient presets are usually provided, but user-defined options can be used to create custom gradients.

Graduation/Gradation The smooth transition from one color or tone to another.

Hard Light A blending mode that creates an effect similar to directing a bright light at the subject. Depending on the base color, the paint color will be multiplied or screened. Base color is lightened if the paint color is light, and darkened if the paint color is dark. Contrast tends to be emphasized and highlights exaggerated. Somewhat similar to Overlay but with a more pronounced effect.

Hex(adecimal) The use of the number 16 as the basis of a counting system, as distinct from our conventional decimal (base ten) system or the binary (base two) system used by basic computer processes. The figures are represented by the numbers 1 to 9, followed by the letters A to F. Thus decimal 9 is still hex 9, while decimal 10 becomes hex A, decimal 16 becomes hex 10, decimal 255 becomes hex FF, and so on.

High key An image comprising predominantly light tones and often imparting an ethereal or romantic appearance.

Histogram A graphic representation of the distribution of brightness values in an image, normally ranging from black at the left-hand vertex to white at the right. Analysis of the shape of the histogram (either by the user or an automatic algorithm) can be used to evaluate criteria, such as tonal range, and establishes whether there is sufficient detail to make corrections.

Image size A description of the dimensions of an image. Depending on the type of image being measured, this can be in terms of linear dimensions, resolution, or digtal file size.

Kelvin temperature scale (K) A unit of measurement that describes the color of a light source, based on absolute darkness rising to incandescence.

Lab color Lab color (as opposed to the CIE L*a*b* color model) is the internal color model used by Photoshop when converting from one color mode to another. "Lab mode" is useful for working with PhotoCD images.

Lasso The freehand selection tool indicated by a lasso icon in the Toolbar. there are many other variations on the basic lasso, such as the Magnetic Lasso (that can identify the edges nearest to the selection path, aiding accurate selection of discrete objects) and the Polygon Lasso (that allows straight-edged selections to be made). In the case of the latter, to draw a straight line, place the cursor point at the end of the first line and click. Place the cursor at the end of the next line and click again to select the second segment.

Layer Method of producing composite images by "suspending" image elements on separate "overlays." It mimics the method used by a cartoon animator wherein an opaque background is overlaid with the transparent "cells" (layers) upon which pixels can be painted or copied. Once layers have been created they can then be re-ordered, blended and have their transparency (opacity) altered. The power of using layers is that effects or manipulations can be applied to individual layers (or to groups of layers) independent of the others. When changes need to be made to the image only the relevant layer need be worked upon. Adjustment layers are specialized layers that perform modifications to the underlying layers without being visible themselves.

Layer effects/layer styles Series of effects, such as Drop Shadow, Inner Glow, Emboss, and Bevel, enacted on the contents of a layer.

Layer mask A mask that can be applied to the elements of an image in a particular layer. The layer mask can be modified to create different effects but such changes do not alter the pixels of that layer. As with adjustment layers (of which this is a close relation), a layer mask can be applied to the "host" layer (to make the changes permanent) or removed, along with any changes.

Layer menu Menu dedicated to layer manipulations. Options allow you to create, delete or duplicate layers, link, group, and arrange layers, and flatten an image.

Lens Flare filter A Render filter that introduces (controllable) lens flare into images that previously had none. Lens flare can often be simulated for a variety of lenses (for example, using multiple artefacts for multi-element zoom lenses).

Lighting Effects filter Powerful set of rendering filter effects that can be used to alter or introduce new lighting effects into an image. Most of these include an extensive range of tools to achieve credible effects. For example, the Photoshop implementation uses four sets of light properties, three light types and 17 styles to produce endless variations of lighting effects. "Bump Maps" (texture grayscale files) can be linked to the image to create contour-line three-dimensional effects.

Linear Gradient Option of most Gradient tools. Shades uniformly along a line drawn across the selection. The start point is colored in the first color (or foreground color, in a foreground to background gradient) and the end point in the last color (or background). A gentle gradient is achieved by drawing a long line over the selection (which can extend beyond the selection at either extreme); a harsher gradient will result from drawing a short line within the selection.

Liquify Photoshop 6 and above. An image distortion "filter" or filter set that allows a series of tools to be used to alter the characteristics and linearity of an image. Distorting tools include Twist, Bloat, and Pucker, the last giving a pinched, pincushion effect. Reconstruction modes are provided to undo or alter the effect of the distorting tools. The three modes of reconstruction are known as Amplitwist, Affine, and Displace. A Warp Mesh is drawn over the surface of the image to enable distortions to be easily seen and monitored. Image areas can also be masked at any point (prior to distorting, prior to reconstruction or otherwise) to prevent the tools taking effect in those areas. In Liquify this masking, and the consequent unmasking, is known as freezing and thawing.

Low key A photographic image comprising predominantly dark tones either as a result of lighting, processing or image editing.

Mask In the printing industry a mask was a material used to protect all or part of an image or page in photomechanical reproduction, photography, illustration or layout. Image-editor applications feature a digital equivalent that enables users to apply a mask to all or selected parts of an image. Such masks are often stored in an "alpha channel."

Mean noon sunlight An arbitrary color temperature to which most daylight color films are balanced, based on the average color temperature of direct sunlight at midday in Washington DC (5,400K).

Midtones/middletones The range of tonal values in an image anywhere between the darkest "shadow" tones and lightest "highlights." Usually refers to the central band of a histogram.

Mixed lighting Lighting comprising several different sources—such as tungsten and fluorescent artificial sources mixed with daylight. Such mixes are difficult to compensate for, but can be used to creative effect.

Motion Blur filter One of the blur filters, Motion Blur creates a linear blur (implying movement) at any angle. The degree of blur can be altered between arbitrary levels that introduce mild through to excessive blurs. Works most effectively when applied to an inverted selection: a selection is made of an object (say, a car, a runner or a train), the selection is inverted (to select the surroundings) and the filter applied to the inverse selection.

Multiply Useful tool for creating or enhancing shadow effects. Uses the paint pixel values to multiply those of the base. The resultant color is always darker than the original except when white is the paint color. Using a light paint imparts a gentler, but similar, effect to using darker colors.

Ocean Ripple filter Distort filter that places random ripple effects across the image, simulating the appearance of an object through the media of a changing refractive index, as distinct from "ripple" filters. The latter create the effect of ripples on the surface of water, such as when a pebble is dropped in an (idealized) stream. Also useful for creating image edge effects.

Opacity The degree of transparency that each layer of an image has in relation to the layer beneath. Layer opacities can be adjusted using an opacity control in the Layers palette.

Overlay Retains black and white in their original forms but darkens dark areas and lightens light areas. The base color is mixed with the blend color but retains the luminosity values of the original image

Path A line, curve, or shape drawn using the Pen tool Paths typically comprise anchor points linked by curved (or straight) line segments. The anchor points can be repositioned to alter a path if required. Each anchor features a direction line (Bézier line) and (normally) a pair of direction points. These can be pulled and moved to smoothly reshape the curve. Closed paths can easily be converted into selections and vice versa.

Pen tool Tool used to create paths. The basic Pen tool is used to draw around an intended selection, adding anchor points that are connected to make the path. You can add as many or as few anchor points as required to draw the path; simple, basic shapes will require few anchor points, while more complex selections will need more. Closed paths are completed by clicking on the original starting point. Open paths (for example, a straight line) are completed by clicking in the Pen tool icon in the Toolbar. The Magnetic Pen uses the same technique as the Magnetic Lasso: it identifies the "edge" closest to the track being described by the user and snaps the path to it. Anchor points are automatically added as the path progresses and can be added, removed, or moved later. The Freeform pen provides a means of drawing a freeform path. Use this to draw paths when the selection outline is not critical or you are confident of your drawing abilities. Again, anchor points are added along the path automatically. Additional options for these tools (that appear in dialog boxes or on pull-out menus) include the Add/Delete Point tools, Direct Selection tool (selects points on a path) and Convert Point tool (converts corner points into curve points and vice versa).

Perspective Command used principally to aid the correction of perspective effects in images, but also for the introduction of such effects for creative effect. The most common use is to remove converging verticals in buildings when the original image was taken with a conventional lens (relatively) close up.

Polar Coordinates filter Distort filter that converts an image's coordinates from conventional rectangular x–y axis to polar, and vice versa. The rectangular-to-polar conversion produces cylindrical anamorphoses—images that make no obvious logical sense until a mirrored cylinder is placed over the centre, when the image is displayed in conventional form again.

Quick mask Provides a quick method of creating a mask around a selection. The mask can be drawn and precisely defined by using any of the painting tools or the eraser respectively.

Radial gradient Option of most Gradient tools. Shades along a radius line in a circular manner. The start point of the line is the "origin" and is colored in the first, or start, color, while the end point defines the circumference and is colored with the end color.

Raster image An image defined as rows of pixels or dots.

Raster(ization) Deriving from the Latin word "rastrum," meaning "rake," the method of displaying (and creating) images employed by video screens, and thus computer monitors, in which the screen image is made up of a pattern of several hundred parallel lines created by an electron beam "raking" the screen from top to bottom at a speed of about one–sixtieth of a second. An image is created by varying the intensity of the beam at successive points along the raster. The speed at which a complete screen image, or frame, is created is called the "frame" or "refresh" rate.

Reflected gradient Option of most Gradient tools. Produces a symmetrical pattern of linear gradients to either side of the start point. The effect is one of a "ridge" or "furrow."

Resolution The degree of quality, definition, or clarity with which an image is reproduced or displayed, for example in a photograph, or via a scanner, monitor screen, printer, or other output device. The more pixels in an image, the sharper that image will be and the greater the detail. The likelihood of jaggies is also reduced the higher the image resolution.

Rim lighting A variation on backlighting where a strong light source is placed behind (and completely concealed by) the subject. In portraiture situations, this light is diffused through the hair to create a rim of bright light—the rim light. Careful metering is often called for to balance the rim light with that directed at the subject from the front.

Ripple filter Distort Simulates random pond-like ripples. The Wave filter provides similar results but provides more control.

Rubber Stamp tool Sometimes called the cloning tool (on account of its action), the Rubber Stamp tool is often considered by newcomers to be the fundamental tool, in as much as it provides the image-editing principle of "removing unwanted image elements." Later Photoshop versions (and some other editors) feature two Rubber Stamp tools, the basic tool, and the Pattern Stamp. The basic tool is normally used as a brush (and shares the common Brushes palette for brush type selection) but "paints" with image elements drawn from another part of the image, or a separate image. Choose the point you wish to use as the origination point for painting, and Alt-click or Option-click on it. Now move to the image element you wish to cover or remove and click the mouse to paint on the pixels from the origination point. When you click and drag the selection point can be set to move also, thus providing an exact copy of the original area. Careful use of the opacity setting in the Rubber Stamp Options palette can provide more subtle results and further options.

Screen Calculates the inverse of the blend and multiplies this with the base pixel values. The resultant color is always lighter than the original with the darkest parts of the base removed to give a bleached effect. There is no bleaching only if the blend color is black. This mode has been likened to printing a positive image from two negatives sandwiched together.

Sidelighting Lighting that hits the subject from the side, causing sharp, and often very profound, shadows.

Soft Light A more gentle, but similar, effect to Overlay. A light paint or layer color lightens the base color, a dark one darkens the base color. Luminosity values in the base are preserved. If the blend paint or layer is lighter than 50% gray, the image is lightened in the same manner as would result from photographic dodging. Blends darker than 50% produce a burned effect.

Specular highlight An intense highlight usually resulting from reflection of a light source from a convex section reflector. Specular highlights are plentiful on photographs of cars, for example, where curved brightwork produces such highlights. Also used for the lightest highlighted area in a reproduced photograph, usually reproduced as unprinted white paper.

Stroke path The Stroke Path command in Photoshop enables a previously constructed path to be painted using one of the painting tools.

Unsharp Mask filter One of the most potent Sharpening filters, Unsharp Mask can sharpen edges whose definition has been softened by scanning, resampling or resizing. Differing adjacent pixels are identified and the contrast between them increased. The Unsharp Mask uses three control parameters: Amount, Radius, and Threshold. Amount determines the amount of contrast added to boundary (edge) pixels. Radius describes the number of pixels adjacent to that boundary that are affected by the sharpening and Threshold sets a minimum value for pixel contrast below which the filter will have no effect. Once mastered it is a powerful filter and can achieve more subtle, but more effective, results than any other normal sharpening filter.

Wave filter Version of the Ripple Distortion filter that features customizable controls. Using "wave generators," ripples are created. The number of wave generators can be specified, as can wavelength and wave height. Though waves are conventionally sinusoidal, i.e., following the shape of a sine curve, they can also be triangular or square.

White balance "White" light is rarely pure white and tends to have unequal levels of red, green, or blue, resulting in a color cast. This color cast may not be visible to the human eye but can become very pronounced when a scene is recorded digitally. Almost all video cameras and many digital cameras feature a "white balance" setting that enables these to be neutralized, either by reference to a neutral white surface or against presets (precalibrated settings for tungsten lighting, overcast sky, fluorescent lighting, etc.). An auto white balance (AWB) setting ensures that the white balance is neutral by continuous or periodic monitoring (for example, prior to exposure) of environmental lighting conditions.

White light The color of light that results from red, blue, and green being combined in equal proportions at full saturation. If the saturations are anything less than full (and the proportions remain equal), then the color gray results.

White point Point on a histogram denoting where those pixels that define white are. Though nominally at the extreme end of the histogram, the white point should normally be moved to the position of the first "white" pixels in the histogram.

INDEX

ACKNOWLEDGMENTS

Thanks to the National Oceanic and Atmospheric Administration/Department of Commerce for the underwater source image on page 152.

ONLINE RESOURCES

Note that website addresses can change, and sites can appear and disappear almost daily. Use a search engine to help you find new arrivals or check old addresses that have moved.

Absolute Cross Tutorials (including plug-ins)
www.absolutecross.com/tutorials/photoshop.htm

The Complete Guide to Digital Photography
www.completeguidetodigitalphotography.com

creativepro.com: news and resources for creative professionals
www.creativepro.com

The Digital Camera Resource Page: consumer-oriented resource site
www.dcresource.com

Digital Photography: news, reviews, etc.
www.digital-photography.org

Digital Photography Review: products, reviews
www.dpreview.com

ePHOTOzine
www.ephotozine.com

The Imaging Resource: news, reviews, etc.
www.imaging-resource.com

Laurie McCanna's Photoshop Tips
www.mccannas.com/pshop/photosh0.htm

panoguide.com: panoramic photography
www.panoguide.com

photo.net: photography resource site - community, advice, gallery, tutorials, etc.
www.photo.net

Photolink International: education in photography and other related fields
www.photoeducation.net

Photoshop Today
www.photoshoptoday.com

Planet Photoshop (portal for all things Photoshop)
www.planetphotoshop.com

Royal Photographic Society (information, links)
www.rps.org